Light through a lens

AN ILLUSTRATED CELEBRATION OF 500 YEARS OF TRINITY HOUSE

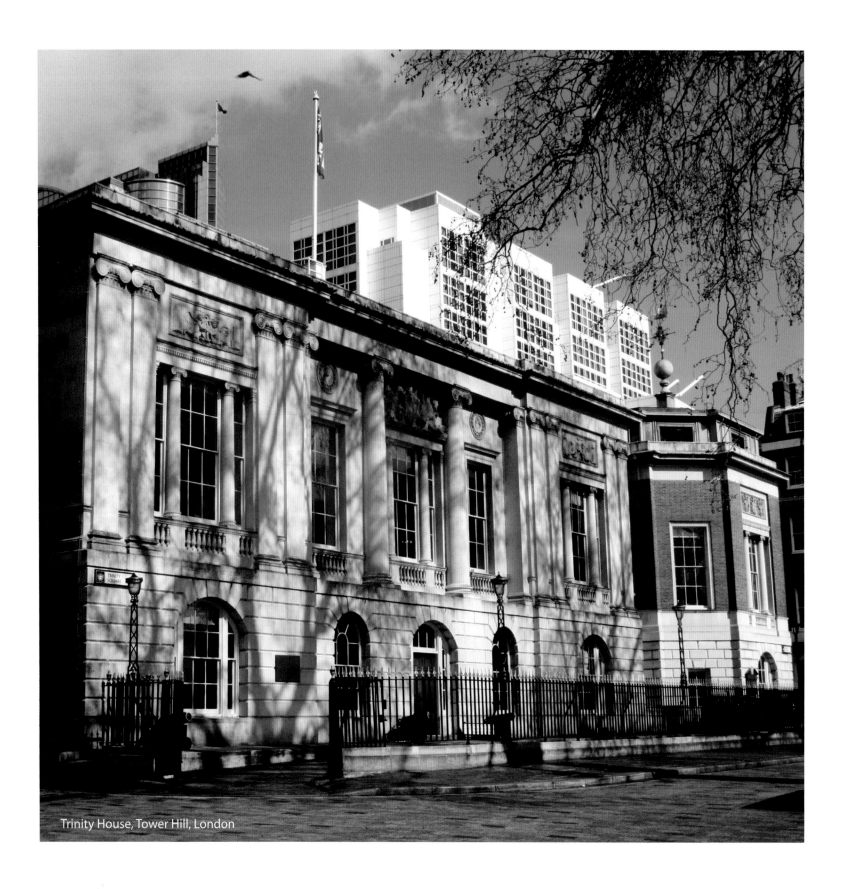

Trinity House, Tower Hill, London

Light through a lens

AN ILLUSTRATED CELEBRATION OF 500 YEARS OF TRINITY HOUSE

NEIL JONES AND PAUL RIDGWAY

ADLARD COLES NAUTICAL

B L O O M S B U R Y

LONDON · NEW DELHI · NEW YORK · SYDNEY

Published by Adlard Coles Nautical
an imprint of Bloomsbury Publishing Plc
50 Bedford Square, London WC1B 3DP

www.adlardcoles.com

Bloomsbury is a trademark of Bloomsbury Publishing Plc
Copyright © the Corporation of Trinity House 2014
First published by Adlard Coles Nautical in 2014

ISBN 978-1-4081-7595-8
ePDF 978-1-4729-1374-6
ePub 978-1-4729-1373-9

A CIP catalogue record for this book is available from the British
Library.

This book is produced using paper that is made from wood grown in
managed, sustainable forests. It is natural, renewable and recyclable.
The logging and manufacturing processes conform to the environ-
mental regulations of the country of origin.

Typeset in MonionPro by gridlock-design
Printed and bound in China by Toppan Leefung Printing

Note: while all reasonable care has been taken in the publication
of this book, the publisher takes no responsibility for the use of the
methods or products described in the book.

10 9 8 7 6 5 4 3 2 1

FOREWORD

20th May 2014 saw Trinity House mark the 500th anniversary of their Royal Charter, a very rare occasion by anyone's standard. Granted by Henry VIII so as to raise the standard of pilotage and safety on the River Thames, the Corporation's business in the main was to improve the art and science of navigation, to attend the wholesome government and increase of shipping and sea-faring men and to relieve aged seamen and their dependants.

For half a millennium the Corporation of Trinity House of Deptford Strond, with a fraternity of over 300 Brethren and staff, ships and depots across the nation, has served the mariner in almost every conceivable capacity; today Trinity House has three principal functions, being a General Lighthouse Authority, a major maritime charity and a Deep Sea Pilotage Authority.

As Master of the Corporation, I am proud to present this anthology of images curated from the archives of Trinity House, many of them being presented to the public for the first time. There is a great wealth of imagery to be found here: dramatic snapshots all the more interesting for being taken not by professional photographers in closed locations but rather by lighthouse keepers, Elder Brethren and engineers in the thick of it; fine artworks from the Trinity House at Tower Hill, London and painstaking architectural drawings, charts and ancient prints illuminating the Corporation's early history. Together, they show some of the most striking visuals of five centuries of service and acknowledge a debt to generations of 'Trinity men' and their families. I know you will enjoy this fascinating book.

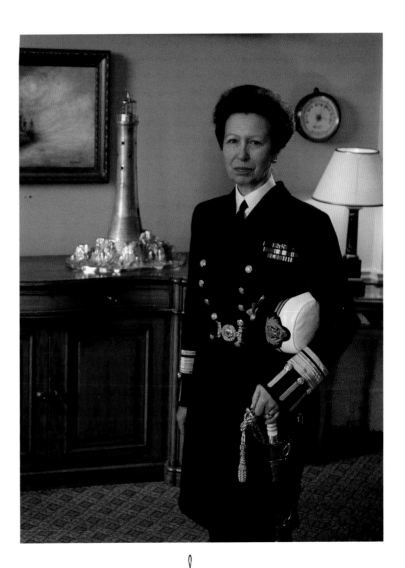

HRH The Princess Royal
Master
May 2014

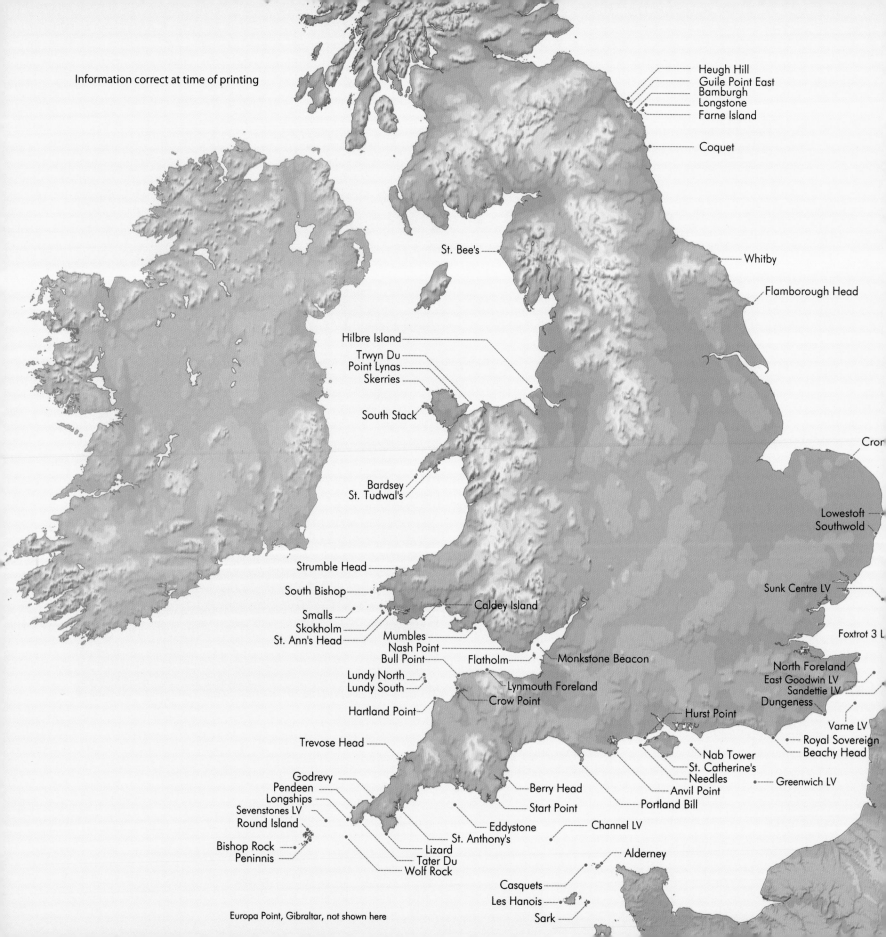

Information correct at time of printing

Heugh Hill
Guile Point East
Bamburgh
Longstone
Farne Island

Coquet

St. Bee's

Whitby

Flamborough Head

Hilbre Island
Trwyn Du
Point Lynas
Skerries

South Stack

Bardsey
St. Tudwal's

Cror

Strumble Head

South Bishop

Lowestoft
Southwold

Smalls
Skokholm
St. Ann's Head
Mumbles
Nash Point
Bull Point
Lundy North
Lundy South
Hartland Point

Caldey Island

Sunk Centre LV

Foxtrot 3 L

Flatholm
Lynmouth Foreland
Crow Point

Monkstone Beacon

North Foreland
East Goodwin LV
Sandettie LV
Dungeness

Varne LV

Trevose Head

Hurst Point

Royal Sovereign
Beachy Head

Nab Tower
St. Catherine's
Needles
Anvil Point
Portland Bill

Godrevy
Pendeen
Longships
Sevenstones LV
Round Island

Bishop Rock
Peninnis

Berry Head

Start Point

Eddystone
St. Anthony's
Lizard
Tater Du
Wolf Rock

Greenwich LV

Channel LV

Alderney

Casquets
Les Hanois

Sark

Europa Point, Gibraltar, not shown here

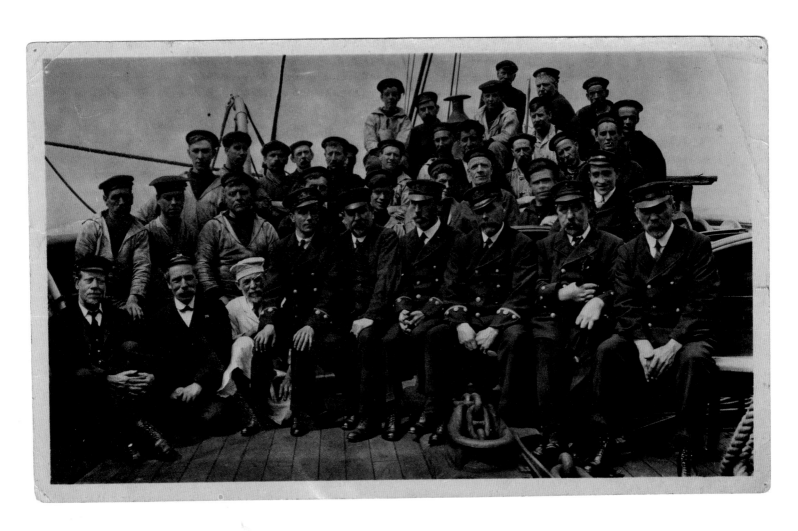

Above: Group portrait of the crews of the Trinity House Steam Vessels *Irene* and *Stella* plus men from Blackwall Depot and nearby lightvessels on the *Irene*'s foredeck, pre-1916.

Opposite: A map showing positions of the operational lighthouses and lightvessels of Trinity House.

TO T

MAST

WARDENS and AS

OF THE

TRINITY H

OF

DEPTFORD-ST

able and Right Worſhipful,

firſt His Majeſty King *CHARLES* the Second,

wing the Sea-Coaſt, I then, as in Duty-bound (being a

most humbly laid the Propoſals before you ; whereupon

but did moſt bountifully advance towards the Charg

with all Submiſſion and Gratitude, I aſſume the Bold

Protection and Patronage, of any Rocks, or

hould be made, often they do) I ſhall be

'As a matter of history the record of Trinity House is fascinating. In its time it has been many sided. It has served the nation in this capacity and that, and all the while it has somehow managed to make itself so indispensable that, in an age of scant reverence for ancient institutions, it stands not only unassailed, but, we might also add, unassailable.'

Lloyd's List, 20 May 1914.

Greenville Collins' dedication to the Elder Brethren in his seminal 1693 chart folio of the British Isles.

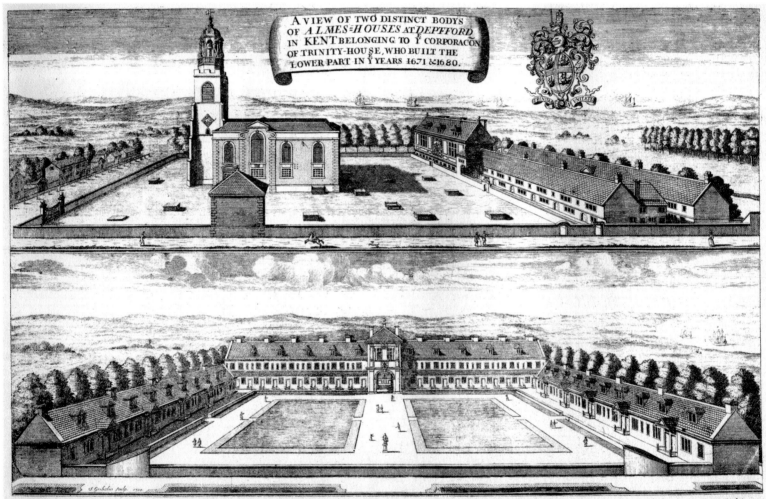

In these ALMES=HOUSES Fifty nine decay'd MASTERS of SHIPS, and PILOTS, or the Widows of such are by the Corporation of TRINITY-HOUSE maintaind ; As are TwentyEight more in other their Almeshoufes at Mile end near London] Besides, upwards of Two Thousand poor Aged Seamen, or their Widows, do receive conftant monthly Penſions from ÿ ſᵈ Corporation. and Six in their Almshouses at the Dogrow.............................. ſ

The Corporation's almshouses at Deptford. The late 17th century print indicates that more than 2000 poor, aged seamen, or their widows, were provided for with constant monthly pensions from the Corporation of Trinity House.

INTRODUCTION

The Corporation of Trinity House is a venerable English institution the purpose of which is not widely understood, though a vague notion may exist of its involvement with pilotage and lighthouses. It is, in fact, a complex organisation with several arms and differing purposes. Among the former are its ruling Court, its Fraternity of seafarers, its estate and its lighthouse service. While the last provides a wider range of services to the mariner than its name suggests, the Corporation's far-ranging activities include the examination and licensing of deep-sea pilots, the relief of distressed and disabled seafarers and their dependants, and the promotion of maritime education and training, including a cadet scheme providing future officers for the Merchant Navy and our national maritime infrastructure.

It is the purpose of this book to illustrate some of these activities, both past and present, in order to reveal to a public increasingly divorced from our national maritime life the vital part still played by Trinity House.

The origins of Trinity House are obscure, founded in verbal tradition rather than recorded fact. However, it is known that prior to its incorporation by Henry VIII in 1514 there was a Fraternity or Guild of Seamen of a semi-religious character with benevolent objectives, and that it possessed a hall and almshouses at Deptford on the Kent side of the Thames.

Subsequent loss of valuable records and artefacts occurred during the Great Fire of London in 1666 when the Trinity House in Water Lane was destroyed. Another fire in Water Lane in 1715 did further damage and in 1940, by which time

the Corporation had been in possession of its headquarters on Tower Hill, the present Trinity House was gutted during the Blitz when a direct hit by a German incendiary bomb set the building alight.

Despite these vicissitudes, it is known that on 20 May, 1514 Henry VIII granted Trinity House its charter following a petition from the mariners of the Guild for their incorporation in order to regulate pilotage on the River Thames, complaining that 'Scots, Flemings and Frenchmen have been suffered to learn as lodesmen [pilots] the secrets of the King's streams'. Henceforth, 'the Master, Wardens and Assistants of the Guild or Fraternity of the most glorious and undivided Trinity and St Clement in the Parish Church of Deptford Strond' were given various powers and rights to protect and further the interests of mariners and to provide benefit for them when in need.

St Clement, Clemens Romanus, third Bishop of Rome, who was martyred in AD 101, is one of the patron saints of mariners and, like St Nicholas, he is the patron of many seaside churches.

A later charter refers to the distinction between Elder and Younger Brethren, the governance of the Corporation being placed and remaining to this day in the hands of the former. The Corporation's Court is presided over by the Master, supported by a Deputy Master, two Wardens, a number of Mariner Assistants and other Elder Brethren.

The first Master was Sir Thomas Spert, a leading Tudor mariner who owned and commanded merchantmen acting as sailing

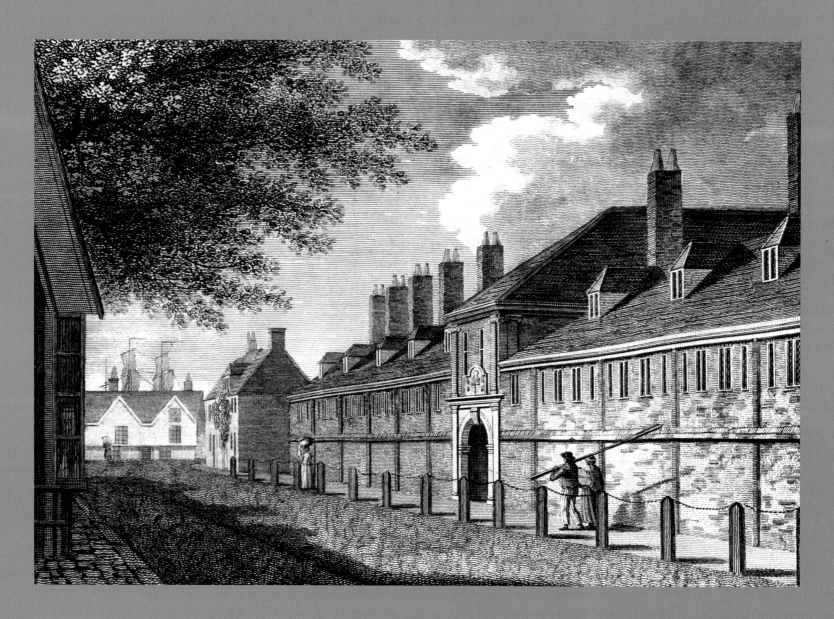

The Deptford Lower Ground almshouses were built close to the River Thames as indicated by the ships' masts in the background. The riverside town of Deptford was the principal naval base in Britain where warships were designed and constructed during the reign of Henry VIII. A guild of Deptford-based mariners petitioned the king in 1513 for the regulation of shipping. The resultant body incorporated by Royal Charter on 20 May, 1514 was the Trinity House of Deptford Strond.

Master and Master attendant to the king. He was sailing Master of the *Mary Rose*, though not at the time of her sinking, and of the king's greatest ship, the *Henri Grâce à Dieu*, or *Great Harry*. By the 19th century the position of Master had become honorary and in 2011, following her father, HRH The Prince Philip Duke of Edinburgh, HRH The Princess Royal was elected to the post.

Since the Restoration of Charles II in 1660, the ranks of the Elder Brethren have always included a number of men of note, the first being 'Honest George' Monck, first Duke of Albemarle, who was largely responsible for the return of the king. He has been followed by a number of distinguished statesmen, mainly Prime Ministers, including William Pitt (the Younger), the Duke of Wellington, Lord Palmerston, Winston Churchill, Clement Attlee, Edward Heath, Harold Wilson and John Major. The Royal Navy has also been represented, Admirals Benbow, Anson, Hawke, Boscawen and Howe being typical of the 18th century.

The Younger Brethren consist chiefly of Masters of merchant ships or naval officers who have commanded major warships. However, in accordance with the provisions of the original charter, which specified 'as well women as men', the Younger Brethren can, at the time of writing, boast of a number of women, including Captain Barbara Campbell, who commands the sail-training barque *Lord Nelson*, and the internationally renowned yachtswoman Dame Ellen MacArthur.

Of significance in the Corporation's rising fortunes was the Right of Ballastage, granted by Elizabeth I in 1594. This followed an earlier Act empowering Trinity House to lay buoys and erect beacons and other seamarks for the safer navigation of the Thames and its extensive and dangerous estuary. Selling ballast for sailing ships requiring it provided the income necessary for carrying out these functions, and in withdrawing what had been a perquisite of the Lord High Admiral, Lord Howard of

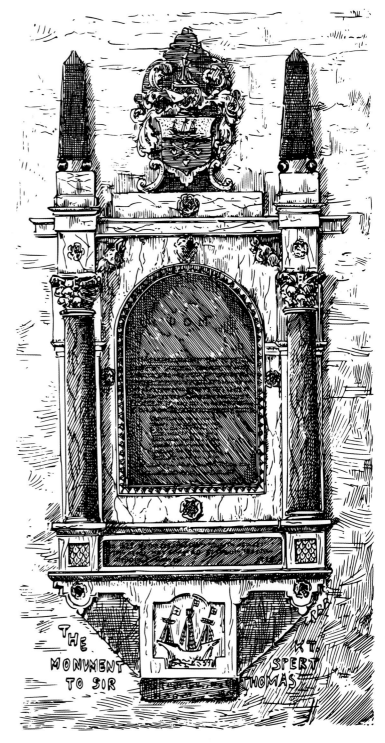

The monument in St Dunstan's Church, Stepney, to Sir Thomas Spert shows the ship motif that would become part of the Corporation's coat of arms in 1573. Spert, the Corporation's first Master, died in September 1541.

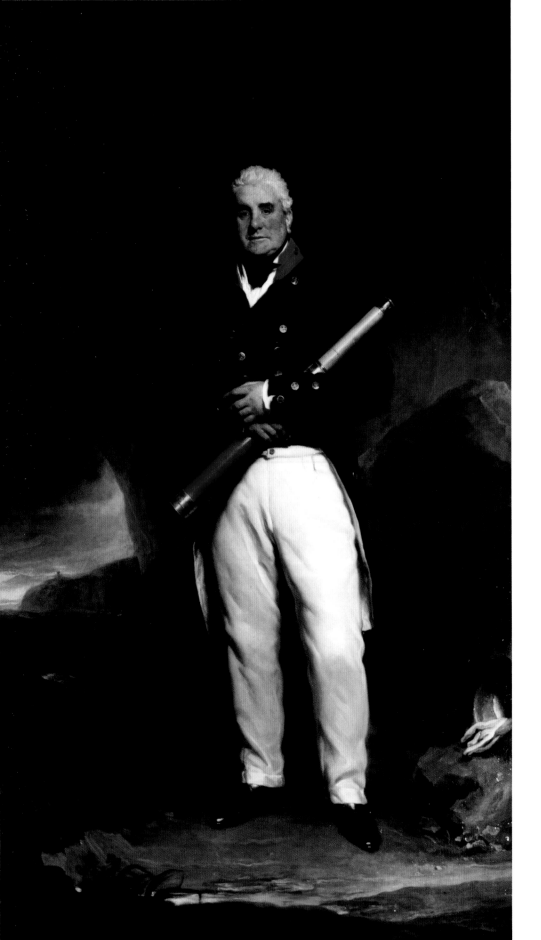

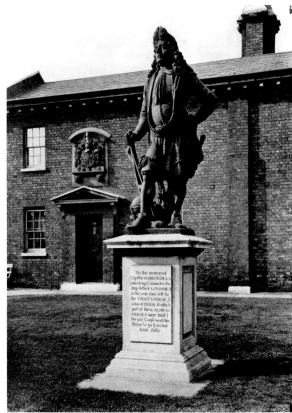

Captain Richard Maples (*above*) was an Elder Brother and benefactor to the almshouses at Mile End. From the earliest days the Fraternity of Trinity House has been concerned with the relief of poor seafarers and their dependants. It is known that the hall and almshouses that formerly stood on the site at Deptford '*for decayed Masters of ships and their Widows*' were extant before Trinity House was incorporated by Royal Charter in 1514.

Left: Captain John Woolmore (1755–1837) was the Deputy Master to the Corporation of Trinity House from 1825 to 1834. He went to sea at the age of 12 in the East India Company's ship, *Granby* and had an extensive career including command, trading to the East in the Company's vessels.

Opposite: The almsbox given to Trinity House by John Woodcot, Master in 1597. Fines among the Brethren for unruly language enabled the princely sum of £200 to be distributed to 1200 applicants for alms on Christmas Day 1705.

Effingham, the Queen empowered the Elder Brethren with a monopoly that would endure until the 19th century when steam power and steel ships rendered dredged ballast obsolete.

Another distinction acquired in the reign of Elizabeth I was the Grant of Arms of 1573. The emblem of St. George's cross and four ships defaces the Corporation's red ensign and the command flags flown by the Master, Deputy Master and Elder Brethren, also appearing in badges of rank and elsewhere as a corporate image.

In 1604, James I granted a charter that conferred on the Corporation the power to appoint pilots. This right ended in 1988, removed by the Pilotage Act, by which time there were more than 600 Trinity House pilots serving ports in England, Wales and the Channel Islands, supported by a fleet of pilot cutters. Today, as noted earlier, Trinity House in London, like its sister institutions in Newcastle upon Tyne and Kingston upon Hull, examines and licenses deep-sea pilots able to assist large vessels through the dangerous and crowded waters of the English Channel, the Strait of Dover and the North Sea.

Throughout its history, Trinity House has acted in support of the state, intially assisting the raising of men and provision of ships for war. The Elder Brethren acted as a consultative and expert body of mariners, advising the Navy Board on the construction, manning, arming and victualling of men-of-war and the making of artillery batteries at Gravesend and Tilbury in the Thames Estuary. Later, during the American War of Independence, the Corporation provided a defensive force for the Thames Estuary. During the Napoleonic War it raised a force of ships and 1200 men to defend the Thames itself, establishing a cordon or boom of armed frigates across the reach of the Thames known as the Lower Hope; the Royal Trinity House Volunteer Artillery

was maintained between 1803 and 1805 at the Corporation's expense.

During the First World War, Trinity House Vessels were attached to the Royal Navy's Dover Patrol and the Corporation's personnel were involved in buoy-laying operations in the White Sea during the Russian Intervention of 1919.

In the Second World War, the Corporation was heavily involved in maintaining safe navigation on the east coast, an important convoy route under almost continuous attack by German forces. Six of the Corporation's tenders played a vital role in the D-Day operations, laying buoys to the beachheads immediately behind the minesweepers, marking the route for the mass of invasion craft that followed.

The chief charitable aim of Trinity House, the relief of poor seafarers and their dependants, has largely been met by the provision of almshouses and the disbursement of money to the needy. In the early years, Trinity House maintained 21 almshouses at Deptford before its removal across the Thames to Ratcliff, Stepney, in 1618. Later almshouses were built in the Mile End Road, replaced in 1958 by new buildings at Walmer in Kent. The Corporation moved to a new Trinity House in Water Lane in 1660, adjacent to where the Custom House stands

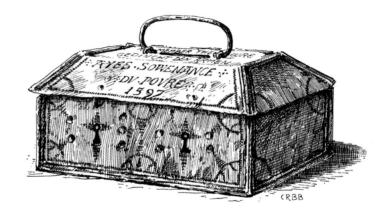

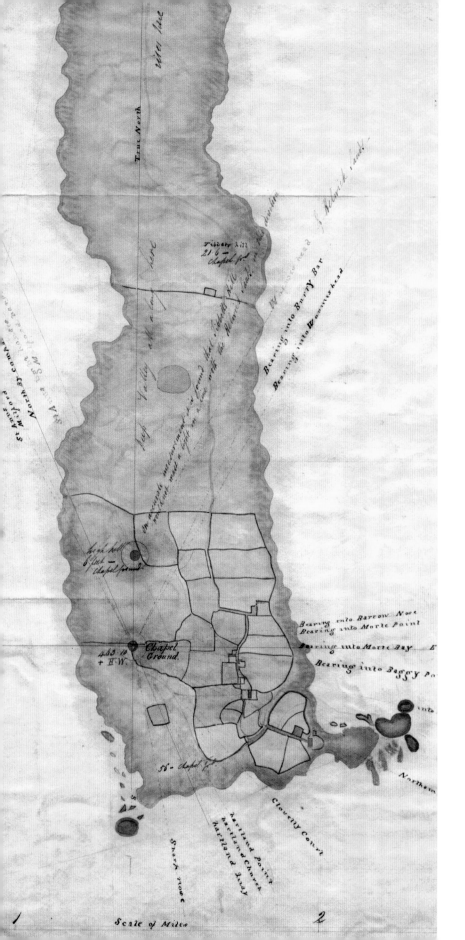

in the City of London today. In 1796, the Brethren moved again, to Tower Hill, where Samuel Wyatt had designed a fine building that was inaugurated by King George III and Queen Charlotte. This remains the Corporation's headquarters, rebuilt after the Second World War and reopened by Queen Elizabeth II in October 1953. By the time Wyatt was commissioned, the Corporation was a wealthy organisation, as were the Elder Brethren of the day, most of them having made fortunes as commanders of East Indiamen who afterwards became managing owners of the East India Company's ships. Besides contributions from individual Brethren, a tradition of bequests had built up considerable funds to which were added properties in Lincolnshire and Essex. The most valuable, however, was the legacy of Captain Merrick, a Younger Brother, who in 1660 conveyed to the Corporation an estate of 200 houses in the Borough. These, now two beautiful Georgian squares in Southwark named Trinity Village continue to raise rents from which the Corporation's annual charitable disbursements of some four million pounds chiefly derive.

Samuel Wyatt, the architect of the present Trinity House, was among a number of distinguished architects and civil engineers who designed and supervised the building of lighthouses, the activity for which Trinity House is best known today. Although the Corporation was granted the right to erect lighthouses and seamarks in 1566 by Elizabeth I, the right was not exclusive, and the monarch continued to grant patents to individuals – subject

Despite heavy losses to the Corporation's archives in 1666, 1715 and 1940, as well as the various disruptive changes of headquarters (from Deptford to Ratcliff in 1618, to Water Lane in 1660 and Tower Hill in 1796), Trinity House has retained a remarkable collection of artefacts and archives, which include architectural plans, paintings, nauticalia, ship models, silverware and lighthouse optics. Today, many of the Corporation's records are to be found in the London Metropolitan Archives.

Left: The proposed position of Lundy Lighthouse, circa 1819.
Opposite: The Certificate of Admission, or 'Branch', for Younger Brother Captain John Woodden of 1699.

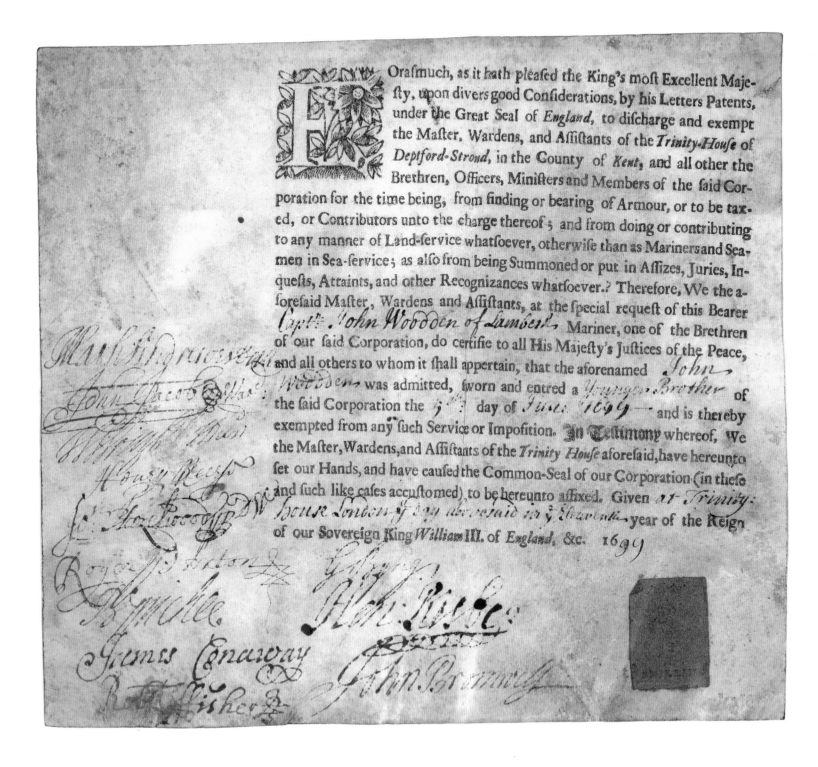

Orasmuch, as it hath pleased the King's most Excellent Majesty, upon divers good Considerations, by his Letters Patents, under the Great Seal of *England*, to discharge and exempt the Master, Wardens, and Assistants of the *Trinity-House* of *Deptford-Strond*, in the County of *Kent*, and all other the Brethren, Officers, Ministers and Members of the said Corporation for the time being, from finding or bearing of Armour, or to be taxed, or Contributors unto the charge thereof ; and from doing or contributing to any manner of Land-service whatsoever, otherwise than as Mariners and Seamen in Sea-service; as also from being Summoned or put in Assizes, Juries, Inquests, Attaints, and other Recognizances whatsoever. Therefore, We the aforesaid Master, Wardens and Assistants, at the special request of this Bearer *Capt.ᵗ John Wodden of Lambert*, Mariner, one of the Brethren of our said Corporation, do certifie to all His Majesty's Justices of the Peace, and all others to whom it shall appertain, that the aforenamed *John Wodden* was admitted, sworn and entred a *Younger Brother* of the said Corporation the *5ᵗʰ* day of *June 1699* and is thereby exempted from any such Service or Imposition. In Testimony whereof, We the Master, Wardens, and Assistants of the *Trinity House* aforesaid, have hereunto set our Hands, and have caused the Common-Seal of our Corporation (in these and such like cases accustomed) to be hereunto affixed. Given *at Trinity-house London ye day aforesaid in ye Eleventh* year of the Reign of our Sovereign King *William III.* of *England*, &c. 1699

to the approval of Trinity House – to display their own lights and raise their finance. After the end of the Napoleonic War in 1815, the increase in trade and development of steamships exposed significant weaknesses in this system, and by an Act of Parliament of 1836 Trinity House was empowered to buy out the remaining private lighthouses. With the introduction of their own steamers a few years later, the Elder Brethren established a tradition of embracing the most modern technology to provide aids to navigation around the coasts.

The first lighthouse built by Trinity House was at Lowestoft in 1609, followed by another at St Agnes in the Isles of Scilly in 1680. Thereafter, construction by the Corporation was sporadic, though it took an interest and approved patents for the first three lighthouses on the Eddystone rock off Plymouth. Passing shipping paid a levy that laid the foundations for the present system, based on the principle that the user pays, known as Light Dues. These are levied on shipping calling at British ports and paid into the General Lighthouse Fund from which the lighthouse service is funded.

Following the Act of 1836, the number of powerful lighthouses, lightvessels and lighted buoys – many fitted with fog signals – increased dramatically to provide for the immense number of vessels navigating offshore. To support these, a number of coastal depots were established, each supported by a steam tender.

Since the 1970s, when certain operations were carried out by helicopter, the number of shore depots and lighthouse tenders has declined. Some lighthouses and lightvessels have been rendered obsolete by changing trade patterns, and the Corporation has always sought to reflect such changes. Modern technology, including long-distance remote control, the adoption of low-powered light-emitting diodes combined

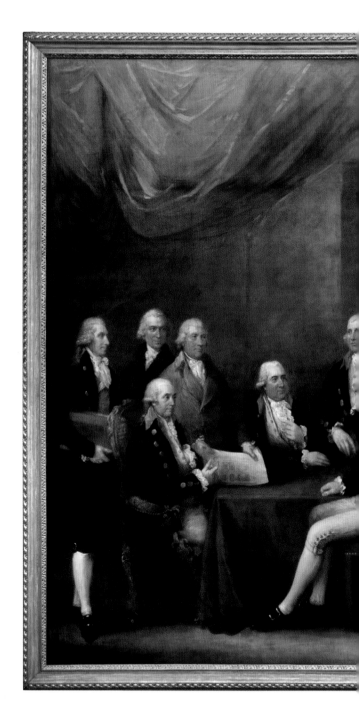

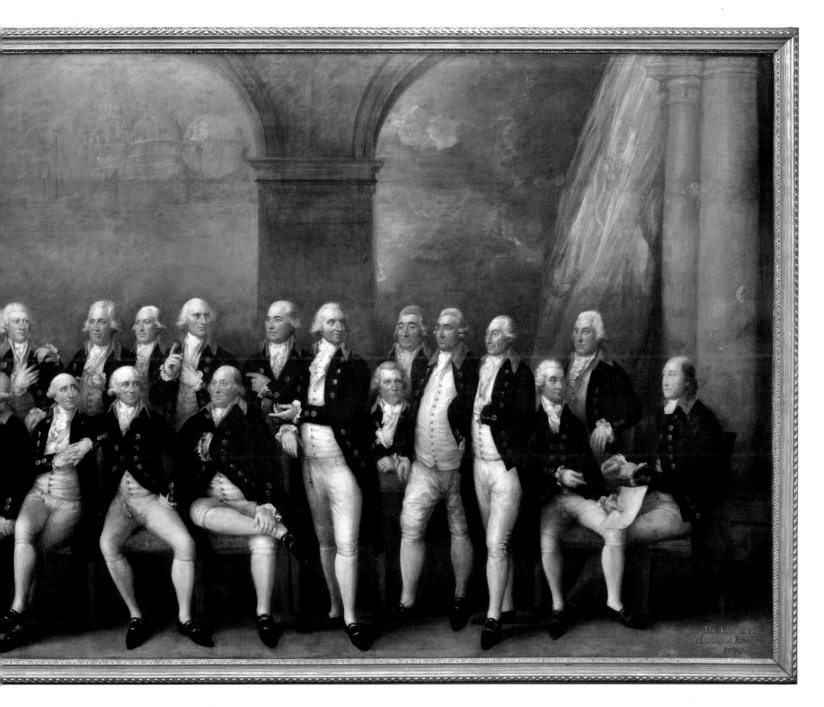

Gainsborough Dupont's group portrait of the Elder Brethren with Trinity House surveyor Samuel Wyatt, standing third left, presenting his plans for the new house in 1794. The Brethren are wearing full dress uniform of the period. Seated, far left, is Captain Sir Hector Rose, Deputy Master 1786–1795. Seated second from the right is Captain Joseph Cotton, Deputy Master from 1803 to 1825. Joseph Huddart, far right, is missing his wig as he was added to the scene much later, being overseas at the time of the sitting.

with advanced battery systems, and the introduction of solar power, has transformed the entire service, radically reducing manpower and reducing costs. From six depots and nine vessels in 1970, the present Trinity House service operates from two buoy depots, one at Harwich, the other at Swansea, and a small forward operating helicopter base at St Just, near Land's End, Cornwall. Today there are two large multifunctional tenders, THVs *Patricia* and *Galatea*, with a Rapid Response Vessel, THV *Alert*, based at Harwich and within easy reach of the Strait of Dover and southern North Sea – an area notorious for wrecks and difficult navigation. A workforce of some 2000 has been reduced to under 350 today.

These vessels, assisted by a service helicopter, tend over 60 offshore lighthouses, nine automatic lightvessels and just under 500 buoys, most of which are solar powered and many of which are fitted with sophisticated instrumentation.

A wide range of supplementary duties is undertaken by the Brethren or their staff, duties laid upon them by ancient rights or Acts of Parliament. Among these is the statutory inspection of local aids to navigation each year. These are provided by 'Competent Harbour Authorities,' of which

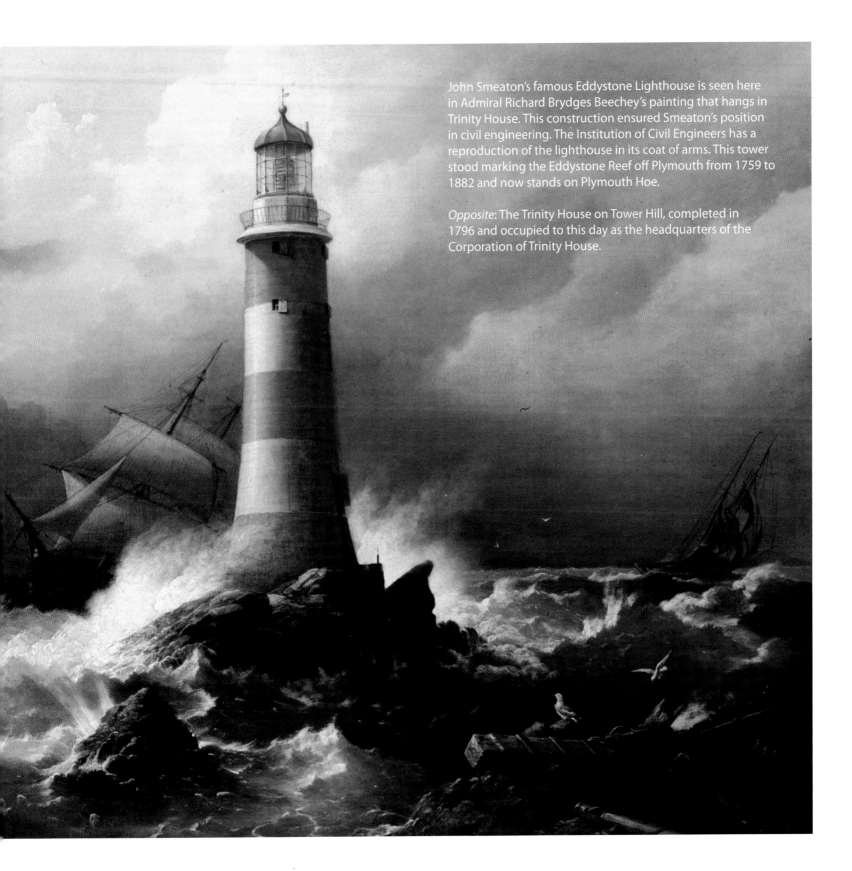

John Smeaton's famous Eddystone Lighthouse is seen here in Admiral Richard Brydges Beechey's painting that hangs in Trinity House. This construction ensured Smeaton's position in civil engineering. The Institution of Civil Engineers has a reproduction of the lighthouse in its coat of arms. This tower stood marking the Eddystone Reef off Plymouth from 1759 to 1882 and now stands on Plymouth Hoe.

Opposite: The Trinity House on Tower Hill, completed in 1796 and occupied to this day as the headquarters of the Corporation of Trinity House.

there are some 60, or are those lights and fog signals positioned on offshore structures, such as gas-production platforms. In 2011, these amounted to no fewer than 9799 aids to navigation.

Parallel with this duty is that of being the consenting authority for the provision of all aids to navigation in the coastal waters of England, Wales and the Channel Islands, and in 2011/2012 over 600 applications for sanction to add, change or remove seamarks were considered. These works included diverse applications such as dredging and marine extraction; well heads; drilling rigs; production platforms; pipelines; cable crossings; oceanographic buoys; wind farms; surveys; harbour redevelopment; boreholes and yacht racing marks. In addition, much valuable advice on

marine marking is given to harbour authorities, government agencies and maritime consultants, as well as the public. An exclusive duty of the Elder Brethren is to serve as Nautical Assessors in the High Court of Admiralty. Part of the Queen's Bench Division, this civil court hears and settles cases involving collisions and damage to ships from around the world, the litigants from which decide to submit their claims to English jurisdiction. In these cases, one or more Elder Brethren may sit alongside the judge to provide technical advice and analysis.

Besides all this, Trinity House has a statutory duty under the Merchant Shipping Act 1995 to locate, mark and, if appropriate, remove wrecks that are a danger to navigation. Besides minor incidents that pass unnoticed by the general public, major

In the 15th century, Trinity House owned 21 almshouses and an adjoining hall at Deptford occupied by former Masters of ships and pilots. These were the original almshouses that belonged to the Guild prior to its incorporation in 1514. Additional almshouses were required, and in 1696 further property was constructed at Mile End, to the east of the City of London (*right*).

The act of charity continues today with Trinity House as the largest endowed maritime charity in the land making grants to other maritime charities enabling them to achieve their aims with regard to welfare and education of seafarers.

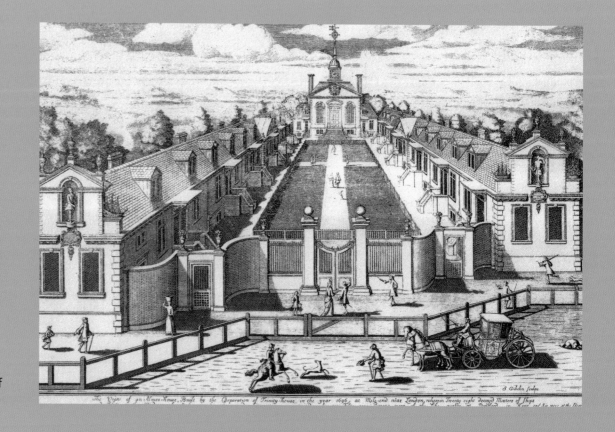

catastrophes in 1971 (see page 95) and 2002 brought this duty, with its heavy responsibilities, into sharp focus. In addition to its remote control of all lighthouses and lightvessels offshore from a central control facility at Harwich in Essex, Trinity House also broadcasts the transmissions that comprise the Differential Global Positioning System, or DGPS, which improves the accuracy of raw GPS data to a phenomenal degree, with coverage around the coasts of the United Kingdom and the Republic of Ireland.

Although it can trace its incorporation back five centuries, Trinity House is today among the world's most advanced, respected and efficient providers of aids to navigation, playing a significant role in consultation with sister services around the world who have similar responsibilities for the safety of the mariner and of the marine environment.

But it is more than a simple public service, for its wider commitments incorporate a number of well-intended activities that make it – as a private corporation ruled by a governing Court who give their services free – a quite unique and surprising institution.

Something of this unusual diversity is, we hope, evident from the following pages.

Neil Jones &
Paul Ridgway

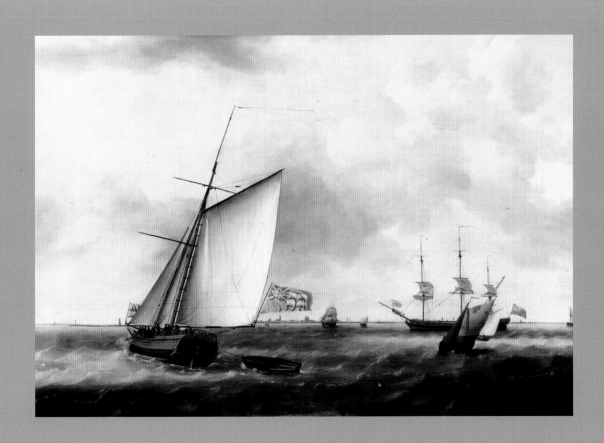

With its responsibilities for marking shoals, rocks and other hazards in the coastal waters of England and Wales, the Corporation required support vessels or 'tenders' to supply and maintain offshore aids to navigation. These were first formally established in the 18th century.

Over the centuries the work of the tenders has continued, in peace and in war, keeping up with new technology.

Left: The Trinity House yacht conveying the Elder Brethren towards Spurn Point, painted by Francis Holman in 1778.

Through the 16th and 17th centuries, the Elder Brethren of Trinity House worked hard to protect the nation's maritime interests and raise standards across the fields of navigation, aids to navigation, ship construction and naval administration, as well as providing welfare for sailors and London's poor. Trinity House earned itself no small reputation for expertise in these and other matters, and was widely consulted; by the start of the 18th century there were not many maritime issues that had not had the involvement of an Elder Brother of Trinity House.

Deemed *'a company of the chiefest and most expert masters and governors of ships'* by Queen Elizabeth I, the Corporation's responsibilities and sphere of influence were considerable, and it could name many great men among its number – Samuel Pepys, William Pitt the Younger and the Duke of Wellington included.

Entrusted with the lives and cargo of the vessels coming in and out of the nation's ports, Trinity House undertook some of the most breathtaking feats of construction carried out by man.

The steady accumulation over many centuries of credibility, responsibility, experience and knowledge has linked Trinity House inextricably to Britain's maritime tradition of excellence and its reputation as a global maritime leader; yet it has always moved quietly through such circles, safe in the knowledge that any organisation that could build 150-foot-tall granite towers on wave-lashed shards of rock could be confident of its legacy without the need for self-aggrandisement.

The Corporation's 500th year would appear to be a good time to take stock of these achievements and enjoy the rich visuals of a fine heritage.

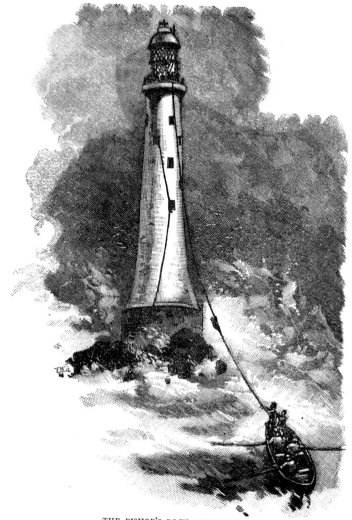

THE BISHOP'S ROCK LIGHTHOUSE.

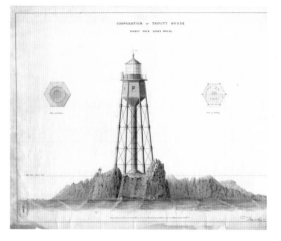

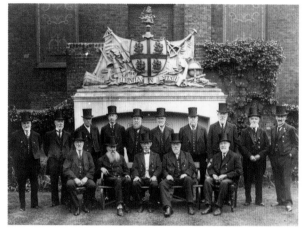

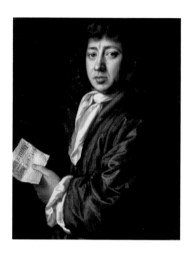

'Are we not Seamen, bred even from our childhood?
In the knowledge of marine affairs, of Navigable
Channels, Sands, ebbing, flowing and setting of Tides,
in the knowledge of setting out seamarks is not this
knowledge within the compass of our element?'

The Elder Brethren address the Privy Council, circa 1617

Opposite top: A dramatic depiction of the hazards of placing a keeper on board the Bishop Rock Lighthouse before the age of the helicopter is clearly seen here in this 19th century print. *Far left*: The first structure erected at the Bishop Rock was destroyed by the sea before completion. *Centre*: A handsome group portrait of the Corporation's beneficiaries at the Deptford almshouses. *Right*: One of the Corporation's most noteworthy Masters, Samuel Pepys.

Above: The Trinity House Yacht off the Casquets, painted by Thomas Whitcombe in 1795.

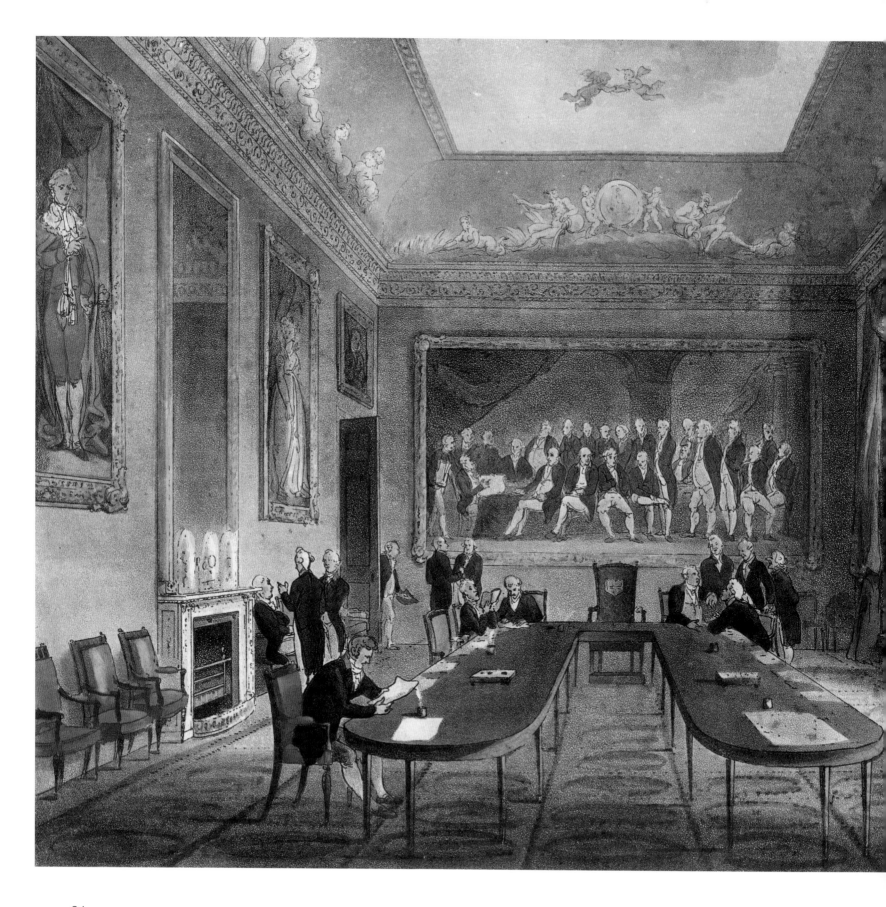

'Lighthouses are marks and signs within the meaning of the charter. That there is an authority mixed with trust, settled in that corporation, for the erecting of such lighthouses, and other marks and signs, from time to time, as the accidents and moveable nature of the sands and channels doth require, grounded upon the skill and experience which they have in marine service: And this authority and trust cannot be transferred from them by law; but as they are only answerable for the defaults, so they are only trusted with the performance; it being a matter of an high and precious nature, in respect of salvation of ships and lives, and a kind of starlight in that element.'

Sir Francis Bacon on Trinity House in 1617.

The Court Room at Trinity House at the start of the 19th century in T. Rowlandson and A. Pugin's *Microcosm of London*.

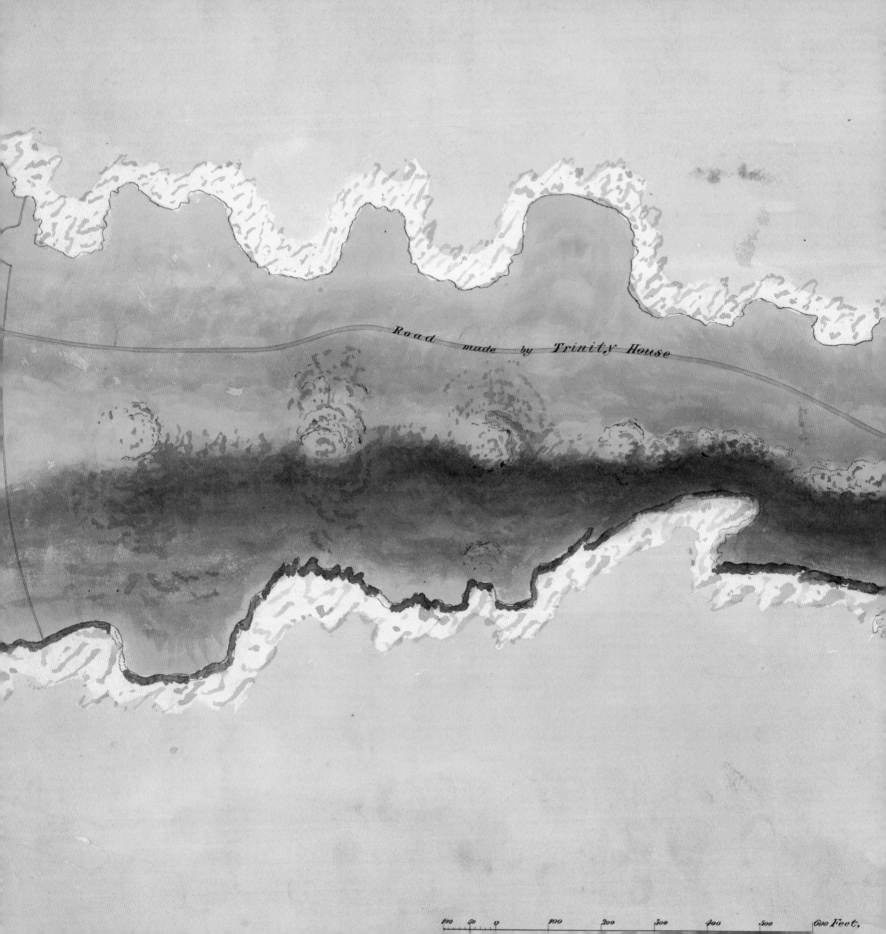

Road made by Trinity House

100 50 0 100 200 300 400 500 600 Feet.

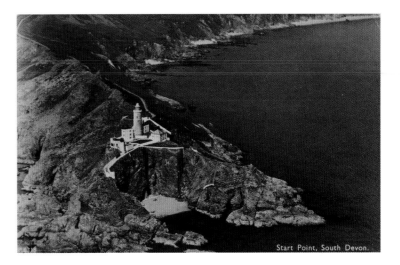

Start Point, South Devon.

Many Trinity House lighthouses are located in naturally spectacular and environmentally sensitive areas and so it works in collaboration with various national and local agencies to maintain the objectives of English Heritage, Natural England, the National Trust, Natural Resources Wales and the Landmark Trust. Many lighthouses are Grade II Listed, in Areas of Outstanding Natural Beauty or Sites of Special Scientific Interest, in Conservation Areas or along the Heritage Coast.

Over four centuries, Trinity House lighthouses have become an integral part of our nation's picture postcard coastline; piercing white towers against slate-grey seas and green countryside, red stripes against white chalk cliffs or shingle beaches, and black fog signal trumpets against blue skies are all iconic aspects of our nation's maritime heritage.

Although these stations used to house roaring oil combustion engines and diesel generator sets, almost all now rely instead on solar energy.

Opposite: A drawing from the Trinity House archive showing the placement of Start Point Lighthouse in South Devon made in the 19th century.

Above: A postcard showing the lighthouse in the early 20th century.

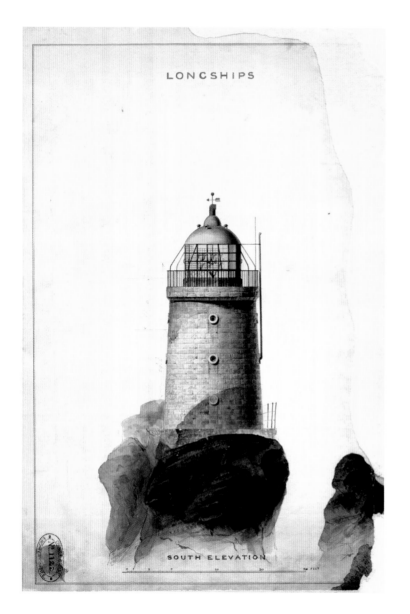

SOUTH ELEVATION

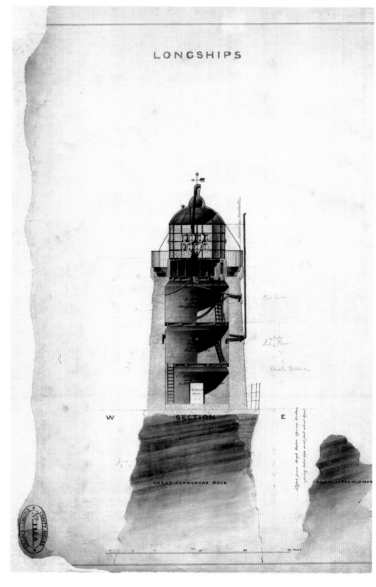

W SECTION E

GREAT CARNVROAZ ROCK

By the end of the 18th century, the open profiteering and shabby management of privately owned lighthouses invited the ire of the public and the government, as Britain's seamen, trade and global standing were at risk. Coincident with this shift in public feeling towards bringing lighthouses under a single public authority, the sharp rise in the country's fortunes – driven by seagoing trade, mass manufacturing and an expanding merchant fleet – brought Trinity House's lighthouse administration to greater prominence. The rise in shipping demanded a system of navigational aids equal to the task, and the Corporation rose to meet its part ensuring the security and prosperity of Britain's trade, the welfare of its mariners and the development of engineering, science and safety at sea.

In 1836, Trinity House took on the responsibility of the last privately owned lighthouses, becoming the authority for all major aids to navigation in England, Wales and the Channel Isles. Before long, depots were established around England and Wales and a great phase of lighthouse improvements was undertaken, as the massive forward strides made in civil engineering, lighting technology and fuel sources were incorporated into the lighthouse service's practices.

Lighthouses quickly came to stand in the public imagination as symbols of

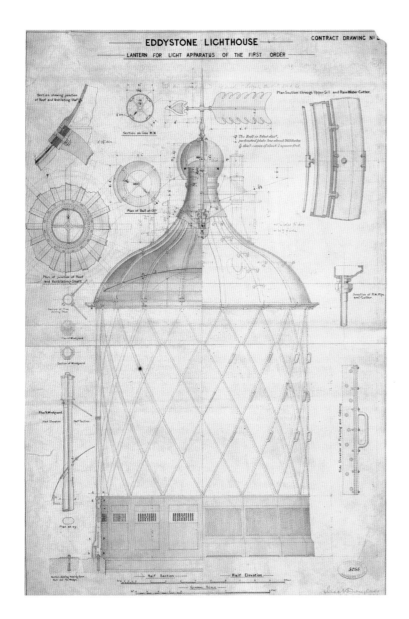

EDDYSTONE LIGHTHOUSE

CONTRACT DRAWING Nº

LANTERN FOR LIGHT APPARATUS OF THE FIRST ORDER

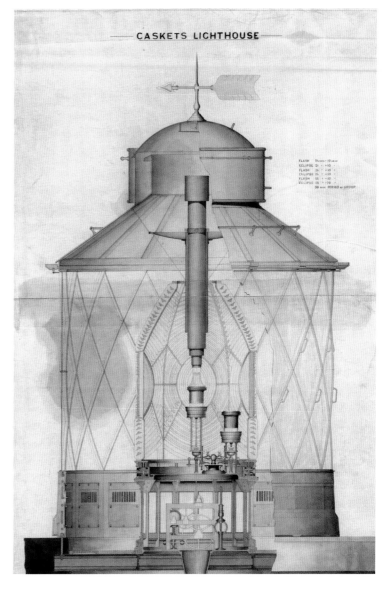

CASKETS LIGHTHOUSE

humanitarian intent and near-superhuman feats of construction and watchkeeping. The same towers built in the middle of the 19th century remain today as stalwart as ever, and each has assimilated over decades the new technologies of each generation. Each station now carries layers of rich archaeological history and a wealth of stories, and still adapts to meet modern needs. Towers built to hold a candelabra and a few brave men – as per Dr Johnson's definition of a lighthouse

as 'a high building at the top of which lights are hung to guide ships' – have welcomed into their fabric at various times oil burners, acetylene burners, electric filament lamps, LED lamps, engines, fog signals, solar energy panels and helicopter landing decks, as well as the occasional red stripe.

Opposite and above: Archive drawings show examples from 18th and 19th century lighthouse buildings: the elevation and section of the first Longships Lighthouse in 1795, and the lanterns of the Eddystone and Casquets lighthouses.

'Be it enacted, established, and ordained by the Queen's most excellent Majesty, by the consents of the Lords spiritual and temporal, and the Commons in this present Parliament assembled, and by the authority of the same, that the foresaid Master, Wardens, and Assistants of the Trinity-House at Deptford-Strond aforesaid, being a company incorporated as before, shall and may lawfully, by virtue of this act, from time to time hereafter, at their wills and pleasures, and at their costs, make, erect, and set up such, and so many beacons, marks, and signs for the sea, in such place or places of the sea-shores, and uplands near the sea-coasts, or forelands of the sea, only for sea-marks, as to them shall seem most meet, needful, and requisite, whereby the dangers may be avoided and escaped, and ships the better come into their ports without peril.'

Seamarks Act of Elizabeth, 1566.

Longships Lighthouse.
Painted by William Melby, 1795.

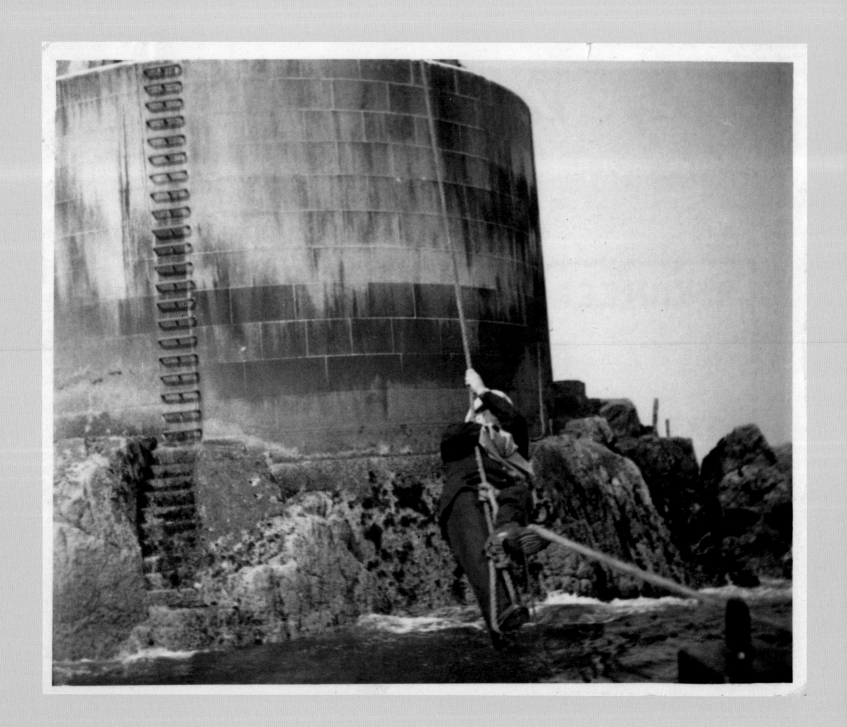

Typically, a lighthouse keeper displayed resource, stoicism, sense of duty, self-discipline, regard for his fellow keepers, economy and due diligence.

Keepers were well trained in maintaining the lighthouse and had a basic knowledge of the engineering skills needed to ensure smooth and reliable operation of machinery in their charge.

The Principal Keeper in charge of each lighthouse establishment was responsible for the cleanliness and efficiency generally. He was thoroughly acquainted with the character and period of the light and of the fog signal and had to satisfy himself that the two Assistant Keepers were equally well acquainted.

Furthermore, the Principal Keeper (generally known as the PK) was responsible for the care and safety of all stores and equipment and that everything was in its place and put to proper use.

Of particular importance was the training process at a lighthouse. Once out of the Training School as a Supernumerary Assistant Keeper (SAK), a new entrant was sent to a lighthouse where, under the watchful eye of a senior Assistant Keeper, he was instructed in the use of the station's machinery and apparatus and, in particular, made conversant with the light and the fog signal.

At rock lighthouses the normal spell of duty was eight weeks followed by four weeks on shore, later amended with the advent of the helicopter to one month on and one month off.

On shore stations a normal leave year of 28 days was adopted.

At a rock lighthouse the relief was achieved by using the gear secured between the lighthouse and the district tender's motor boat. Generally, with the skill of the boat's crew, a dry landing was achieved although there were exceptions.

At the same time as keepers were relieved, stores were placed on the station: oil for the lamps, water for the keepers and for cleaning, light mantles – and later electric lamps – and other stores needed for the efficient running of the lighthouse. Keepers were responsible for providing their own food while they were at the lighthouse.

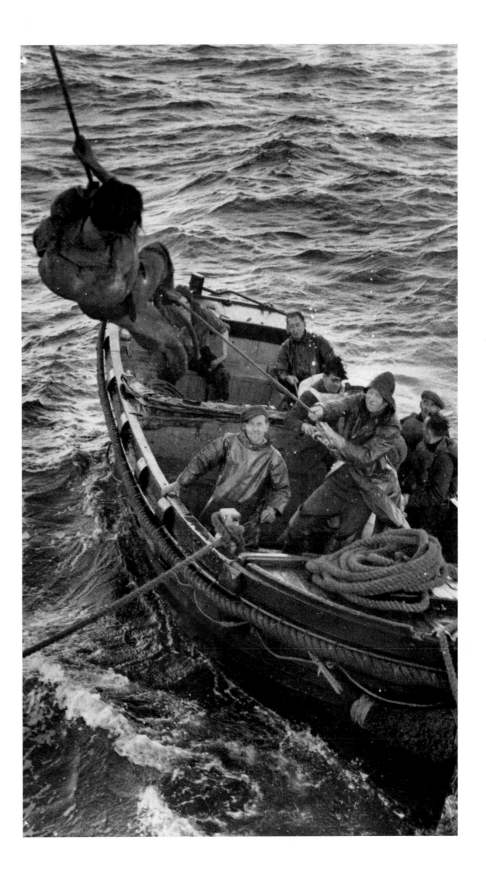

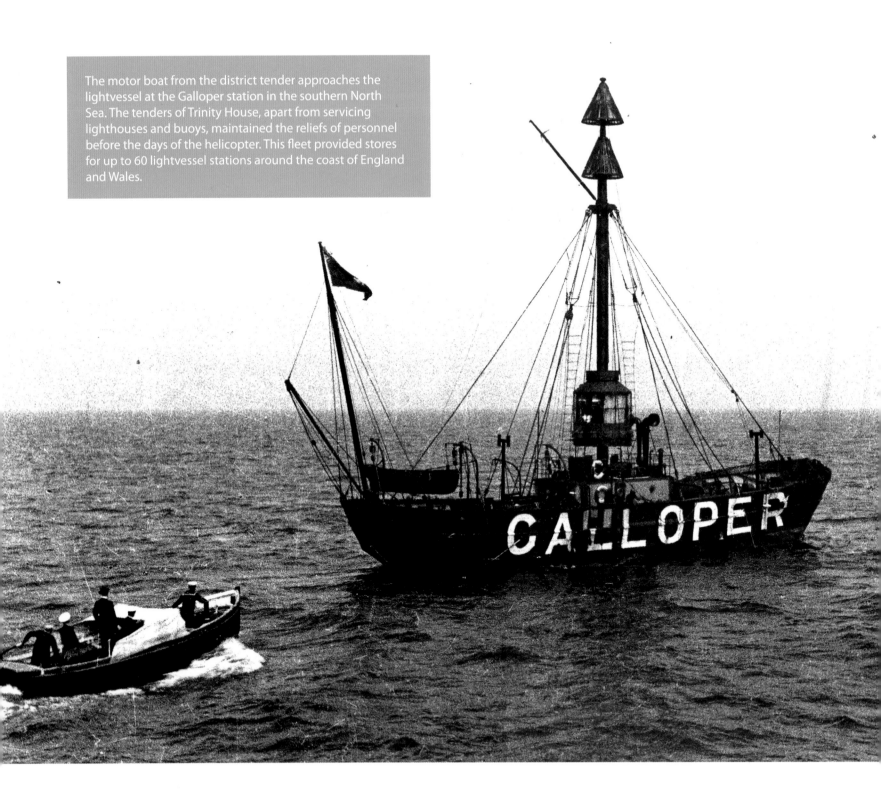

The motor boat from the district tender approaches the lightvessel at the Galloper station in the southern North Sea. The tenders of Trinity House, apart from servicing lighthouses and buoys, maintained the reliefs of personnel before the days of the helicopter. This fleet provided stores for up to 60 lightvessel stations around the coast of England and Wales.

Trinity House has been a maritime organisation since its inception, but it was not until 1741 that it owned its own dedicated vessel. The *Trinity Sloop* was commissioned for surveying and for the care and placing of buoys, as well as for pilot training. Her first assignment, in June 1741, was an inspection of the buoys and beacons in the North and South Channels of the River Thames.

As the number of lighthouses, lightvessels, buoys and depots increased over the centuries, the Trinity House vessel fleet grew in kind, to support lighthouse building, buoy and lightvessel movement and maintenance, channel surveying and the transfer of lighthouse keepers and sometimes their families too.

The way of working with a district tender and motor boat remains today. The photographs here show a district tender of the Trinity House Steam Vessel Service performing with its boat much the same evolution as it would have completed in the 18th century, providing supplies to a lightvessel. The upper photograph shows a television set and radio aerial being delivered to a lightvessel in the Great Yarmouth District. Entertainment of this type was frequently provided by the local townsfolk, especially at Christmas when Santa arrived with gifts for the lightvessel's crew. The bottom photograph shows ship's staff circa 1910 on the bridge of the Trinity House Vessel *Siren* preparing for a relief, a task performed every 28 days.

Although today the Trinity House vessels still visit lighthouses to deliver stores and equipment, with frequent use of the Trinity House helicopter, in past years, when the stations were manned, everything was transferred from the tender by motor boat to the lighthouse or lightvessel.

Below left: THV *Satellite* approaching Wolf Rock Lighthouse. *Below right*: Stores, probably coal, are delivered to a lightvessel.

Opposite: Trinity House apprentices operate the Siebe Gorman diving apparatus circa 1896. At the time, divers were carried to apply explosives in the cutting down of wrecks considered a danger to navigation.

Under the Uniform System of Buoyage in use in our waters until the adoption of the IALA System from1977, the colour green was reserved for all lights marking wrecks. Lightvessels and buoys so used had the word WRECK painted in white letters on their sides.

Trinity House had (and still has) a duty imposed upon it by statute to deal with wrecks considered obstructions or a danger to navigation in its waters, except those that are the responsibility of a harbour or conservancy authority or those of HM ships. Under the Merchant Shipping Act of 1894, Trinity House was charged to take possession of a wreck if its owners were not going to salvage it or its cargo. This often led to a wreck's removal, dispersal or cutting down to a safe height by contractors. In an earlier era, as shown in the photograph, ship's staff in the Trinity House tender took on this task.

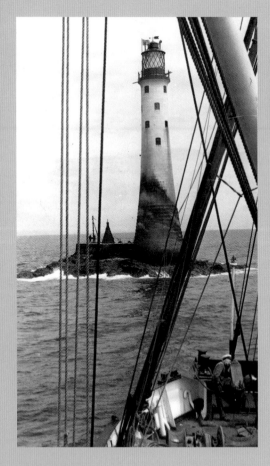

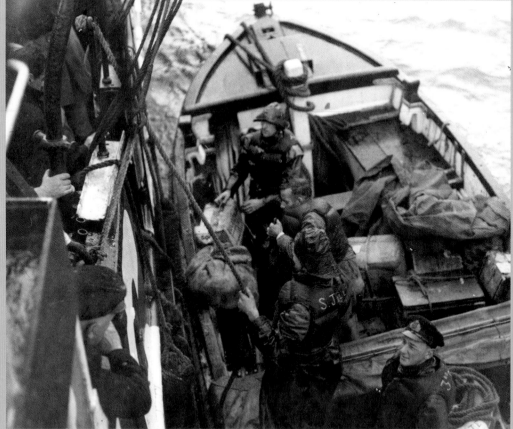

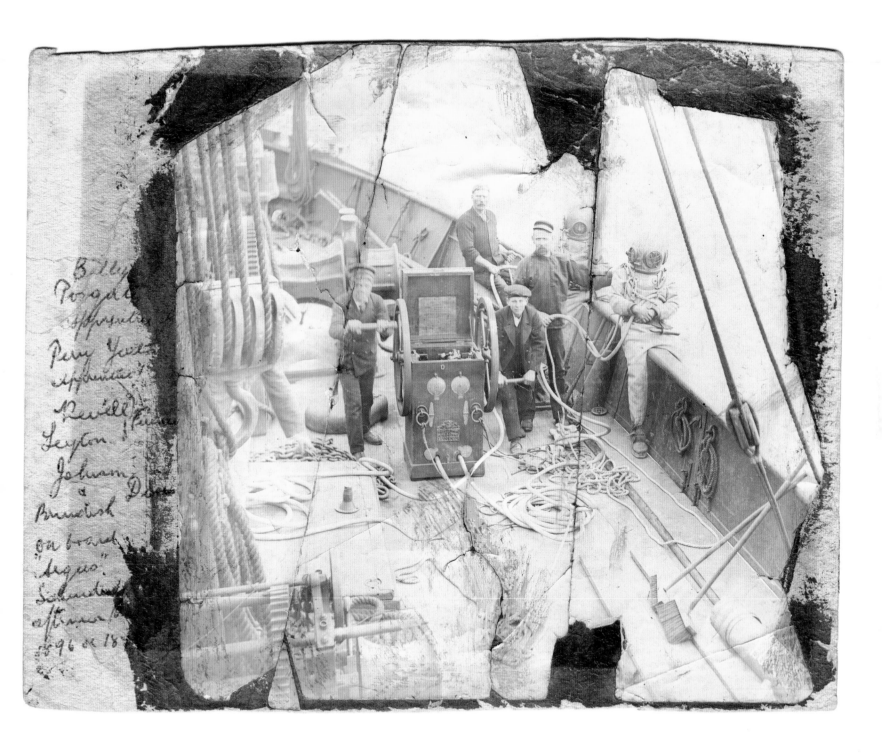

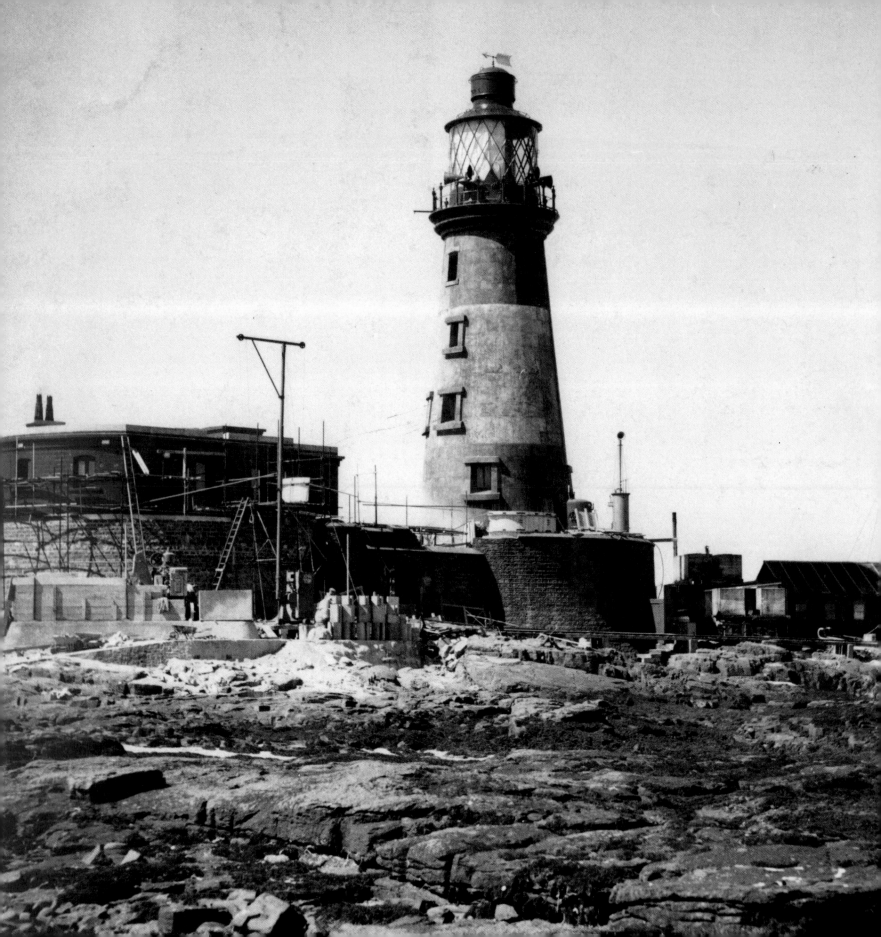

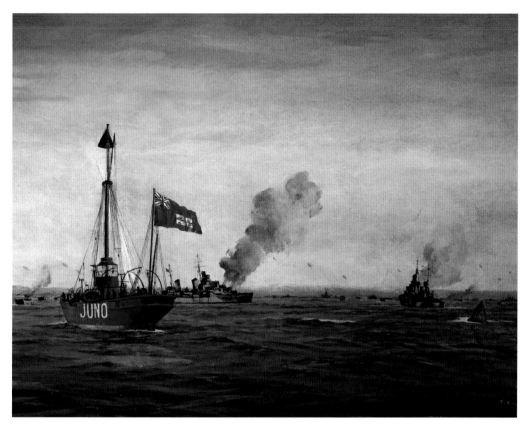

In both World Wars, lighthouses were lit and extinguished at the request of the Admiralty in order to comply with convoy operations. The district tenders carried out their work as near normally as possible and there were, sadly, losses.

Most lightvessels were withdrawn and some remained on station with their lights extinguished. Others were moved at various times to suit naval operations.

In preparation for the Normandy landings of 6 June, 1944, a huge quantity of buoys was established to mark the swept channels toward the beaches, and two lightvessels were placed on station to mark the landings.

As will be seen from the photograph here, there was war damage to Trinity House stations, and the house on Tower Hill was hit on more than one occasion. St Catherine's Lighthouse on the Isle of Wight received a direct hit and its three keepers died in June 1943.

After both conflicts there was considerable restoration needed in all aspects of the service.

Opposite: Longstone Lighthouse under reconstruction in 1951 after damage in 1941.

Above left: Rowland Langmaid's painting depicts Juno Lightvessel marking Kansas Beach following the Normandy Landings of 6 June, 1944.

Above right: Orfordness Lighthouse in camouflage paint, October 1942.

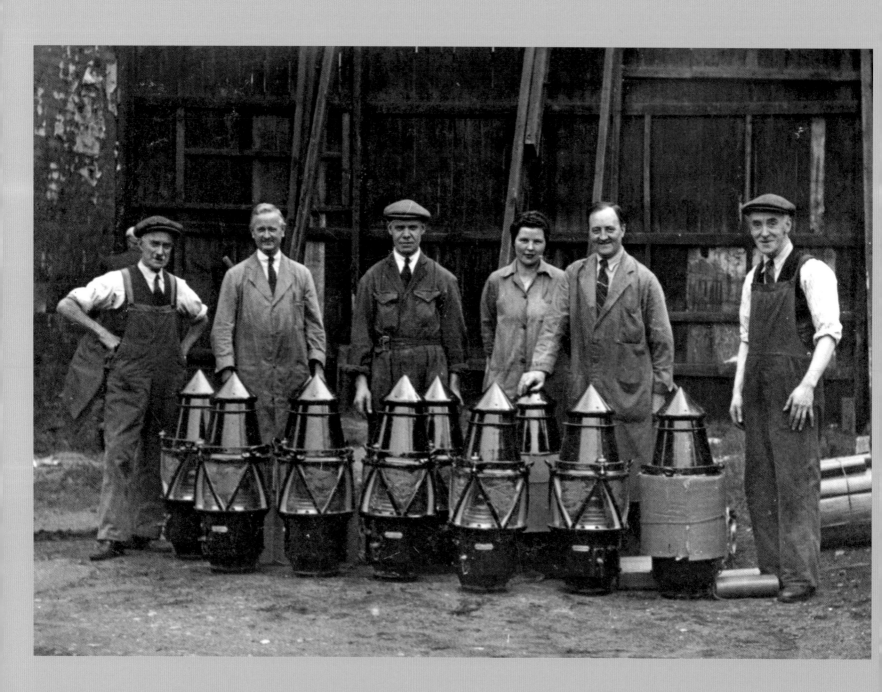

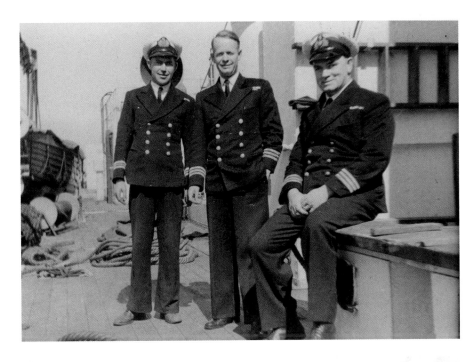

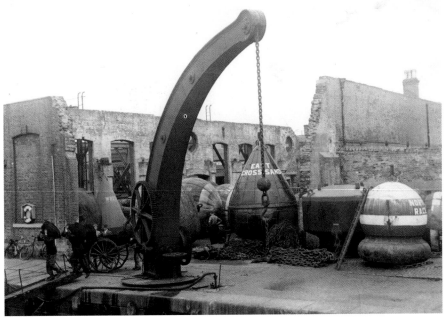

Opposite: Blackwall lantern testers smile for the camera, circa 1940. Here a variety of craftsmen created many of the devices needed in the lighthouses and lightvessels of Trinity House. These included boiler makers, coppersmiths, pattern makers, radio engineers, storemen, carpenters and others as well as the tutors at the training school.

The workforce of Trinity House has always been made up of professional, hard-working and competent men and women.

Top: Captain Alec Batte stands, centre, with fellow officers aboard a Trinity House vessel.

Left: Bomb damage during the Second World War at Great Yarmouth Depot.

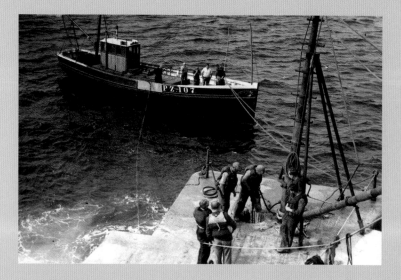

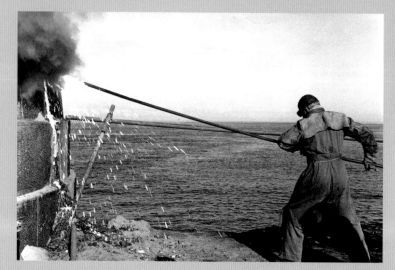

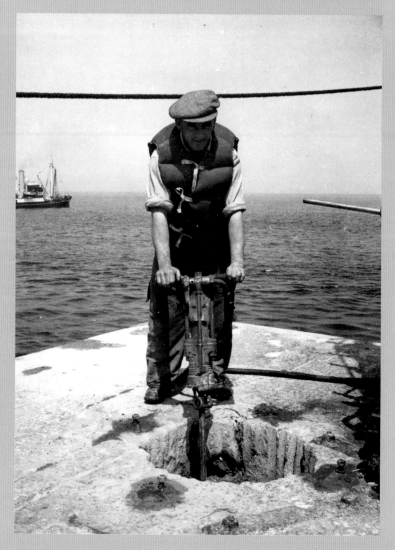

Top left: A local fishing boat, hired to deliver building materials at the Wolf Rock Lighthouse, assists remedial work after winter storm damage.

Top right: A thermic lance being used at the Longships Lighthouse in 1968 to facilitate the running of electric cables.

Bottom left: A Service motor boat from THV *Satellite* landing anthracite at the Wolf Rock.

Bottom right: Repair work on the landing at Wolf Rock on a fine day. THV *Satellite*, the district tender, is in the background.

Opposite page: Engineering stores, including a cement mixer and gas bottles, being landed at Longships Lighthouse in preparation for the creation of a helipad at the station in 1974.

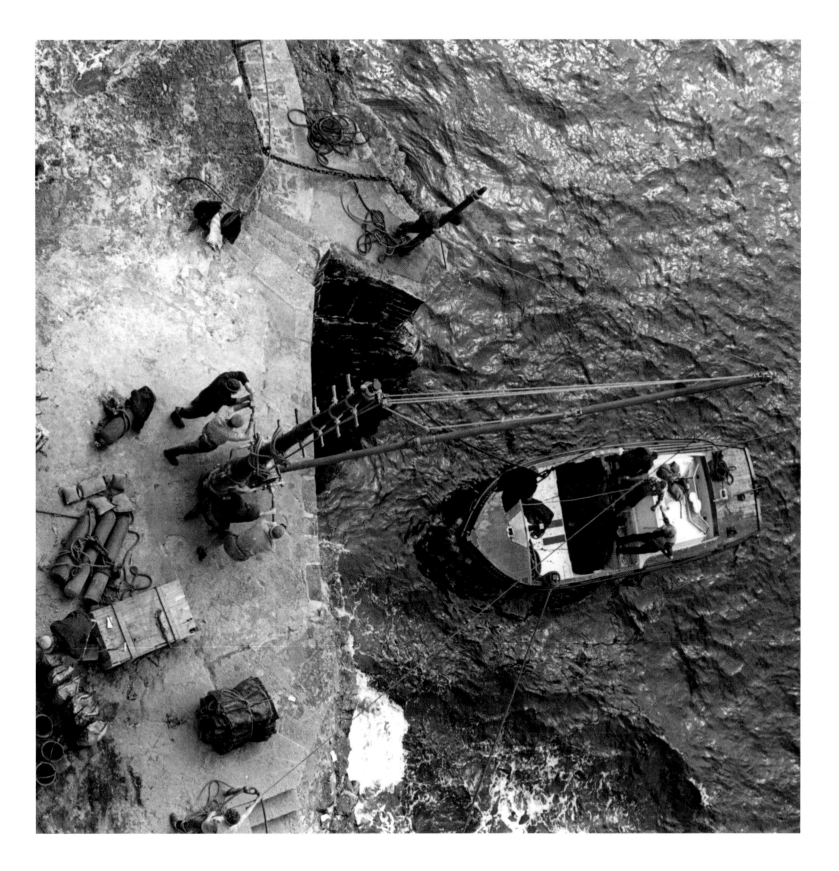

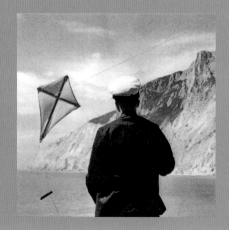
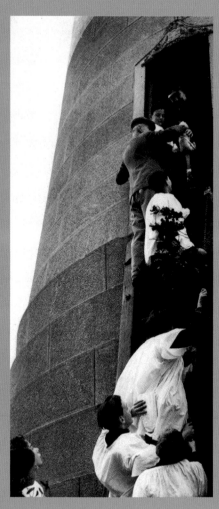
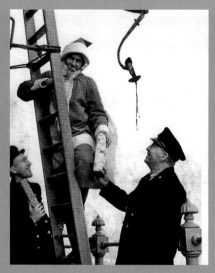
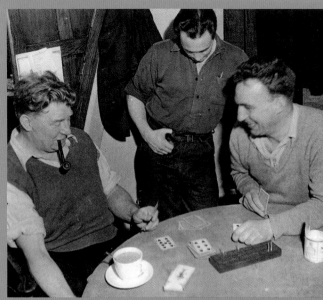
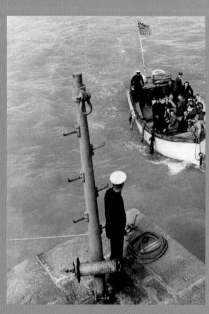
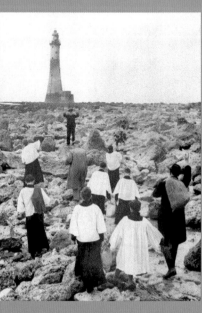

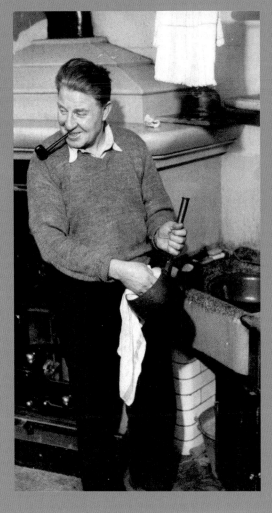

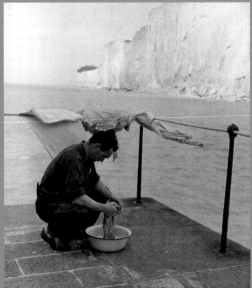

"

While Dad was at Beachy Head we went on several occasions to see him. From Eastbourne there was a path along the cliff top to an opening to the beach called Cow Gap, and from there the path was along the beach, which meant jumping over rocks and big boulders to reach the lighthouse. Halfway along there was a strange formation of rocks called the 'elephant stones', which looked like upturned elephant's feet. Before arriving at the lighthouse there was still another hazard as the tide had to be low and then one had to struggle over slippery wet rocks covered in seaweed.

First there was the 30-foot-high granite base to climb by way of exposed steps, then at the base of the tower a 10-foot iron ladder up to the front door. Inside at the bottom of the tower were housed the weights that drove the mechanism for the rotation of the massive lens at the top of the tower. The lens floated in a huge circular bath of mercury, so there was very little friction involved in moving it. When I first went there the lighthouse was not automated so the weights that drove the clockwork mechanism were still being wound up by hand by the keepers on a regular basis.

There were three men on the lighthouse on eight-hour watches. And apart from day-to-day chores they kept a high standard of cleanliness in the lantern and throughout the tower. Other duties included manning the fog signal when necessary; this meant fixing charges and detonators to a pole outside on the gallery at the top of the tower, and then firing them from inside the lantern.

One stormy night there was a spill of mercury caused by movement of the tower and the following morning the mercury had to be picked up from the lantern floor and put back into the bath.

"

Ronald James recalls his father Frederick's (*top right*) time serving on Beachy Head Lighthouse.

This page and opposite: Snapshots of life at Beachy Head.

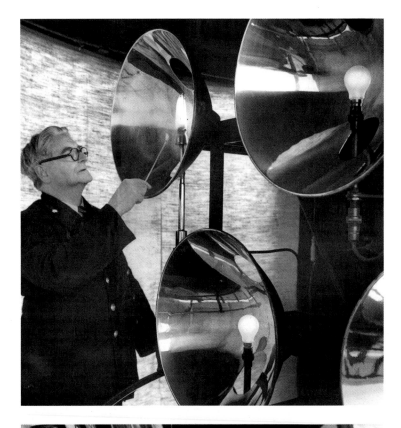

Top left: The lighthouse was both workplace and home for its keepers. The duty keeper is 'putting in the light', igniting the paraffin vapour burners, which are here set within reflectors.

Bottom left: A keeper polishing the great radial optic at Skerries Lighthouse.

Top right: A keeper preparing a kite for fishing, a pastime undertaken by staff at a lighthouse to provide relaxation and something for the table.

Bottom right: A storm cone is hoisted at Orfordness Lighthouse as part of the national gale warning system. The apex uppermost indicates a northerly gale is imminent.

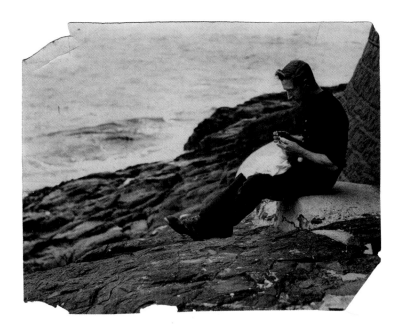

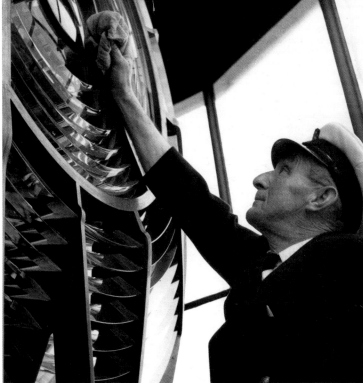

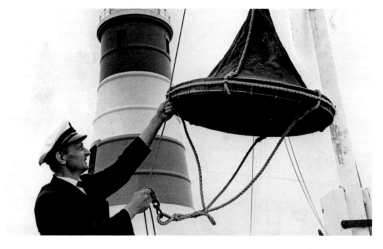

'What a storm! It turned out to be the end of Hurricane Charlie which brewed up in the Gulf of Mexico two weeks ago and already claimed a few lives. In Ireland it got five more and caused hundreds of thousands of pounds worth of damage. Woken up by a howling NW Force 9 wind, damp air in my room and boiling white seas outside. The worst of the storm had passed in the night. A local coaster was saying on the RT that he had lost eight empty containers overboard just NW of us, and with an ebbing tide and the NW wind we thought we may see them, but didn't.

My garden is ruined. The cabbages, swede and carrots flattened and destroyed by wind and sea salt, the radishes torn from the ground and those remaining survivors standing like forlorn red beacons in the brown and flattened soil.'

Diary extract dated Tuesday 26 August, 1986 from
Assistant Keeper Barry Hawkins, Skerries Lighthouse.

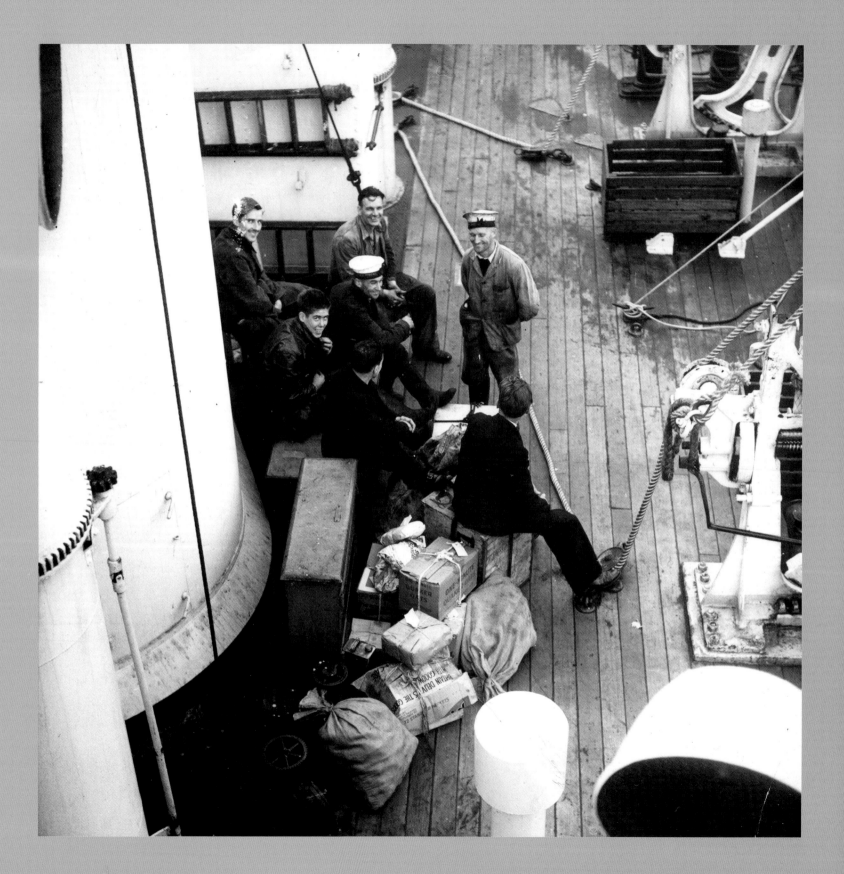

The servicing of lighthouses and lightvessels around the coast depends upon the work of a fleet of tenders, nine-strong in the late 20th century but now served by three vessels. The tenders have necessarily been highly manoeuvrable, an important quality when steaming into sea areas that all other vessels are warned to steer clear of.

Rock tower lighthouses had to be supplied with everything they needed by these ships and their men, working in small boats; this was especially the case when the stations were manned. Fresh water had to be delivered in 9-gallon casks, oil in 5-gallon drums, coal in hundredweight sacks, paints in tins, cotton waste in bales, lamps in crates and incandescent mantles in cartons. Ropes, cleaning stores, stationery, food, clothes, machinery, wireless equipment, granite stones (up to 2 tons in weight) for fabric repairs and scores of other incidentals all had to reach the lighthouses by boat and manpower. At times, weeks of waiting were necessary before the required stores, or men, could be landed safely. The landing conditions differed according to the various lighthouse situations. In some cases men and stores were hove up out of the boat by means of a rope rove through a block or tackle at the top of the lighthouse and then down to a winch on the landing or in a winch room in the tower.

Opposite: Lighthouse keepers and boat's crew aboard THV Vestal await orders to load the boat prior to the relief of Lundy Island's lighthouses.

Below: The Commander and Officers of THV Satellite in their saloon circa 1956.

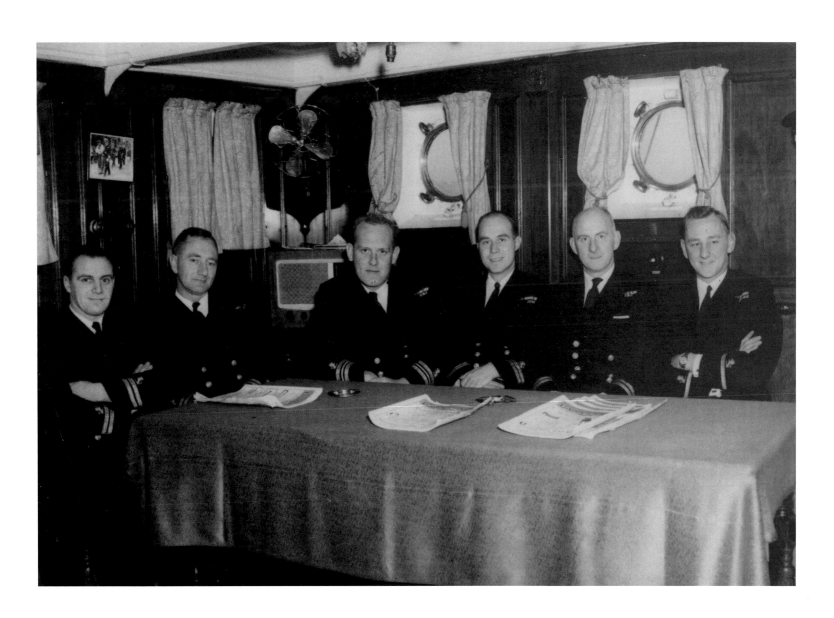

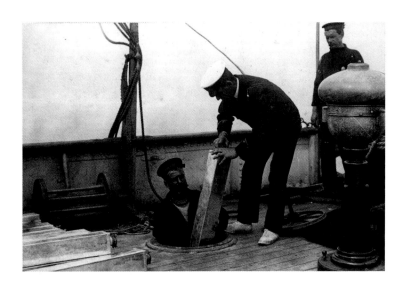

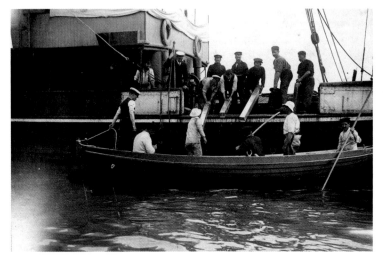

Aside from supplying and relieving stations, the tenders are also kept busy with the care and positioning of buoyage and, on rarer occasions, the survey and dispersal of a wreck that presents a hazard to shipping.

Buoyage entails keeping channels, wrecks, rocks and other dangers marked so that ships may pass in safety; as a globally understood maritime language, buoys have various shapes, sizes, lights, sounds and data-transmitting devices. Trinity House regularly examines and paints its buoys, overhauls their moorings and checks their assigned positions.

Clearing hazardous wrecks is one of Trinity House's statutory duties, and one that put great demands on its Steam Vessel Service after the world wars. Although today the task can be performed with state-of-the-art surveying and moving equipment, historically a wreck would be located by sweeping with an underwater sweep-wire, then buoyed or marked by special wreck-marking vessels. Then came the process of removing the wreck by explosives; charges of Tonite were either placed in the wreck by divers or swept in by boats. Once the charges were laid, the boats withdrew to a safe distance and fired the charges, staying out of range of pieces of wreckage being hurled into the air. Although older wooden vessels could be cleared in days, some wrecks would take several seasons to disperse.

Left top and bottom: The crew of THV *Beacon* remove explosive charges from the ship's magazine and load them into the workboat while dispersing the wreck of the SS *Oceania* off Eastbourne.

Opposite: THV *Vestal*'s crew work on the lantern of South Edinburgh Number 4 Buoy, in the Thames Estuary.

'The Master was pleased to observe that he thought it might be of service to the Corporation & for the Safety of His Majesty's Ships to have a vessel of our own, to be sent down amongst the Sands, to observe their bearings, the setting of the Tides & the Depths of Water, Especially from the Naze to the North Foreland & to have some of our Pilots go therein for their Improvement, under the Direction of some of the Brethren, as also for the better care & placing of our Buoys.'

Board Minute, 16 May, 1741.

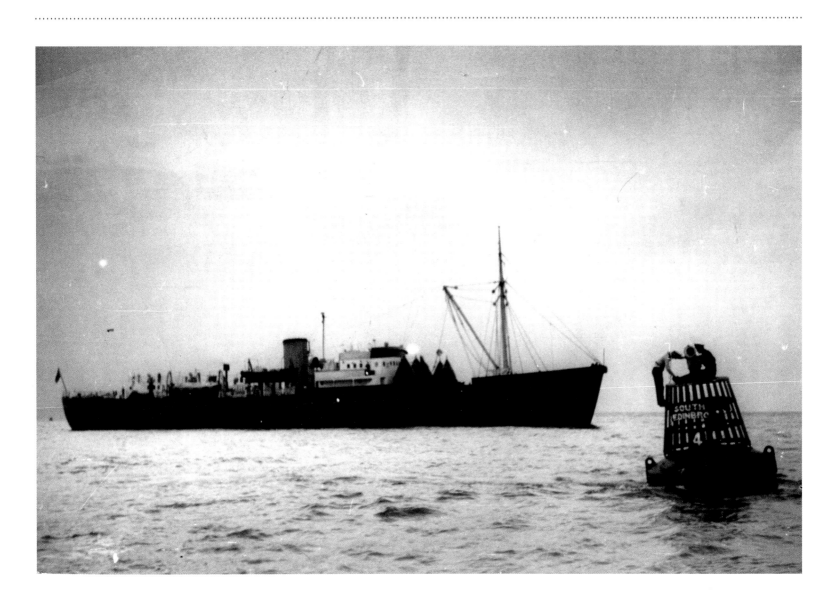

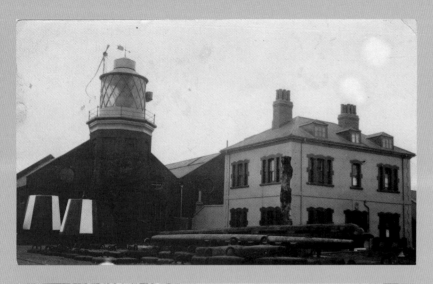

In 1803, the Corporation established the Blackwall Depot at Leamouth as a Thameside workshop. Wooden buoys were made and repaired, and moorings were provided for the Trinity House buoy yachts, which were used to lay the buoys and collect them for maintenance and repair.

To reduce long sea passages to and from Blackwall, six district depots were established around the coast at Harwich circa 1812 (replacing a buoy store that predated 1740), Great Yarmouth in 1841, East Cowes in 1842, Penzance in 1861 and Holyhead circa 1870. Each was overseen by a District Superintendent, who, in addition to his administrative duties, inspected the lighthouses and lightvessels in his district every quarter.

Top: The Marine Superintendent's house at Trinity House's Blackwall Depot, before the Second World War. The adjacent lighthouse was used for the training of lighthouse keepers, and may still be seen at what is now Trinity Buoy Wharf.

Bottom: THV *Siren* and a lightvessel lie alongside at Great Yarmouth Depot in 1972.

Opposite: The hand crane in use at Great Yarmouth, lifting a spherical buoy removed from the South Scroby buoy station for maintenance.

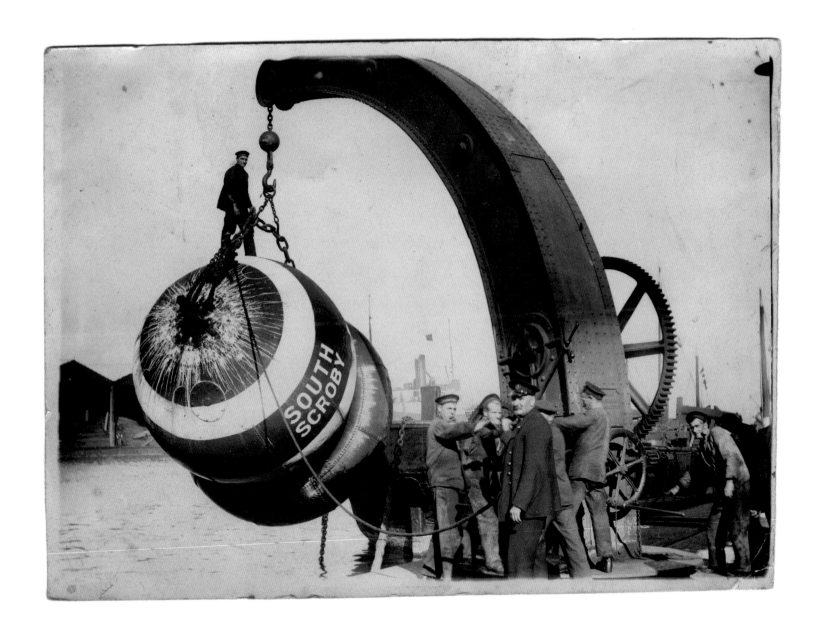

The War was still raging, and the crew of the Swansea Depot Ship (now including myself) was sent around to Plymouth to join a French Lighthouse Tender [*Georges de Joly*] that had escaped from France, and was taken over by Trinity House in 1940. The D-Day landings marked the end of the war, which were commenced by our ship, and I think it was four or five other Trinity House ships all joined each other at East Cowes, where we all loaded approximately 73 small buoys, chains, lamps etc. in preparation for the coming invasion. We were to head the invasion force across the channel, to lay these marker buoys for the American forces to follow across to Arromanches and a place called Vierville. Our other ships worked further up the coast, which was the British and Canadian Sector.

It seemed that the end of the War really had come when the French crew arrived and took the *Georges de Joly* away! And once again we were without a ship, that was until the Navy loaned us one of their ex-Boom defence ships called HMS *Barmouth*; sailing her 'round to Swansea was like a slow boat to China, and she didn't seem to like the weather in the Bristol Channel! Still, we hung on to her until another new ship called the *Vestal* came on the District, in 1949. The next few years seemed to pass very quickly, for our next new ship was the THV *Alert*, which we joined in 1954. She was a really fine ship, and one we were sorry to lose. We managed to sail her down from South Shields to Harwich on one boiler.

Ernest C. Scott, served 1939–84, remembers his time in the Support Vessel Service.

The officers and men of the Trinity House Steam Vessel Service, now known as the Support Vessel Service, are famed for their ship handling and boat work. This photograph shows the foredeck of THV *Winston Churchill,* one of a post-war class of diesel electric lighthouse tenders. She is seen here in a Channel gale.

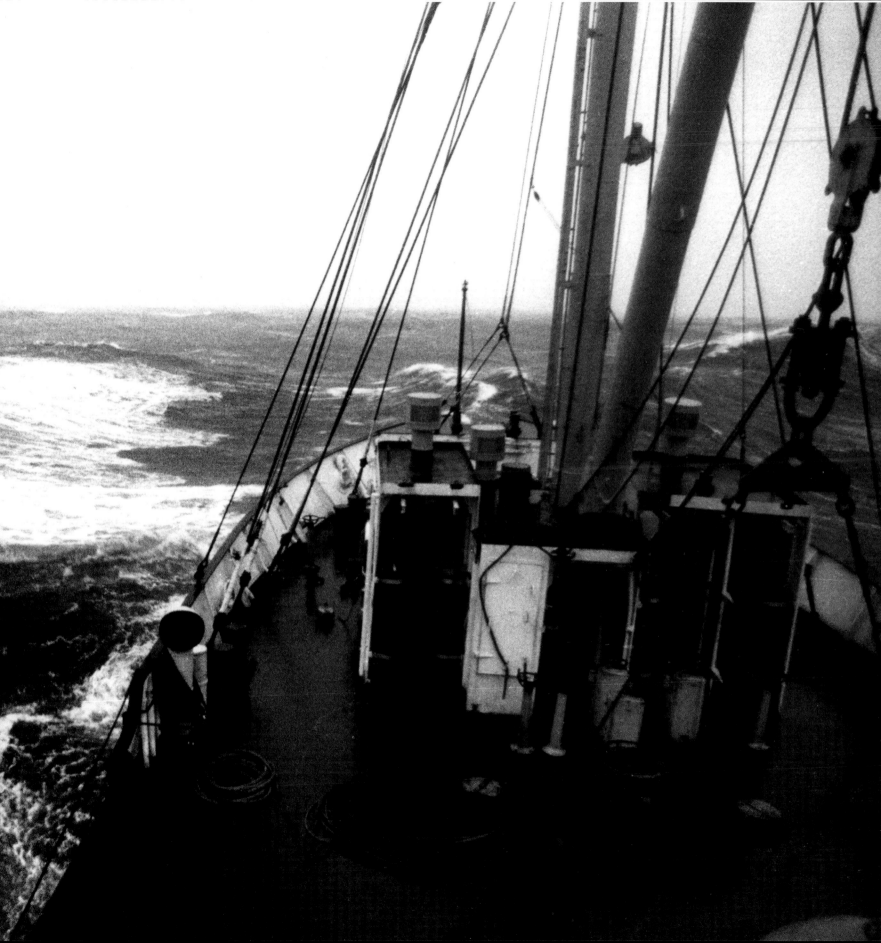

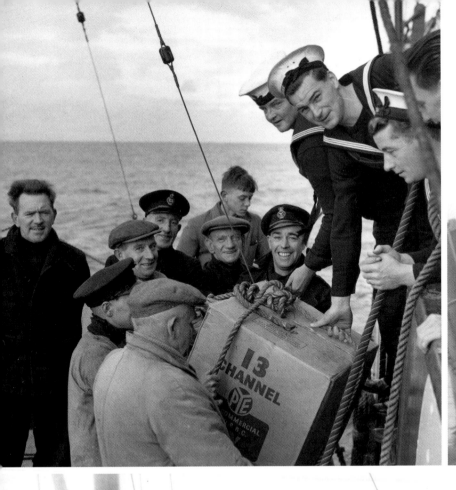

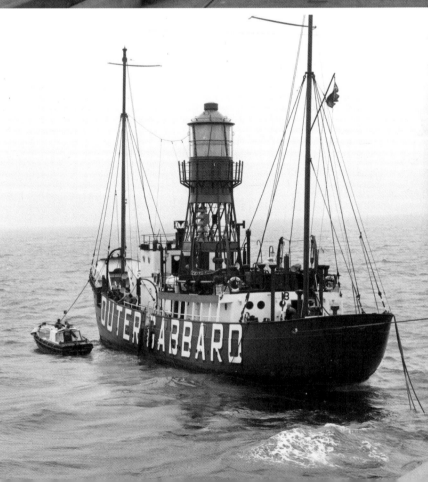

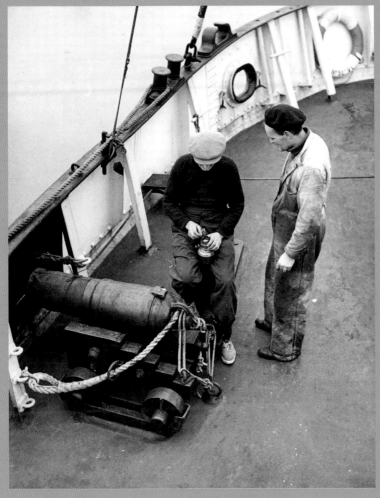

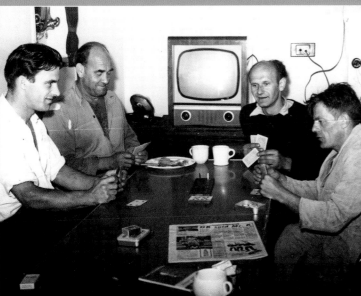

Opposite: This set of four photographs illustrates aspects of the Trinity House Light Vessel Service.

Top left: A television set being delivered to a lightvessel in the late 1960s, reducing the lightvessel crew's sense of isolation.

Bottom left: Members of the crew of No. 73 Lightvessel (built in 1903) pose for the camera at the stern. Note the tiller, and the signal gun, both later discontinued.

Top right: A lightvessel alongside Great Yarmouth Depot. A reserve lightvessel was held in readiness at each District Depot in case a lightvessel on station was damaged by collision or as a replacement when a lightvessel was withdrawn for dry docking and repair.

Bottom right: A photograph taken from the district tender while secured astern of the Outer Gabbard Lightvessel replenishing its stocks of diesel oil and water. This was generally carried out during crew relief being undertaken by the ship's workboat.

This page top: A member of a lightvessel's crew cleans an oil lamp (used in the vessel's accommodation) while seated by a carronade. Until the provision of foghorns powered by the compression of air, the warning gun was the principal means of signalling to a vessel standing into danger. Chinese gongs were also used.

Bottom: Members of the crew of a lightvessel enjoy a game of cards, a meal, tea and television during their off-duty period.

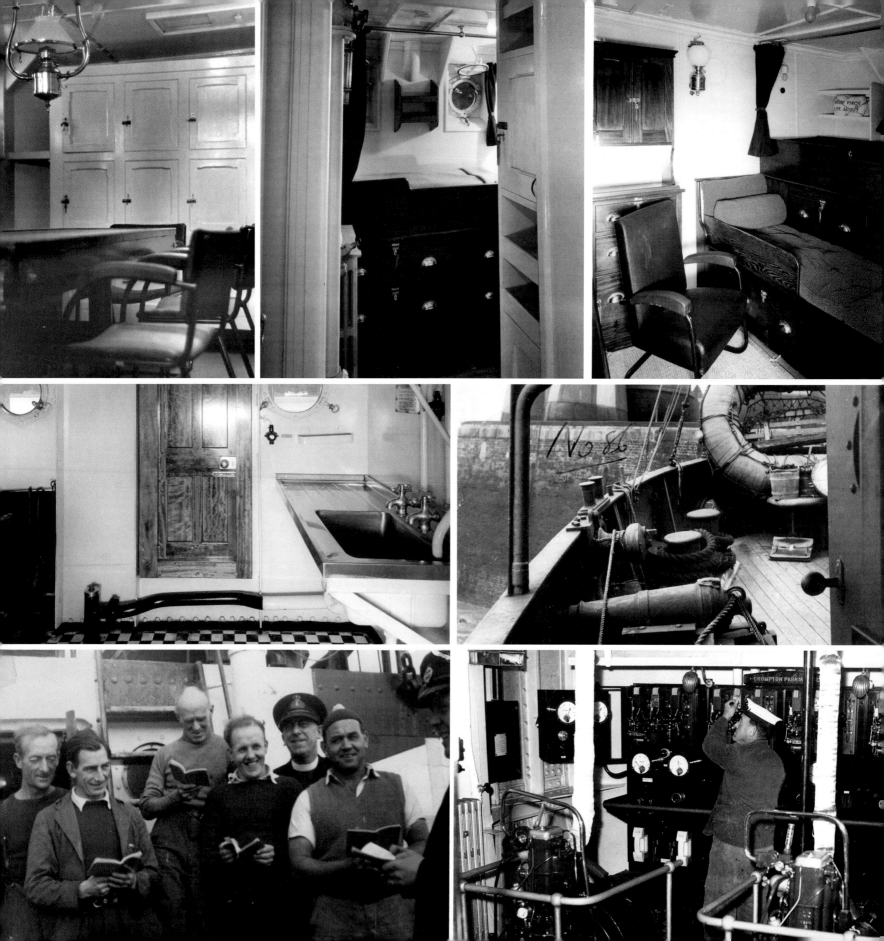

Life in lightvessels could be very demanding and required a sturdy breed of seamen.

The 11-strong crew attached to each lightvessel consisted of two Masters (or a Master and a Mate) and nine ratings, including two Able Bodied Seamen, two Fog Signal Drivers and two Lamp Lighters; one Master and six ratings were aboard at one time. There were originally 12, but the position of carpenter was made redundant towards the end of the 19th century. Each Master served four weeks afloat and had four ashore generally free of all duty; the ratings served four weeks afloat with two ashore free of all duty.

The crews' single-berth cabins were below the weather deck and above the waterline. Radio-telephone equipment was fitted on the later manned lightvessels, replacing semaphore for communication with each other, the shore and nearby lifeboats.

Life for the men on the lightvessels was subject to very little change over the decades and centuries, although developments in shipbuilding made gradual improvements in accommodation and manual labour, such as the introduction of engines to power the fog signal (replacing Chinese gongs) in 1862, oil gas as an illuminant (1905), dioptric lenses (1913) and electric lighting (1926).

The minimum requirement for this job was an Able Seaman's certificate, which appealed to a wide range of seagoing men who were unafraid of manual work in isolated waters, with deep rolling motions for weeks at a time.

Many lightvessels in local shallow waters from the 1950s onwards had domestic radio and television and frequent drop-offs from passing yachtspeople, but lightvessels in deeper waters further from shore were less fortunate, and relied on fortnightly supplies from the Trinity House service tenders for their news, food and entertainments.

Opposite, top row, left to right: The crew's mess room with lockers; a seaman's cabin; the Master's cabin.

Opposite, middle row, left to right: A view of the galley; the upper deck of No. 86 Lightvessel with its warning gun. Against the bulwark is a Carley float, a wartime expedient in the event of loss of the lightvessel's boats.

Opposite, bottom row, left to right: A chaplain carries out his pastoral duties in a lightvessel with a jolly reading and likely boisterous rendition of some well-known seafarers' hymns; a Fog Signal Driver in the engine room operating the air compressor sets to drive the fog signal.

Below: A rating in the Light Vessel Service cleans the lantern glazing.

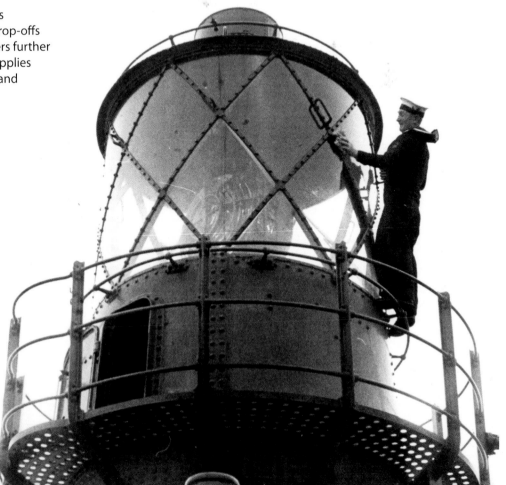

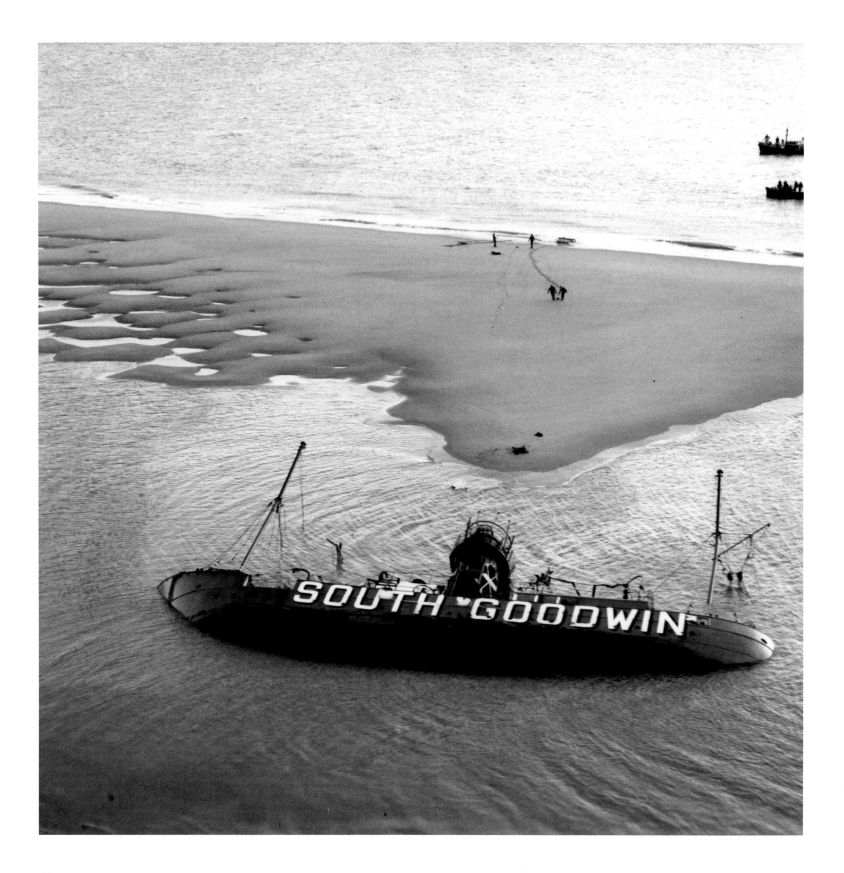

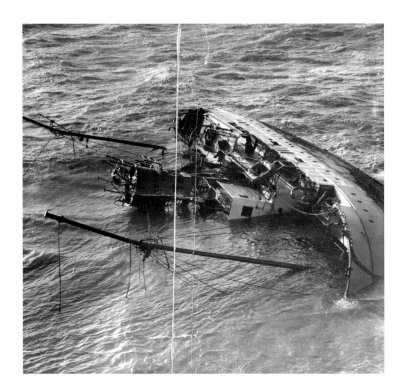

Opposite and above: On 27 November, 1954, No. 90 Lightvessel marking the South Goodwin station broke adrift in the early hours, dragged by extreme weather from its position at the narrowest point of the Dover Strait. HM Coastguard at Deal had indicated that the lightvessel was adrift at 01.15 that day. The lightvessel drifted north and was found lying on its starboard side on the Goodwin Sands. A helicopter from Manston Aerodrome rescued the only man seen on board, a visiting Ministry of Agriculture official who had been studying bird migrations, who was found clinging to the side of the hull.

A temporary buoy was laid on the evening of 27 November and the emergency spare lightvessel, No. 65, was towed from Harwich by tender and placed on the South Goodwin station on 29 November. No trace was ever found of the missing lightvessel crew. Four lightvessels were reported as being off station in heavy weather during the period 27 to 30 November that year. The entire crew was declared lost, as a result of what turned out to be one of the worst channel storms in two centuries. After 27 November, the international maritime community was quick to rally around with commiserations.

Top right: Since the late 1790s, when Trinity House established the first lightvessel at the North Goodwin station, the Corporation has maintained a number of lightvessels and buoys to warn shipping of these dangerous sands. Over time, innumerable vessels have been lost hereabouts, the nature of the sands rapidly filling them and causing them to be known as the 'great ship swallower'.

Such has always been the importance of preserving the life and cargo carried by ships that pilots (or 'lodesmen') have been employed for centuries as freelance mariners. Pilotage is the safe conduct of vessels in coastal waters and estuaries by expert seamen with local knowledge of the safe channels, the leading lights and marks, the sandbanks or rocks, and the effect of winds and tides.

As early as 1190, the Laws of Oléron – an early legal document setting out the customs and usages of the sea – stated that.

It is established for a custom of the sea that if a ship is lost by default of the lodesman, the mariners may, if they please, bring the lodesman to the windlass and cut off his head without the mariners being bound to answer before any judge, because the lodesman had committed high treason against the undertaking of the pilotage, and this is the judgement.

Examining and licensing pilots is the oldest of Trinity House's official duties, and the basis of the Corporation's first Royal Charter, a response to a petition by the mariners of the Thames in which the dire state of pilotage was held up:

The practise of pilotship in rivers, by young men who are unwilling to take the labour and adventure of learning the shipman's craft on the high seas, is likely to cause scarcity of mariners; 'and so this your realm which heretofore hath flourished with a navy to all other lands dreadful' shall be left destitute of cunning masters and mariners; also that Scots, Flemings and Frenchmen have been suffered to learn as loadsmen [pilots] the secrets of the King's streams, and in time of war have come as far as Gravesende 'and sette owte English shippes to the great rebuke of the realm'.

Left: A pilot being shipped from the boarding boat of a cruising cutter.

Opposite: Fast launches of the Trinity House Pilot Vessel Service at Harwich. These replaced the cruising cutter offshore. Similar craft were engaged in other Trinity House outport districts, such as Great Yarmouth and Falmouth.

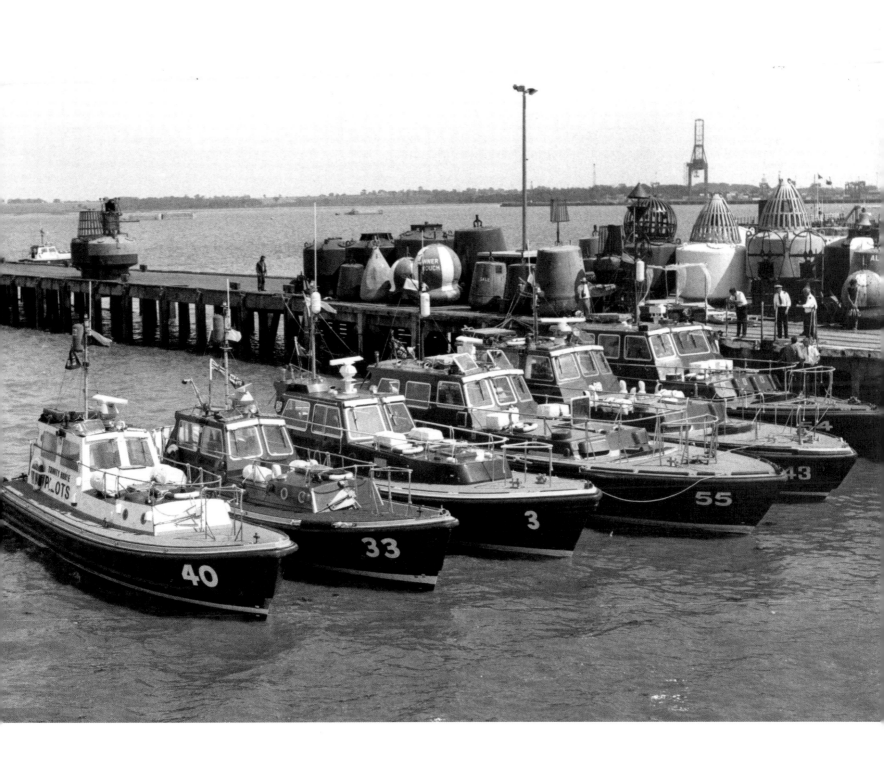

In spite of the development of ships and automatic digital navigation devices, pilotage is still essentially the same as it has always been, reliant on the experienced seaman's intimate knowledge, fine judgement and quick reaction to emergency.

Until the Pilotage Act of 1987, Trinity House was the pilotage authority for London and 40 districts around the coast of England and Wales, responsible for licensing these self-employed master mariners by means of examination. An Elder Brother would question the prospective pilot on the details of the area in which he hoped to serve as pilot and on by-laws for navigating the District: identification of the channels, headlands and shoals; features of the coast; courses and distances; depths of water; tides; anchorages; navigation by seamarks by day and night as well as, more generally, the rules of the road at sea and the uniform system of buoyage.

A pilot would join a ship just off the coast and temporarily take over navigation of the ship until it reached its destination, where his job would be complete.

By the 1980s, Trinity House had licensed about 600 pilots across 41 districts, with about 400 in the London District alone, handling an estimated 60 per cent of the nation's piloted ships.

The 1987 Pilotage Act saw Trinity House passing its District Pilotage responsibilities to various local harbour authorities, becoming instead a licensing authority for deep-sea pilotage.

Below left: Trinity House Pilot Vessel *Valkyrie*, part of a large fleet of 40-foot fast launches. These fast launches were based on a design by Keith Nelson.

Below right: Two pilots on duty on an Esso tanker approaching the Fawley Refinery in the Solent. Berthing a large tanker required two Trinity House pilots.

Opposite: THPV *Vanquisher* about to ship a pilot to a large container ship. This illustrates the difficulties encountered by the pilot with a long climb up a ladder and, frequently, having to transfer from one ladder to another before he gained the main deck.

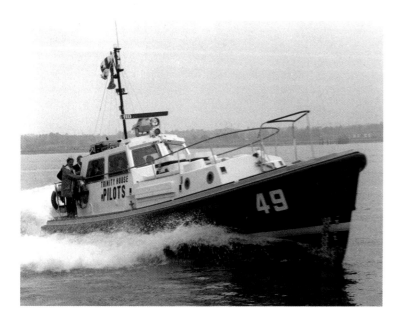

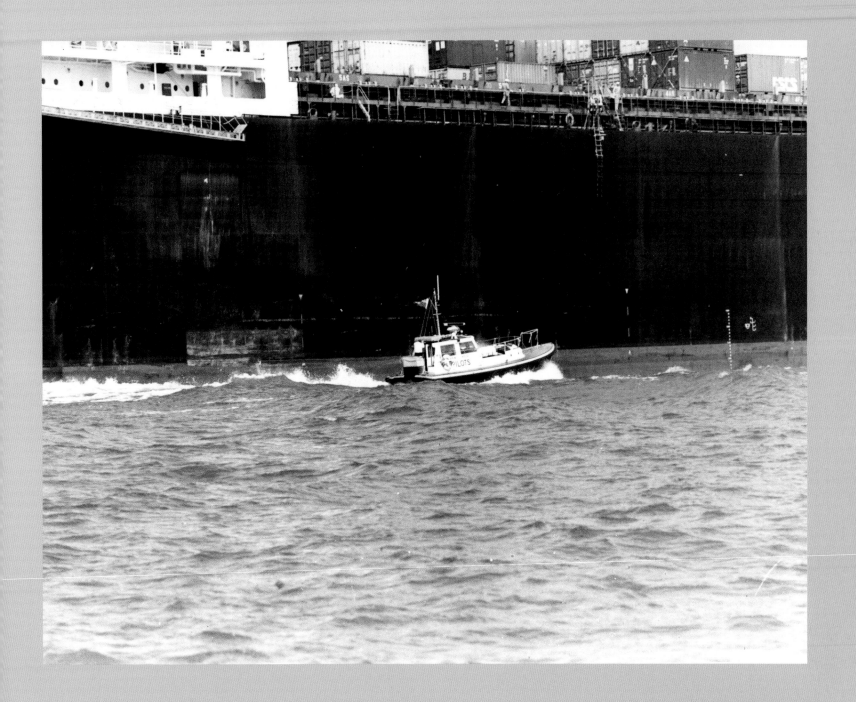

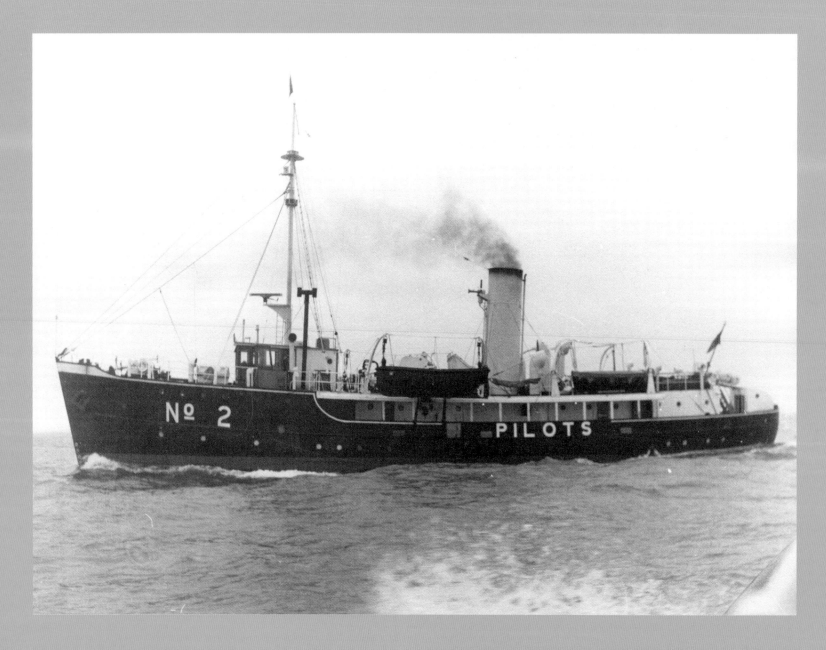

Above: The Trinity House Pilot Cutter *Brook*. Until the introduction of the fast launch, pilots awaited their ships aboard a cruising cutter and then transferred in a boarding boat.

Opposite top left: The *Brook's* wheelhouse.
Top right: THPL *Valery*.
Bottom left: *St. Clement*.
Bottom right: *Vigia* (far) and *Vigilant* (near).

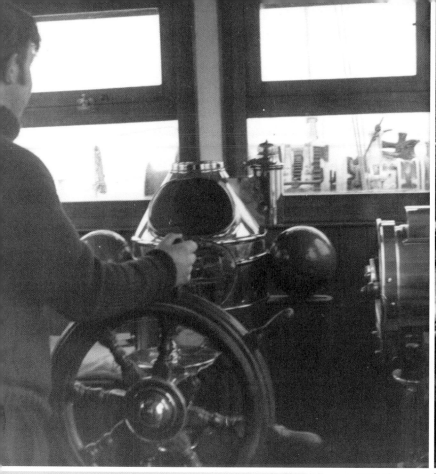
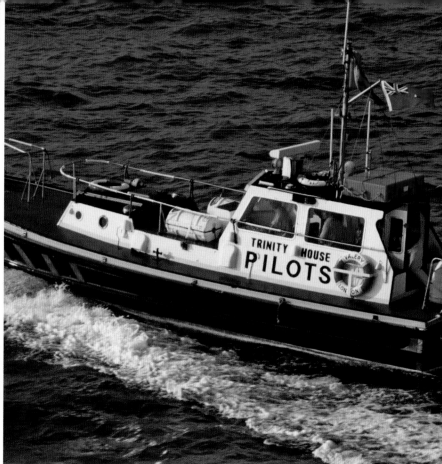
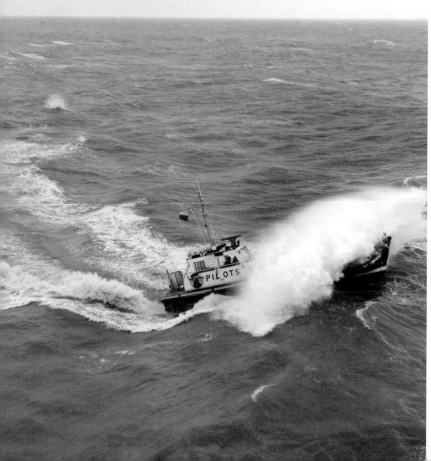
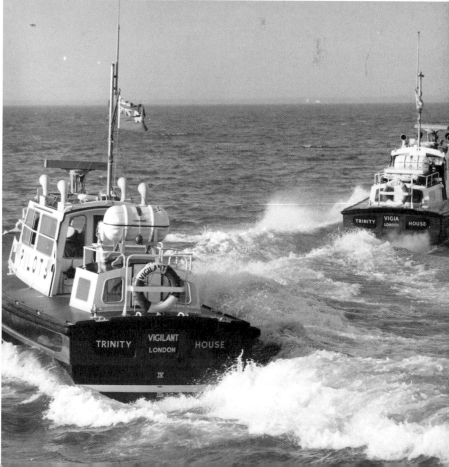

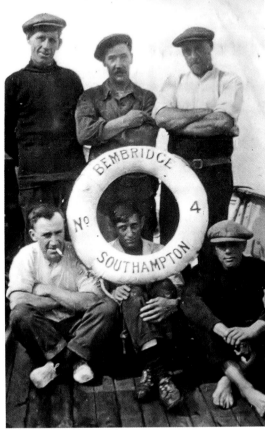

The London area extended from London Bridge to the Sunk Sand off Felixstowe in the north to Dungeness in the south, and at its height 400 pilots were licensed to work these waters. In the 12 months to May 1987, the all-launch pilotage service at the Cork and Sunk stations off Harwich provided 14,547 shipping and landing operations during which 215,846 nautical miles were steamed. Severe weather only restricted the working of 78 operations, successfully reflecting upon the dedication of the launch crews, their support staff and the reliability of the vessels.

May 1986 saw the withdrawal of the cruising cutter *Pathfinder* at the Sunk station after 31 years' service, leaving an all-launch operation from then on.

At the end of 1988, with Trinity House no longer providing district pilotage, tribute was paid to the dedicated staff of the Trinity House Pilotage Service, who worked to the end, ensuring that Trinity House was able to hand over administration of pilotage in good order.

Until 1899, the customary attire for a River Thames Pilot comprised a silk hat and frock coat; after that, Trinity House pilots were distinguished by their uniform of navy blue, without decoration other than eight brass buttons, and a cap with the Trinity House Pilot badge. In the smaller outports, a pilot could go straight from his occupation as a fisherman or boatman to an act of pilotage, signifying this change of occupation simply by donning his Trinity House cap, without the need for a full uniform.

At the start of each year, a Trinity House pilot was obliged to present himself to that district's Pilotage Committee to renew his licence, where his medical fitness, his eyesight and his familiarity with any changes in his area would all be examined.

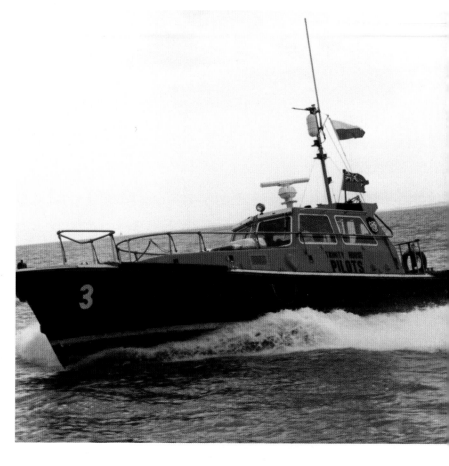

Opposite left: The Pilot Cutter *Preceder* operated out of Harwich supplying the cruising cutter on the Sunk station with pilots.

Opposite right: The crew of THPV *Bembridge*, based at Southampton in the Trinity House Isle of Wight Pilotage District, pose for the camera.

Above left: A pilot of an outward-bound merchant ship hangs at the top of the pilot ladder awaiting the arrival of the fast pilot launch, top right.

Right: A pilot launch passes the Needles Lighthouse to meet an inbound merchant ship bound for Southampton.

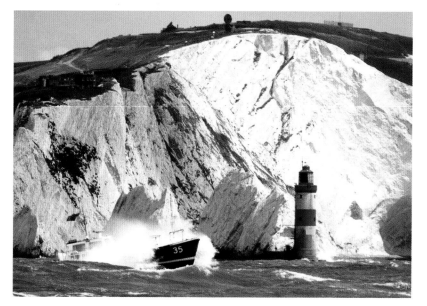

'The glass founder, in the first place, must exercise his highest art to produce a colourless glass free from striae and other flaws. Roughly cast in moulds, the lenses and prisms must then have their surfaces accurately ground to particular curvatures, whose calculation is the province of a skilled mathematician.

When they have received their final forms, and have been finely polished, they must be fitted into their places with the most scrupulous nicety, in order that the rays falling upon each may be transmitted exactly in the direction required…

He cannot employ always the same design on different occasions, but must have regard to particular local requirements, and may be called upon to invent new forms or arrangements to suit them.'

The Lighthouse Work of Sir James Chance, 1902.

As the fundamental element of any lighthouse, the light source had to be clear and fuel efficient, the optic had to be of the most scrupulously engineered design and the lantern had to be clean and well ventilated; all had to be built to the highest possible standards. Chance Brothers of Smethwick, near Birmingham, were the principal lighthouse optic manufacturer in Britain in the 19th and the first half of the 20th century.

Many Trinity House lighthouses still employ a Chance Brothers optic and lantern, such was their original build quality; the often colossal gunmetal-and-glass optics still turn steadily and quietly on a bed of near-frictionless mercury supported on their deep-green cast-iron pedestals.

Opposite: The optic and lantern at Orfordness Lighthouse, once the most powerful in the service at 30 million candela.

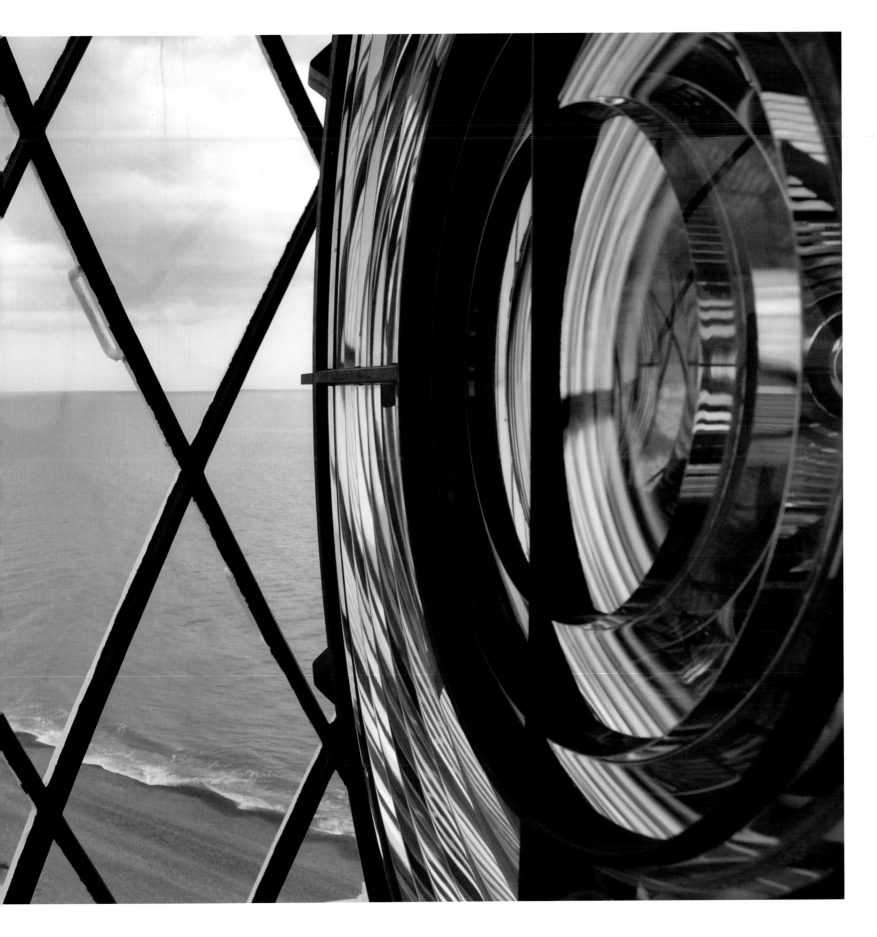

The engineer's drawing below of 1810 shows the improved light exhibited at the Eddystone Lighthouse in August of that year. This was a reflector light consisting of 20 individual convex units. The drawing is signed off by Joseph Huddart, elected an Elder Brother of Trinity House in 1791 and created a Fellow of the Royal Society. He was also a founder member of the Institution of Civil Engineers. In his time he served with the East India Company, commanding the East Indiaman *Royal Admiral*, and surveyed the waters of Sumatra and India.

Great advances were made with light sources and fuels in the 19th century in England and in France. Professor Michael Faraday was Scientific Adviser to Trinity House from 1836 to 1866, and much work was undertaken by the Chance Brothers and the great lighthouse engineers James (later Sir James) Walker and the

Douglass family. Other contributors were Professors Holmes and Tyndall, and Thomas (later Sir Thomas) Matthews.

Opposite upper left: A large filament lamp at North Foreland Lighthouse. Beside it is a standby lamp that automatically came into operation on the failure of the former.

Upper centre: A keeper lighting, or 'putting in', the Hood incandescent oil burner at Bardsey Lighthouse.

Opposite bottom: At Bardsey Lighthouse, a 400-watt MBI lamp with an intensity of 89,900 candela and a range, through a First Order catadioptric optic, of 26 nautical miles.

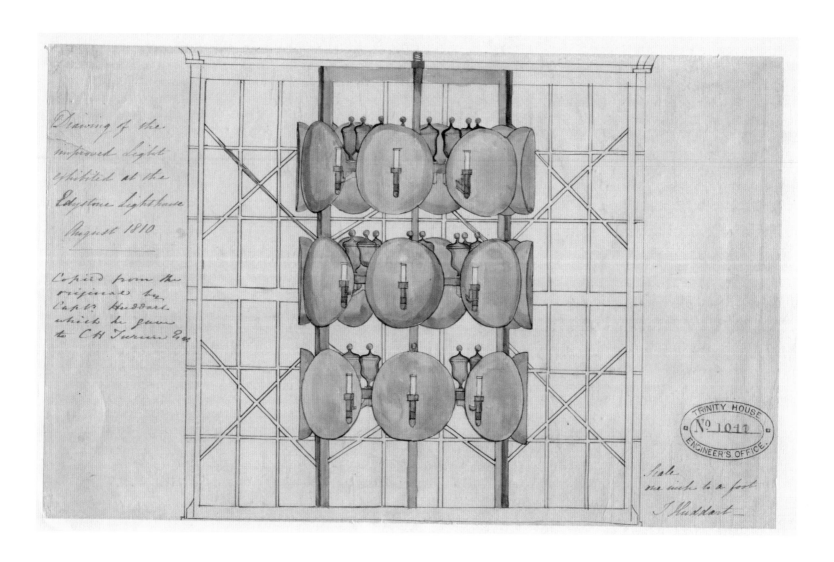

Top right: A drawing illustrating Augustin Fresnel's principle of focussing light by means of refraction and reflection. Below this is a Hyper Radial single flashing apparatus of 1330 mm focal distance consisting of four panels made up of glass prisms and a central bullseye lens. This apparatus will have been installed in a major light providing a range of 25 nautical miles.

The arrangement of prisms and a bullseye lens – the 'dioptric' sytem – was developed by Fresnel in 1823; that ingenuity was built on over the years by lighthouse engineers and scientific advisors, giving us the catadioptric optic and the group flash character system.

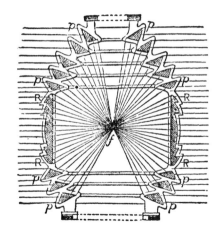

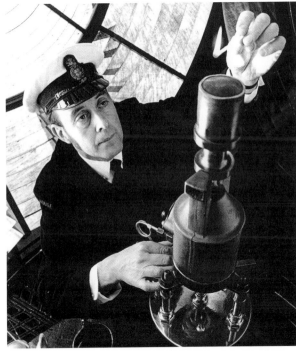

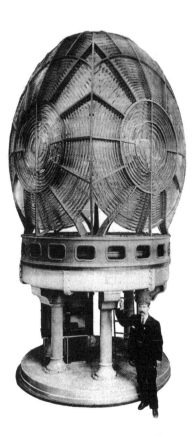

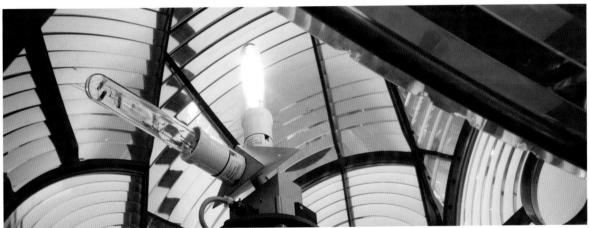

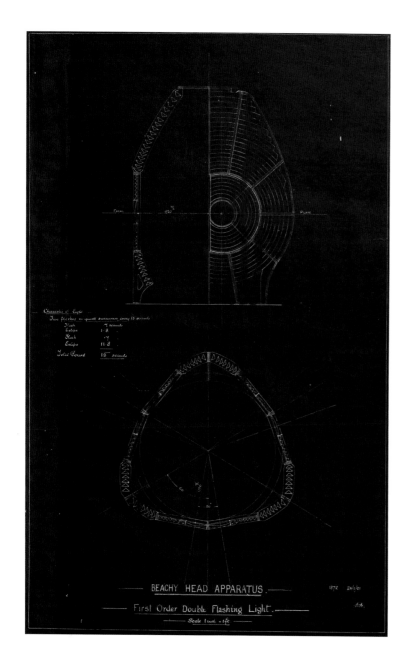

Character of Light.
Two flashes in quick succession every 15 seconds.
Flash .7 seconds
Eclipse 1.8
Flash .7
Eclipse 11.8
Total Period 15 seconds

BEACHY HEAD APPARATUS.

First Order Double Flashing Light.

Scale 1 inch = 1ft.

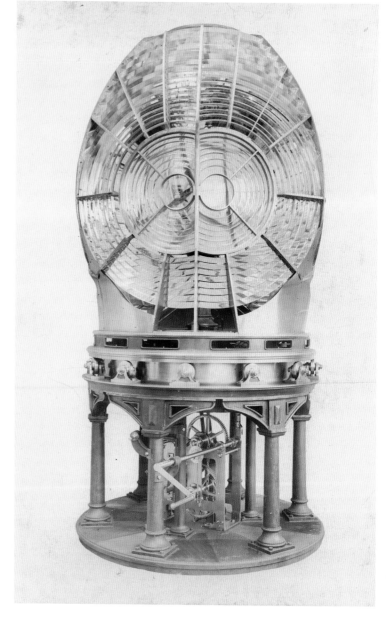

Left: A blueprint showing the early 20th century optical apparatus for Beachy Head Lighthouse, a First Order double flashing light providing two flashes of 0.7 seconds' duration every 15 seconds.

Right: The Beachy Head Lighthouse First Order optic as produced by the Chance Brothers in 1901.

Opposite: The beautiful clockwork optic drive mechanism *in situ* at Beachy Head Lighthouse. This operates not unlike a grandfather clock in that the weight had to be wound up several times in the course of the night, and as it dropped, so it rotated the optic at the top of the tower to provide the flash as the bullseye appeared opposite the viewer. Eventually, with electrification, this mechanism was dispensed with and replaced by an electric motor and a geared drive created to maintain the light character of flash 0.7 seconds, eclipse 1.8 seconds, flash 0.7 seconds, eclipse 11.8 seconds, giving a total period of 15 seconds.

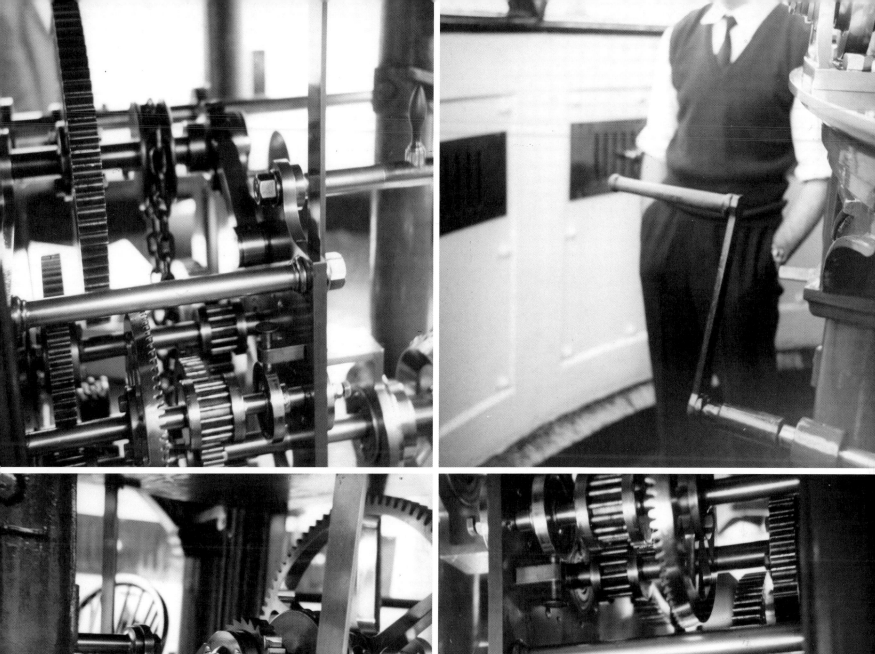
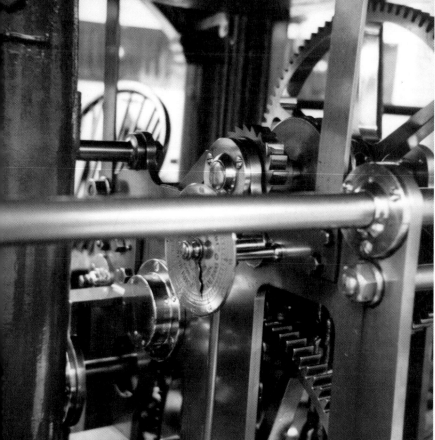
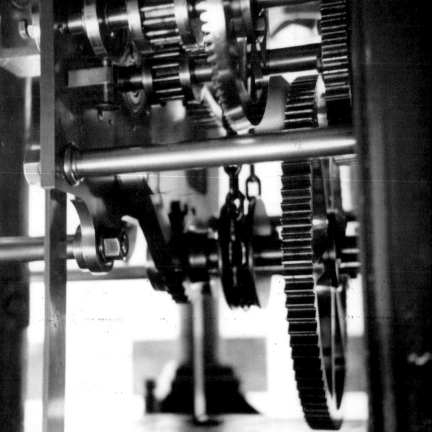

The conversion of lighthouses to automatic, unwatched operation was anticipated with the construction of a new lighthouse at Dungeness in 1961 (above). The automatic status was necessary in the event that the ness had to be evacuated following an emergency at the nearby nuclear power station.

Early efforts to convert some of the minor, more remote lighthouses to unwatched operation began around the end of the 19th century, and were much improved by Gustaf Dalén's Nobel Prize-winning research into making acetylene gas a less volatile source of fuel for lights.

Trinity House began its research in earnest into the remote operation of lighthouses in the 1950s, tackling radio-based telemetry and fog detection at its Experimental Station at Dungeness (opposite). The first lighthouse to be retrofitted with this new technology was Orfordness Lighthouse on the Suffolk coast in 1964, controlled from Harwich Depot. After a successful trial period, Orfordness Lighthouse went fully automatic, with the keepers handing over the station in September 1965. The automation programme was gradually rolled out across Trinity House's estate of lighthouses and lightvessels for the next 33 years, culminating in the automation of North Foreland Lighthouse in November 1998.

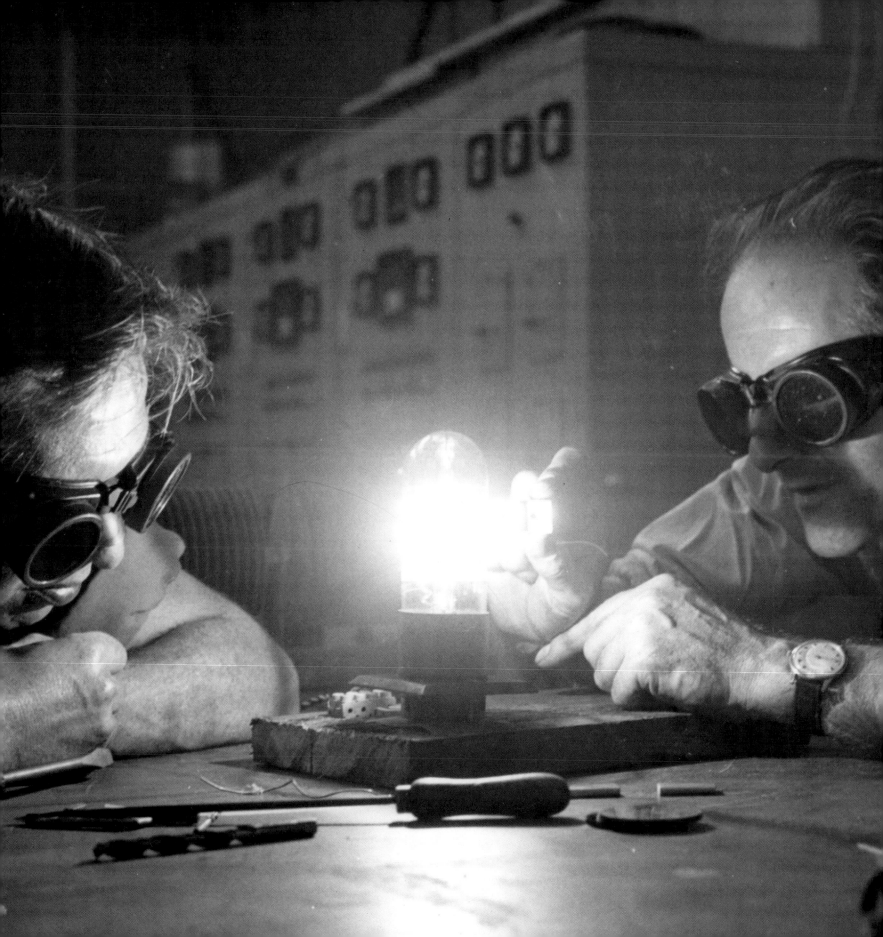

One of the more enduring accounts of the perils of a delayed relief relates the death of Thomas Griffith and the suffering of Thomas Howell at the Smalls Lighthouse circa 1800, having been stranded on the wooden lighthouse by four months of continuous storms. A week or so into their spell of duty, passing ships reported to their ports that an indistinguishable distress signal appeared hoisted at the lighthouse, alongside the dim outline of one of the men standing on the gallery of the lighthouse; but as the light burned with its usual brightness, the signal did not seem to indicate the suffering of the keepers.

It was later understood that Griffith had fallen ill and, without assistance, had died after weeks of suffering. Howell was now faced with the problem of whether to occupy a small living space with a decomposing body or to send Griffith to a watery grave and risk suspicion of foul play.

Howell's skill as a cooper enabled him to fashion a makeshift coffin out of boards prised from a bulkhead; hence the body was secured to the outside railing. For three weeks it occupied this position, before the weather moderated. When Howell was finally rescued he was reportedly unrecognisable to his friends as a result of his mental and physical trials.

Left and above: Extreme weather at Longships showing the station in a Force 11 storm in 2008, caught by intrepid photographer Tim Stevens. Although at the time the station had been automated, it has to be remembered that keepers here endured conditions like this from the station's establishment in 1795.

'I spent three years as a prisoner-of-war, and would rather go behind barbed wire again than face a further few weeks on that damned rock.'

Edward Ward, BBC Reporter, talking about the Bishop Rock Lighthouse after being marooned for 29 days from 21 December, 1946.

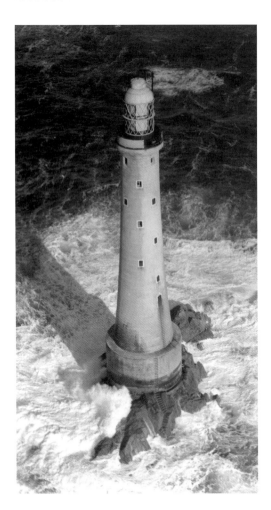

In December 1946 the BBC's radio features department revived the pre-war round-the-world link-up of Christmas Day greetings that preceded the annual message from the Monarch. So Edward Ward and an engineer set off for Bishop Rock Lighthouse, the most westerly part of England, some 40 miles off Cornwall and 7 from the Isles of Scilly, to record the Yuletide contribution from the isolated keepers.

The two men had planned to stay on the lighthouse for only a few days, but the same gale-force winds and heavy seas that featured in their Christmas round-up also prevented their scheduled relief.

For almost a month the weather did not let up, and with five men on station the supply of fresh food dwindled; the lighthouse keepers radioed Trinity House for permission to break into the emergency stores of bully beef and biscuits.

'*It was always the same old walls*,' Ward recalled, '*living completely in one room about 15 ft in diameter, and the only change of view was a trip up to the light above, and walk around the balcony, or a trip down into the rock's "vitals" to look at bits of machinery… I made my own bed each day and helped with the kitchen and housework… Then there was always the polishing of the light and wireless talks with other lighthouses and the coastguard station ashore. But it was all pretty boring once the novelty wore off… we had nothing stronger than tea to drink, and towards the end the cigarettes ran out.'*

On the 29th day, a lifeboat made it to the lighthouse and the men were lowered by rope towards the boat through the surf. '*It took just 10 minutes to leave the lighthouse in the breeches buoy and reach the lifeboat*,' he told the gathered newspaper reporters, '*but it was the longest 10 minutes of my life… There I was, dangling on what seemed a dreadfully thin rope between the sky and the boiling sea. It was not funny at all.'*

Now remembered as one of the very best of the BBC's war correspondents, Ward (1905–1993) was held as a POW in Italy and Germany from 1941 to 1945. Four or five days on a lighthouse must have seemed a relatively trouble-free assignment in comparison. He signed off his stretch as a lighthouse keeper with a palpable sense of relief: '*I wore the same shirt for 29 days, and I am fed up with the sight of it. Now I am going home for a bath a drink, and a change of clothes, and I hope I don't get another job like that in a hurry.'*

Opposite, first column from top: Bishop Rock relief, 1980; approaching Wolf Rock, 1972; Wolf Rock helipad; Longships helipad. *Far right top*: An emergency relief at Wolf Rock by RAF helicopter in 1948, which prefigured the introduction of Service helicopters in 1969. *Below*: Principal Keeper Abrahams loses his cap during relief from Wolf Rock Lighthouse at Christmas, 1956.

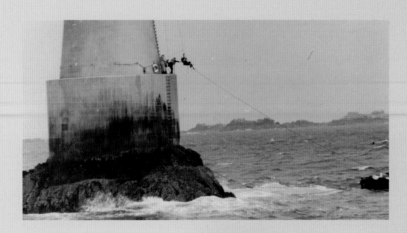

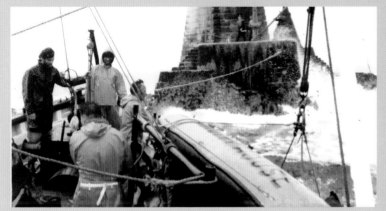

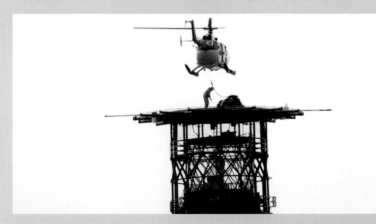

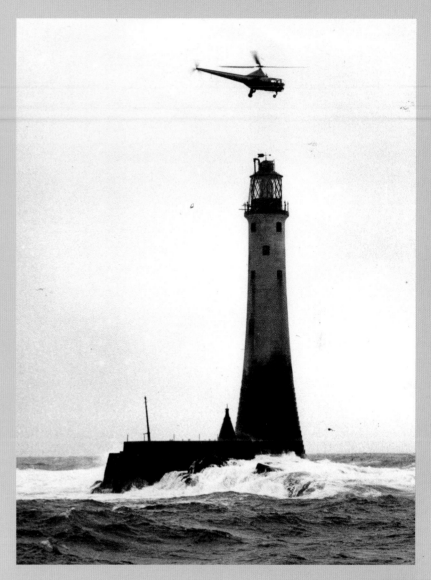

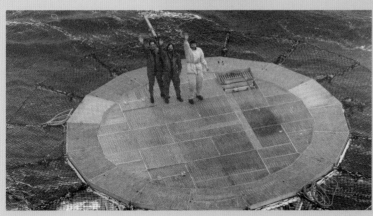

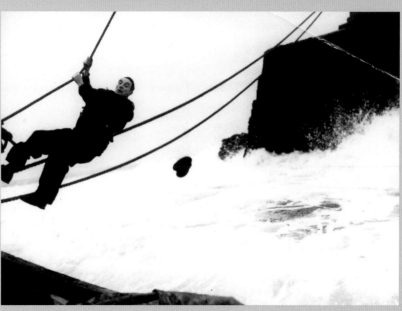

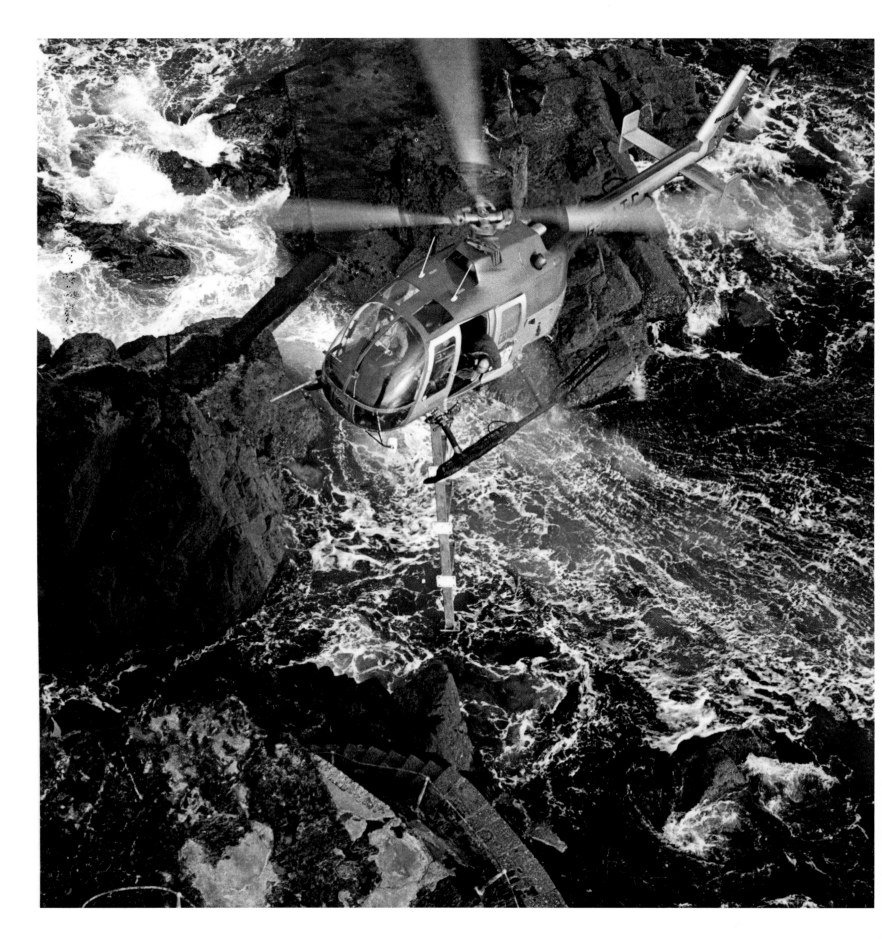

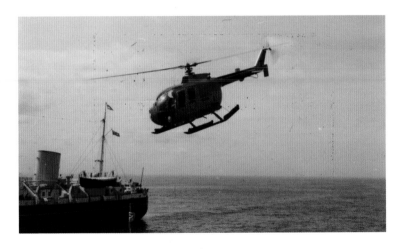

Opposite: Engineering stores being delivered to Longships Lighthouse in 1974 during the construction of the helipad.

Top left: A helicopter flies over the district tender THV *Mermaid*.

Below: Keepers and stores are unloaded after a relief at St Just near Land's End. *Centre left*: The Trinity House Helicopter G-BATC, known widely as 'Tango Charlie', on the helideck of the Newarp Lightvessel in 1974. *Below left*: Oil and water are lifted from the deck of THV *Winston Churchill*. The pillow tanks contain fuel oil for the lighthouse's generators. *Below right*: The Service helicopter approaches the 27-foot-wide helideck above the lantern at Eddystone Lighthouse. Access to the tower was through trapdoors.

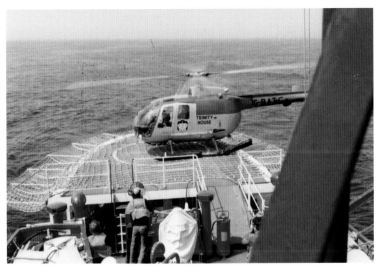

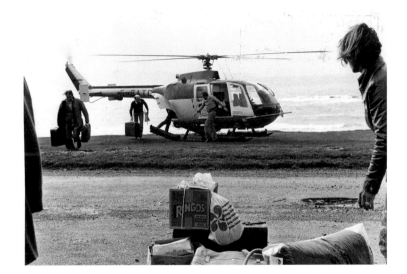

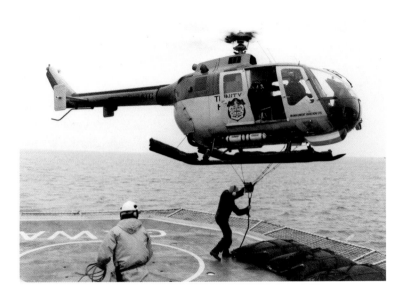

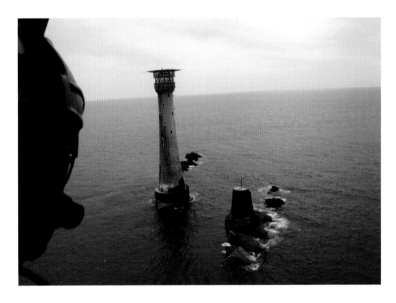

Lots of changes have taken place since I entered the Service on the Lighthouse Staff in the year 1910, when the wages were 17/6 per week, with free uniform and victualling at Rock Stations at 1/9 per day, and strong discipline, which was administered by the PKs [Principal Keepers]. Without a doubt the present generation of Lighthouse Keepers today don't know they are born, what with the amenities and big wage packets, and travelling about in comfort. Which was much different in the good old days of 60 years ago, when SAKs [Supernumerary Assistant Keepers] used to sit in the shanty at Blackwall Depot waiting for orders to proceed to a certain station, for quarterly or sick duty. You would arrive at your lodging, get a 5 ft sailor's bag packed with your belongings and set off for Poplar railway station en route to Broad Street [Liverpool Street] and hire a hansom cab, and the driver would hoist the sailor's bag on top of where he was sitting and you would direct him to Paddington or Waterloo, and a good mare would jog along, to get you on time for your train. No hold-ups for traffic in those busy streets, as a hansom got priority, the public surmising someone of an official capacity sitting inside.

A donkey's breakfast to lie on in your bunk, no television or RT so as to speak to your wife ashore, no Aldis lamp for Morse messages. We had an antique lamp of the shutter style for Morse. When going off on the relief you took garden produce off with you such as turnips, cabbage, carrots, potatoes; the former would only last about two weeks as they got withered. There were no tinned vegetables like we get today, and the same with the yeast. In my time you got your yeast from the chemist's, and took enough to last two months. As soon as you landed on the rock, the ounces of yeast had to be put into a glass 1 lb jar and filled with water to keep it fresh, and the water had to be changed every other day so as to keep the yeast fresh. The meat was put in a cask with salt brine until the later years when it was put in 1 lb stone jars and simmered in the oven for four hours.

Letter to Trinity House from Mr S. D. Knox in 1974, a retired Principal Keeper born in 1886 who served 1910–48.

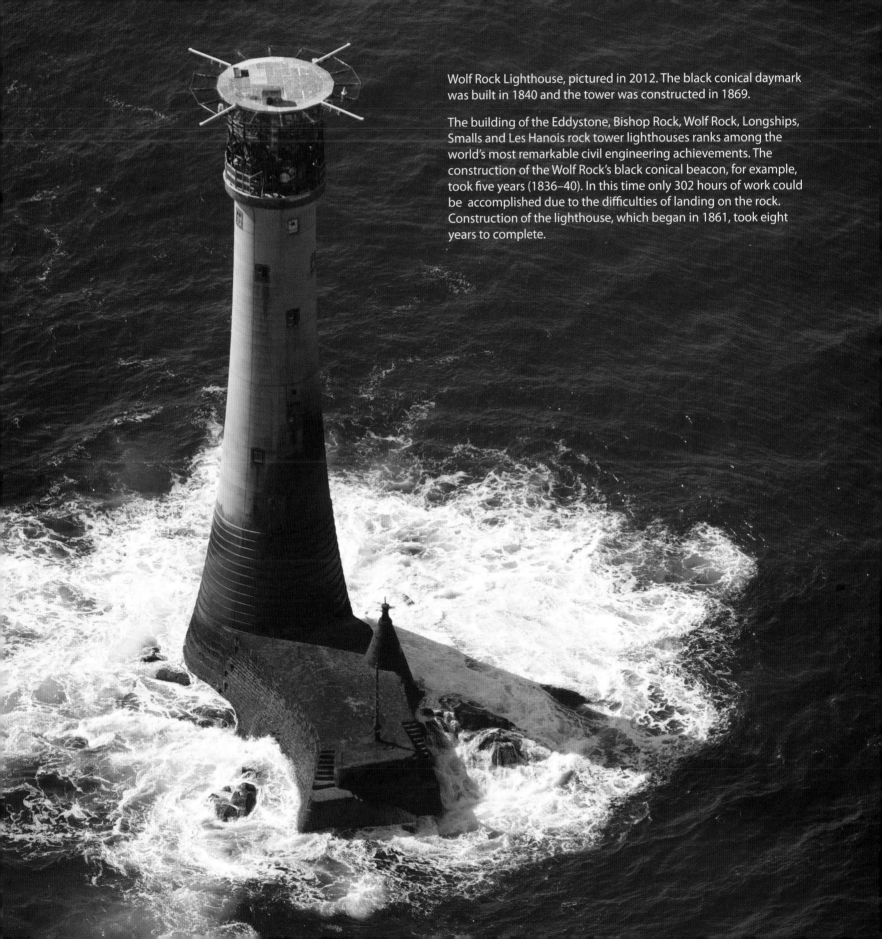

Wolf Rock Lighthouse, pictured in 2012. The black conical daymark was built in 1840 and the tower was constructed in 1869.

The building of the Eddystone, Bishop Rock, Wolf Rock, Longships, Smalls and Les Hanois rock tower lighthouses ranks among the world's most remarkable civil engineering achievements. The construction of the Wolf Rock's black conical beacon, for example, took five years (1836–40). In this time only 302 hours of work could be accomplished due to the difficulties of landing on the rock. Construction of the lighthouse, which began in 1861, took eight years to complete.

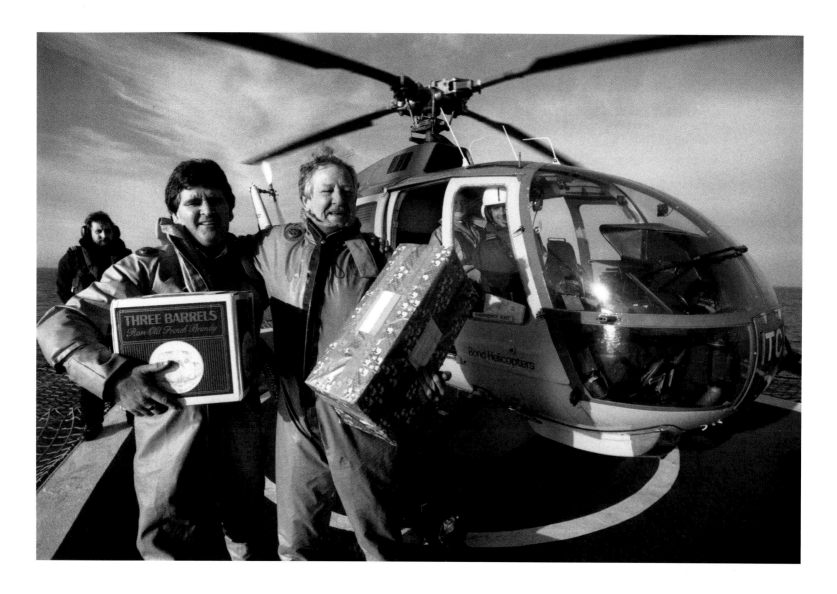

Relief of the lightvessels by helicopter was a great step forward for safety, economy and time. The photograph opposite shows a trial relief of Smiths Knoll Lightvessel off the Norfolk coast in October 1972 with a Bristow S-58T helicopter flown from North Denes Airfield, Great Yarmouth. The motor boat comes from the Trinity House flagship, *Patricia*, which was standing by. *Above*: The last relief of the crew of the Helwick Lightvessel.

The use of the helicopter enabled district tenders to concentrate on other district work and, with double manning, the Support Vessel Service fleet was reduced.

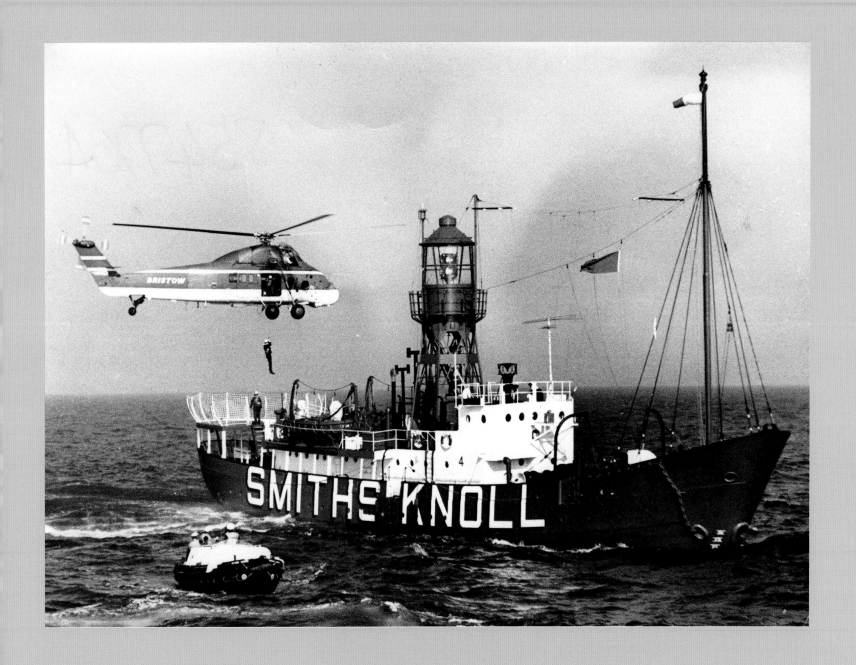

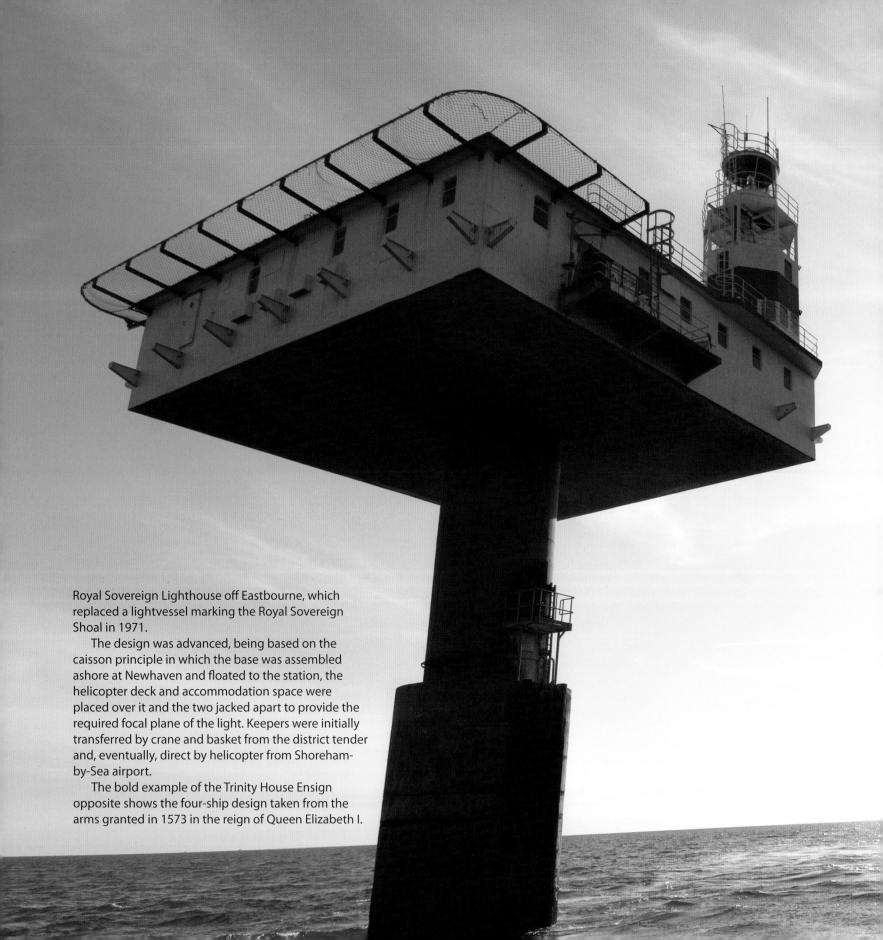

Royal Sovereign Lighthouse off Eastbourne, which replaced a lightvessel marking the Royal Sovereign Shoal in 1971.

The design was advanced, being based on the caisson principle in which the base was assembled ashore at Newhaven and floated to the station, the helicopter deck and accommodation space were placed over it and the two jacked apart to provide the required focal plane of the light. Keepers were initially transferred by crane and basket from the district tender and, eventually, direct by helicopter from Shoreham-by-Sea airport.

The bold example of the Trinity House Ensign opposite shows the four-ship design taken from the arms granted in 1573 in the reign of Queen Elizabeth I.

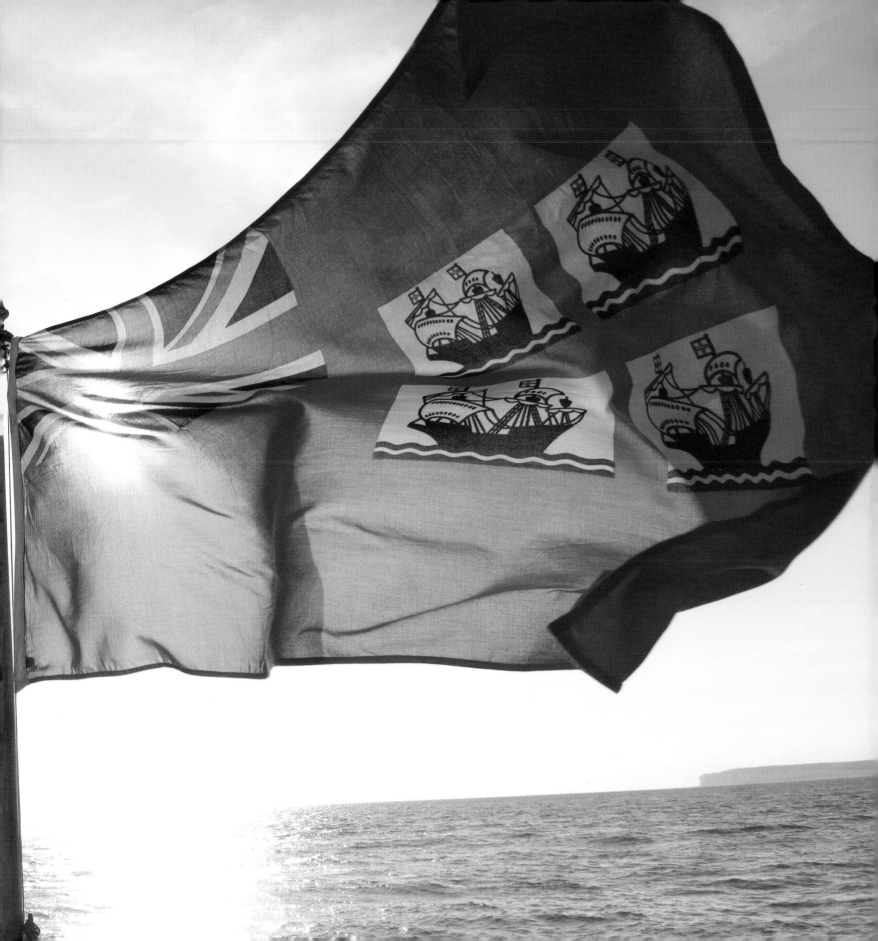

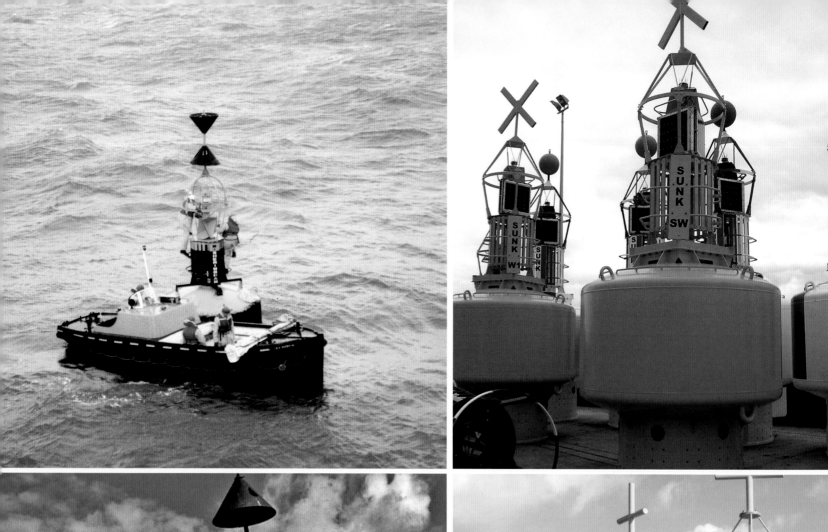

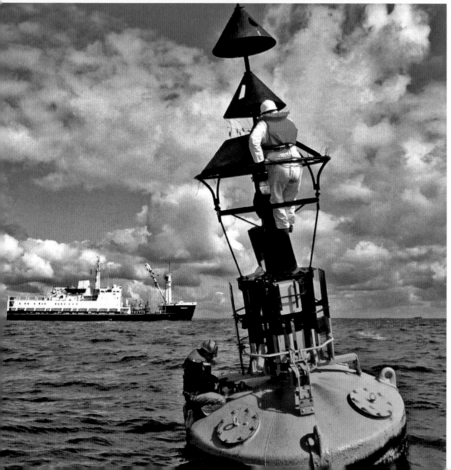

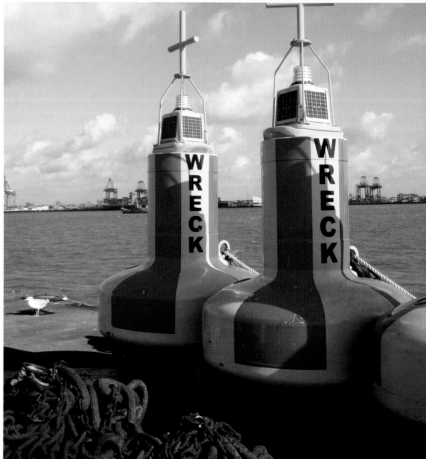

Trinity House is one of many dedicated and forward-thinking lighthouse authorities around the globe. All work for the safety of the mariner. In the late 1920s, the loosely assembled International Lighthouse Conference was brought together to gather the various global maritime agencies, to pool their respective experiences and drive forward developments in navigational aids.

In 1956, an invitation went out to these maritime agencies 'to propose the establishment of the most simple and effective organization, viz an international association of lighthouse authorities'. As a result, the International Association of Lighthouse Authorities – IALA – was established in 1957.

Perhaps its most significant achievement to date is the IALA Maritime Buoyage System, implemented in 1977 to address the unsatisfactory and sometimes disastrous mix of over 30 buoyage systems being used worldwide; 30 different systems were rationalised to two, System A with red to port and System B with green to port. The general principles of the systems introduced five types of marks that could be used in combination and that carried readily identifiable characteristics: lateral marks, cardinal marks, isolated danger marks, safe water marks and special marks.

Trinity House played a leading part in the systems' successful deployment, with an Elder Brother chairing the committee; THV *Ready* had the honour of laying the first IALA buoy in a ceremony off Dover, watched over by representatives of 16 nations on 15 April 1977.

Opposite: Examples of the IALA Maritime Buoyage System introduced in 1977.

Right: Hooking in the lifting gear of THV *Patricia*, circa 1984; the hazards of this operation are clearly indicated in this dramatic photograph.

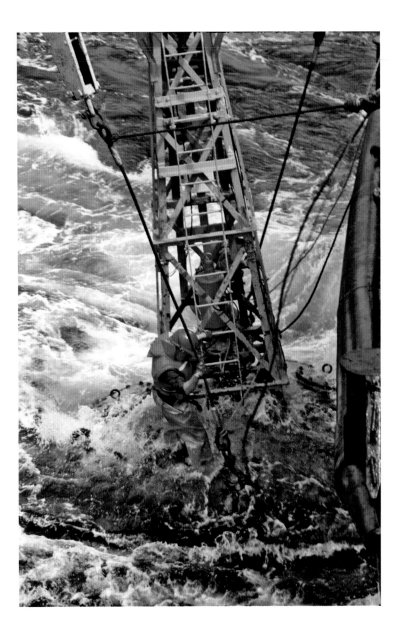

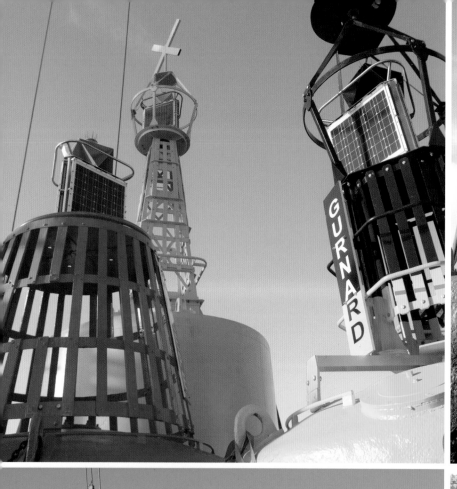
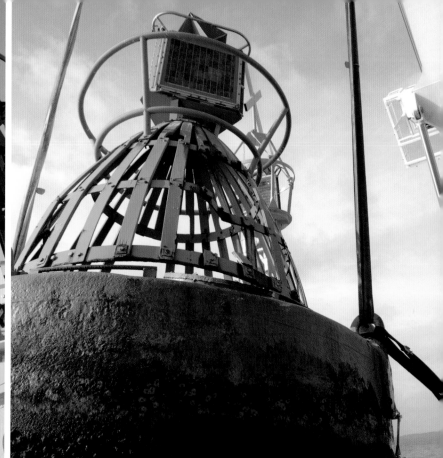
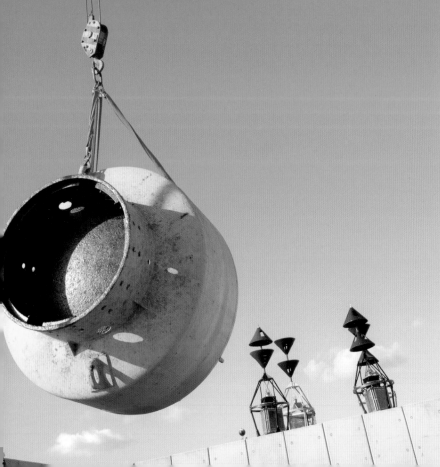

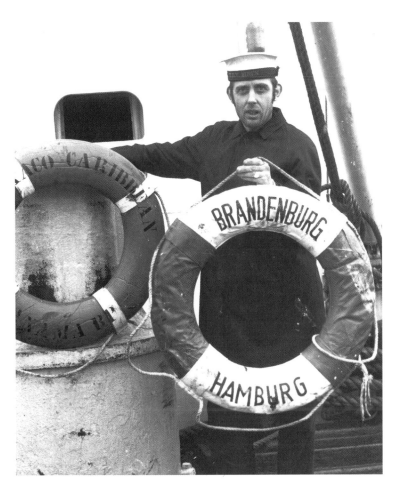

What I do say about working for Trinity House was that the seamanship was far superior to what I was used to in the Merchant Navy; for example lowering the boat in all weathers to service buoys and lightship relief which involved personnel, stores, coal, water and oil. Because if we were late with the relief it was the lightship crew's leave that was affected.

I also served on the previous THV *Patricia* and lastly on the THV *Siren* as Quartermaster where we were involved with surveying and marking of the sinking of the vessel *Texaco Caribbean* in the English Channel.

In early hours of the morning the *Brandenburg* sunk on top of the *Texaco Caribbean* so we were involved in the recovery of bodies and also marking the two wrecks. Enclosed is a photo of me on returning to Harwich after spending two weeks marking the [sunken] vessels before proper wreck buoys were prepared. Also a third vessel met the same fate in the same spot which resulted in two lightships and 14 wreck buoys guarding the wrecks.

A series of disastrous events followed a collision in the Dover Strait in 1971, resulting in the loss of the *Texaco Caribbean* (*below*), the *Brandenburg* and the *Niki*. Trinity House Vessels (including THV *Siren*, *below right*) marked the site with numerous buoys and two lightvessels to warn approaching ships that they were standing into danger.

Keith Morris, retired SVS crewman (pictured left).

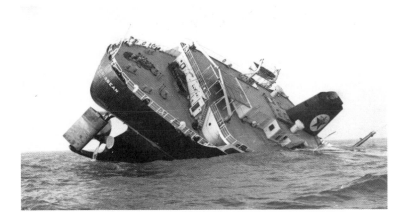

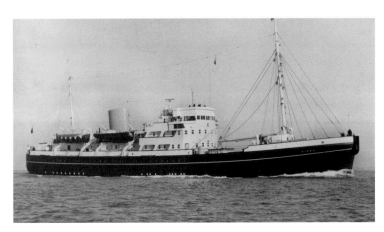

Class 2 buoys awaiting refurbishment at Harwich Buoy Yard.

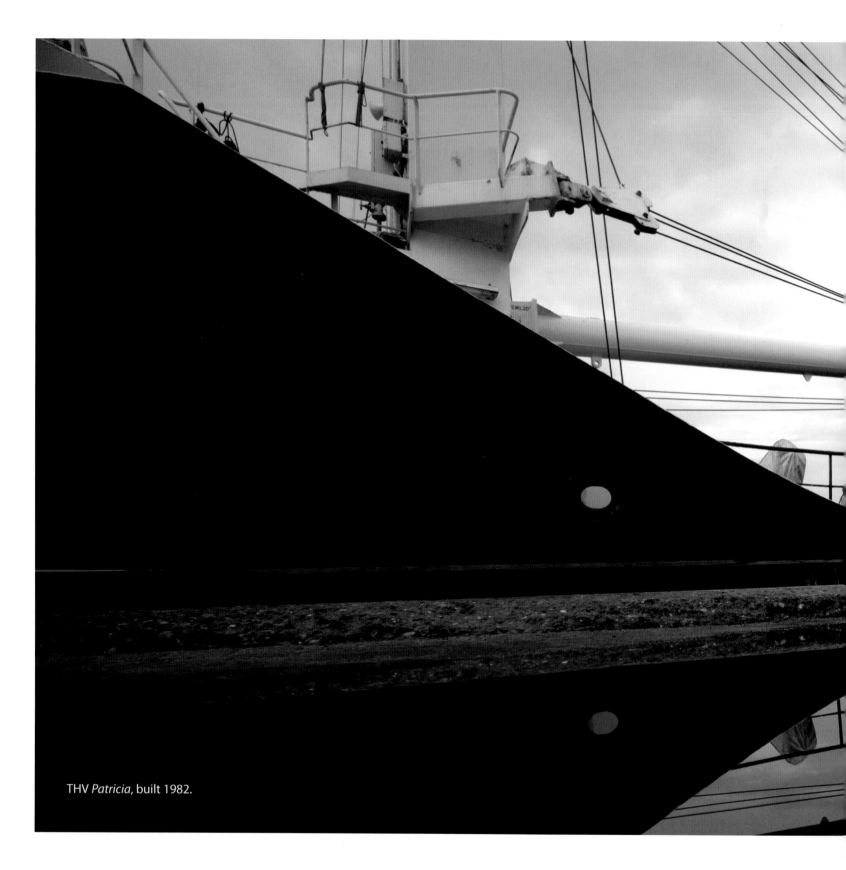

THV *Patricia*, built 1982.

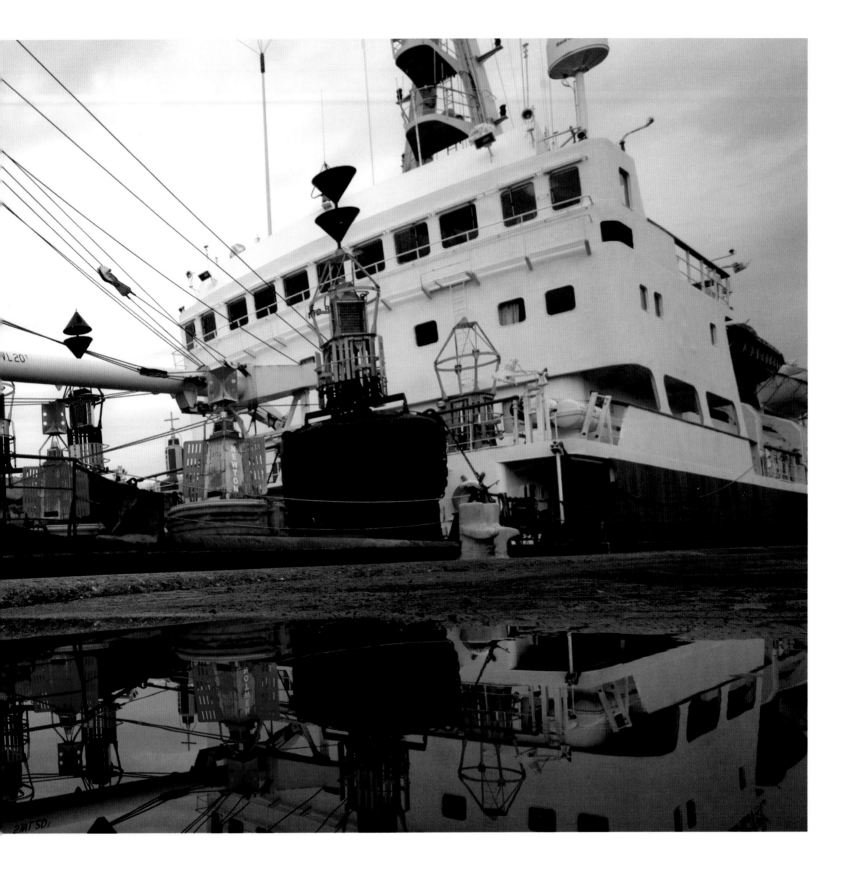

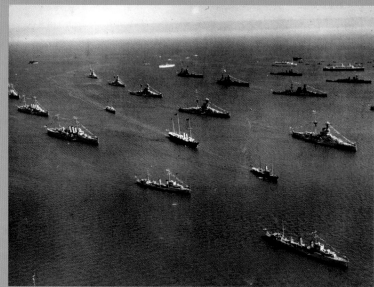

The Trinity House flagship is traditionally named *Patricia*, after Lady Patricia Ramsay, daughter of the Duke of Connaught and Strathearn, Master of Trinity House from 1910 to 1942. She appears again, in the photograph, bottom right, seen leading HMY *Victoria and Albert (III)* in a Fleet Review in 1935. The privilege of the Elder Brethren of Trinity House escorting the monarch while in pilotage waters dates back to 1822.

The first vessel so named, top left, was originally the steam yacht *Miranda*, built for Lord Leith of Fyvie; she was purchased by Trinity House after the First World War and renamed *Patricia*.

Top right is the second *Patricia*, in commission from 1938 until 1982.

THV *Patricia*, commissioned in 1982, was built by the Robb Caledon Yard in Leith in 1980. Her design provided for a helideck for the servicing of rock lighthouses and she remains equipped with the most modern navigational aids, including search sonar for wreck finding. She is able to carry up to 12 buoys and has a 20-ton speedcrane. Deck machinery facilitates recovery of buoys and chain cable on the foredeck. A high degree of manoeuvrability is achieved with twin screws, twin rudders and a bow thruster. She is of diesel-electric propulsion and full bridge control is available. Of 86.3 m length overall, she has a service speed of 14 knots.

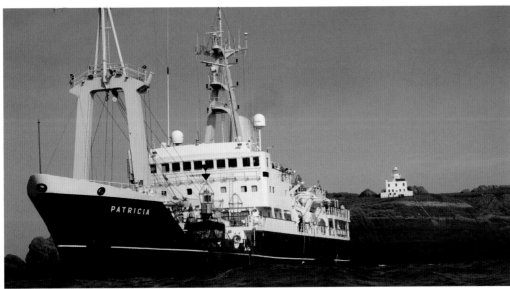

After 30 years in commission, in 2012 *Patricia* underwent an upgrade and life extension programme, including a dynamic positioning system, to enable her to provide good and effective support to 2020.

The series of photographs here illustrates her work in buoy handling, escorting HM The Queen embarked on HMS *Endurance* and, bottom right, the Elder Brethren on her helicopter deck during a Royal Escort.

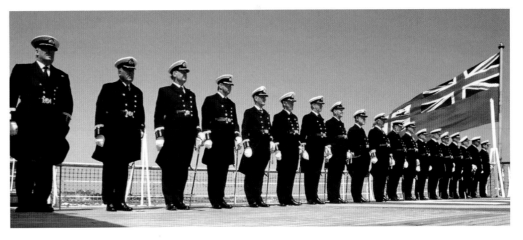

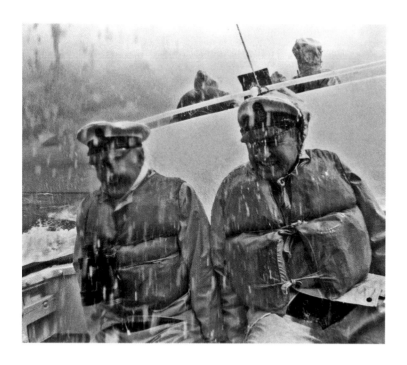 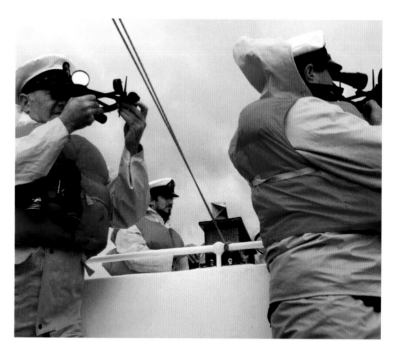

Every year, a number of Elder Brethren form a Visiting Committee and set out in either THV *Galatea* or THV *Patricia* to inspect Trinity House's major aids to navigation and properties around the coast.

In the days of manned lighthouses, the Elder Brethren and the District Superintendent would assiduously view every aspect of a lighthouse station's function from the accurate timing of its light to the cleanliness of its most obscure storeroom. Needless to say, the sheen of the brasswork, the shine of the optic and the personal presentation of the keepers themselves also came under scrutiny. While the condition of the vegetable gardens on a shore station might seem to be of only a passing importance, other matters such as the condition of a lighthouse's exterior paintwork were fundamental, providing as it did a conspicuous daymark for mariners.

Their observations – and if necessary their commendations or reproaches – would be recorded in the station's Order Book as a standing record of the keepers' diligence.

Today, the members of the Visiting Committee start their day with a dawn briefing on the navigational significance of the stations to be inspected that day and the relevant engineering issues, such as structural works or repairs and technological installations. A debrief at the conclusion of the day's work in consultation with the senior managers on board ensures that the highest possible standard is maintained.

Opposite: The ship's motor boat taking the Committee ashore flies the Deputy Master's flag based on the four-ship design from the coat of arms, in the centre of which is the rampant lion – the crest of the Corporation's coat of arms.

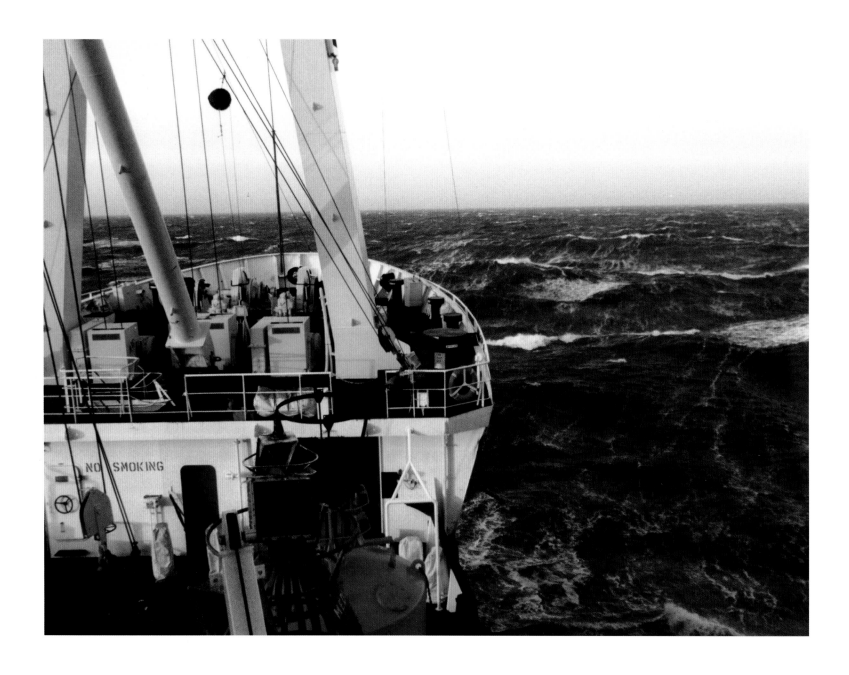

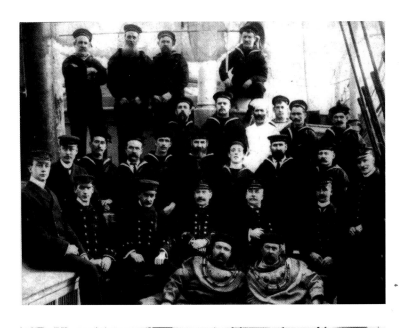

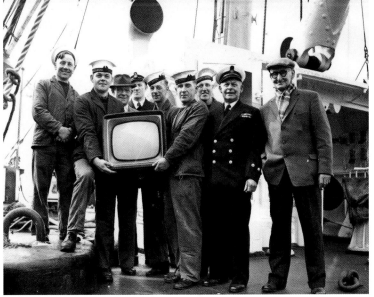

As the proverb goes, smooth seas never made a skilful sailor. Working in an unpredictable environment makes demands upon the skills of the Officers and ratings of the Trinity House service.

Ships that supply the lighthouses, lightvessels and buoys that mark treacherous hazards must necessarily go into places that other ships are warned away from; manoeuvrable ships and skilled seamen are a must, and this was especially true in the days before live seabed imaging and computerised Direct Positioning took some of the risk out of putting a ship alongside a floating buoy or lightvessel or a partially concealed hazard.

Conditions in the waters for which Trinity House is responsible are remarkably varied. They include the rock-girt west-facing coasts of England and Wales, where, in the Bristol Channel, the second highest tides in the world occur; the violent tidal streams of the Channel Islands; the congested waters of the international highway that is the English Channel; and the shifting sands and extensive shoals of England's east coast. Add to these natural features the increased proliferation of gas production platforms and wind farms, over all of which prevails the unpredictable weather systems of our northern latitude, and one begins to grasp the inherent challenges of these seafarers' working environment.

Opposite: The view from the bridge of THV *Mermaid* at anchor offshore in heavy weather. She was commissioned in 1987 and sold out of service in 2006.

Left: The crew of THV *Siren* of 1904.

Below: The crew of an older THV *Mermaid* welcomes the arrival of a television set for their mess area.

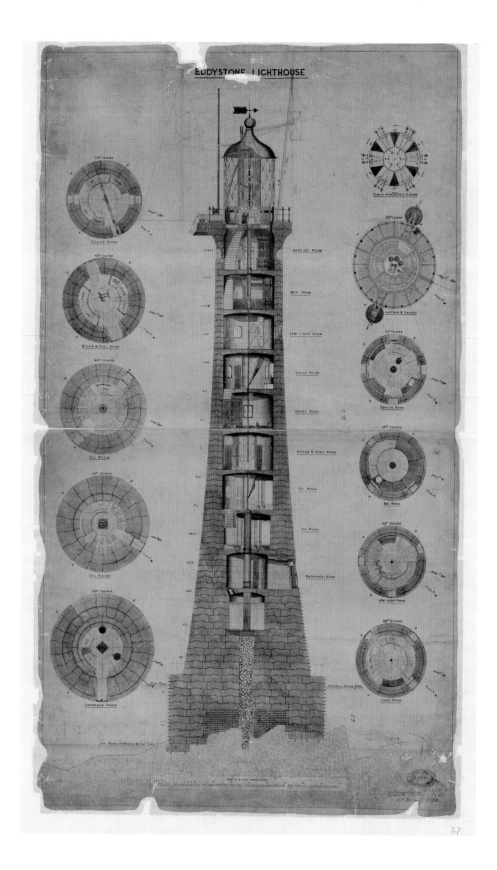

EDDYSTONE LIGHTHOUSE

The conversion of Eddystone (this page and opposite) to fully automatic operation was achieved in 1982 to mark the centenary of the present tower. Eddystone was the first Trinity House rock tower lighthouse to be converted to automatic operation, with the remote control and monitoring achieved by telemetry link to shore. The first part of the automation programme was the creation of a helideck above the lantern, which enabled engineers and equipment to be flown in.

On completion of this Douglass tower, that of John Smeaton, erected in 1759, was brought ashore and rebuilt on Plymouth Hoe where it remains today as an attraction. The inauguration of the Douglass tower was in the hands of HRH The Duke of Edinburgh, Master of Trinity House from 1867 to 1894, and the procedure in 1982 was presided over by HRH The Prince Philip, Duke of Edinburgh, Master of Trinity House from 1969 to 2011.

The party conveying the Master to Eddystone in 1882 took passage in THV *Galatea*, so named after His Royal Highness' previous command in the Royal Navy, HMS *Galatea*. The ship's name lives on in the Trinity House service with the modern *Galatea*, named by HM The Queen in 2007.

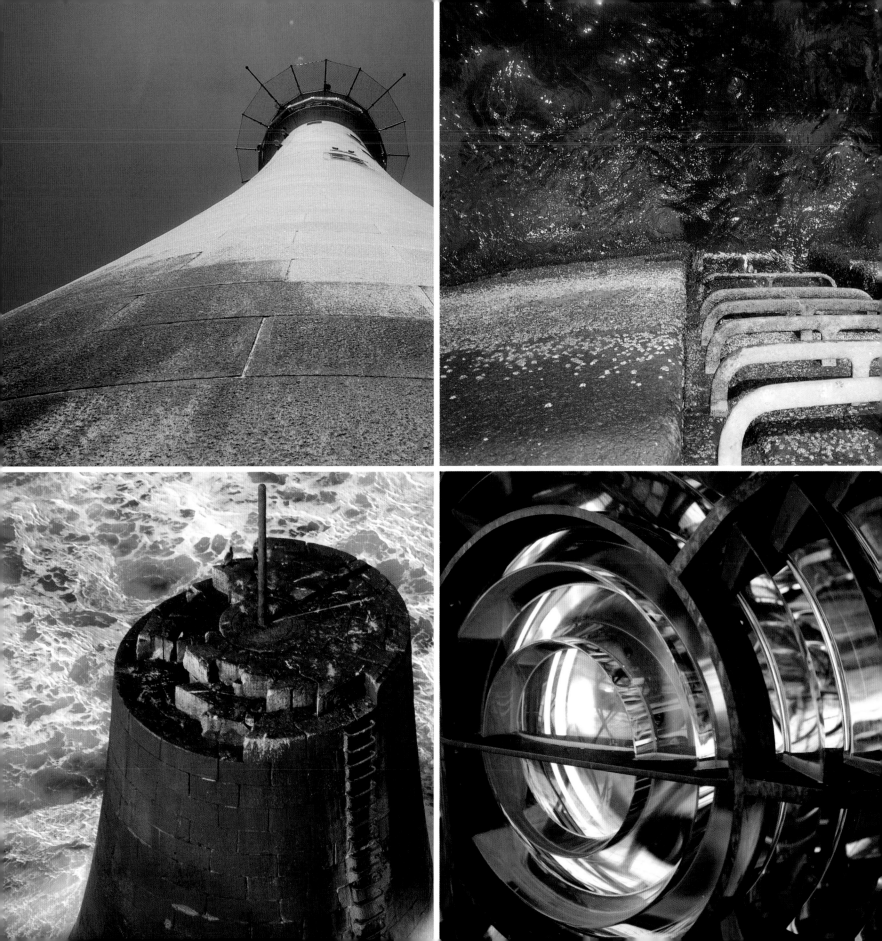

In light of the extreme dangers of constructing a stone tower out to sea, it is a great mercy that no lives have been lost. One of the more interesting close calls occurred to William Tregarthen Douglass, son of the great Engineer-in-Chief Sir James, who had begun work dismantling the upper two-thirds of the now-defunct Eddystone tower built by John Smeaton in 1759. The tower was to be relocated to Plymouth Hoe as a monument, upon the successful erection of the current tower by Sir James Douglass in 1882. Standing at the top of the tower, William was caught off guard when a great lifting chain broke and struck his legs, throwing him high into the air and some distance from the tower's edge, towards the rock landing. It seemed certain he would be dashed on the rocks below, but Providence smiled and a heavy wave rolled in over the base of the tower, covering the rocks and cushioning William's fall. The cold bath quickly roused him from unconsciousness and he managed to stay afloat until being taken on board the steamer *Hercules*. He was black and blue as a result of landing on water from a height of 85 feet, but was soon in Plymouth for medical attention. One week later he was back on the rocks, dismantling Smeaton's finest achievement for posterity.

Below: The temporary lightvessel established to mark the Eddystone Reef during the lighthouse's conversion to automatic operation.

Opposite: The stump of Smeaton's tower and the completed automatic Eddystone Lighthouse, powered by the array of solar panels around the lantern's gallery.

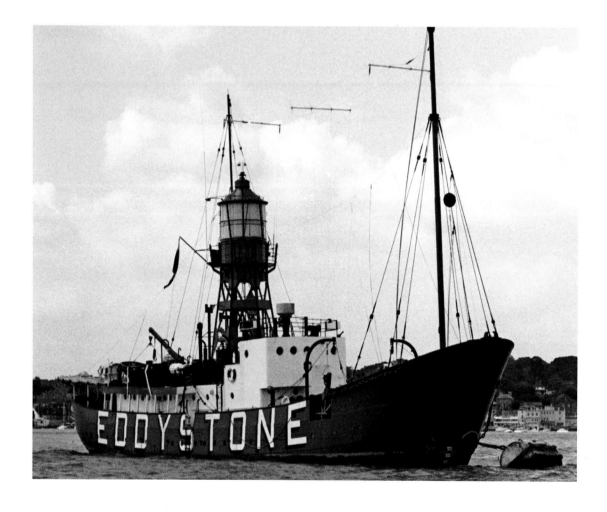

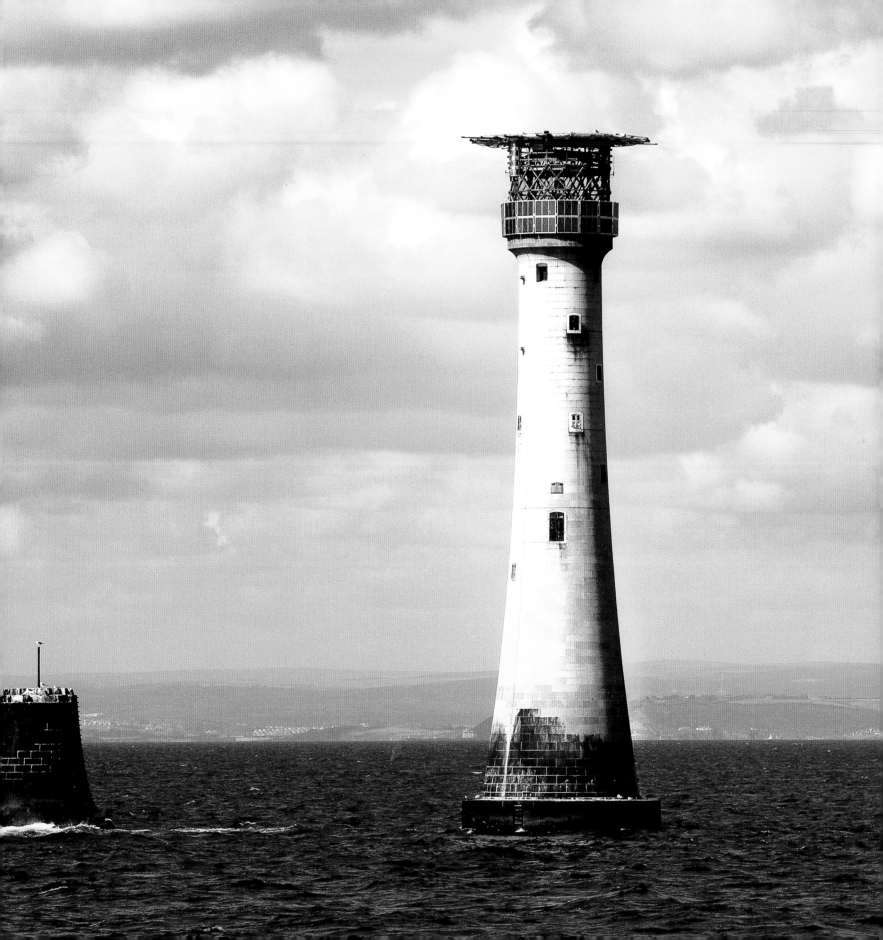

THE LIGHTHOUSE, ANVIL POINT, SWANAGE

Hunstanton Lighthouse & Signal Station.

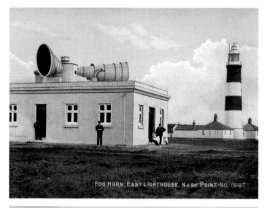

FOG HORN, EAST LIGHTHOUSE, NASH POINT No. 1316T

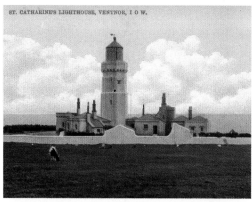

ST. CATHARINE'S LIGHTHOUSE, VENTNOR, I O W.

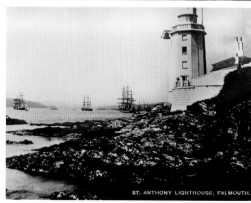

ST. ANTHONY LIGHTHOUSE, FALMOUTH.

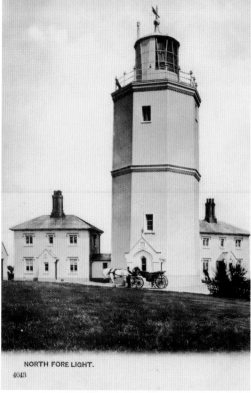

NORTH FORE LIGHT.
4043

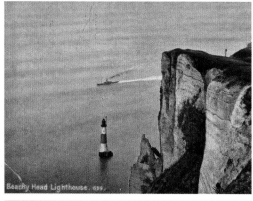

Beachy Head Lighthouse. 639.

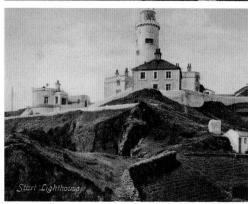

Start Lighthouse.

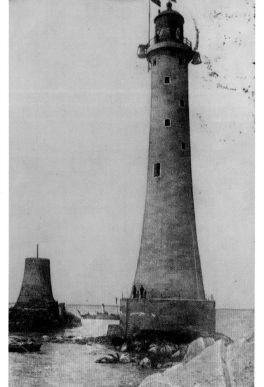

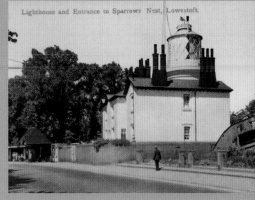

Lighthouse and Entrance to Sparrows Nest, Lowestoft.

Dovercourt Lighthouse

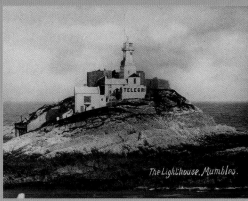

The Lighthouse, Mumbles.

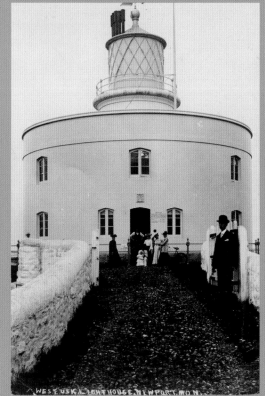

WEST USK LIGHTHOUSE NEWPORT, MON.

ST MARYS ISLAND WHITLEY BAY

Berry Head Lighthouse, Brixham

A collection of lighthouse postcards, a long-standing staple of British seaside tourism.

In addition to being pleasant to look at, the postcards served Trinity House in a practical manner. The mechanics at the Blackwall workshops kept a hefty scrapbook filled with such lighthouse postcards arranged by station, stuck down and scrawled upon as an easily accessible record of the changes made to each lighthouse over the years; page after page of hand-drawn antennae, gas tanks, pig sties and pipeworks.

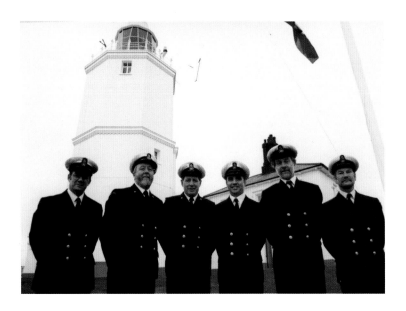

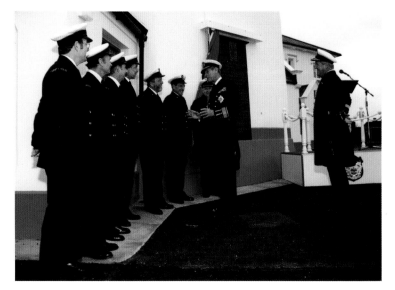

The last of the lighthouse keepers left the Trinity House service in 1998. On 26 November that year, HRH The Master presided at the final switchover from manned station to automation at North Foreland Lighthouse when a ceremony was held and a way of life maintained over four centuries came to an end.

North Foreland Lighthouse, at the north-east point of the Isle of Thanet in Kent, provides an aid to navigation for vessels leaving or entering the Thames, for those on a north/south passage and for vessels bound for Ramsgate. It is said that there was a light exhibited here in 1499. Later, a patent was granted to Sir John Meldrum to build a lighthouse on the Foreland in 1637 and this consisted of a two-storey octagonal tower. It was destroyed by fire in 1683 and the present structure, built in 1691, is recorded in 1698 as consuming 100 tons of coal each year. After passing into the hands of the Trustees of Greenwich Hospital in 1719, Trinity House purchased the lighthouse in 1832 and in 1890 installed a new lantern.

For nearly four centuries, Trinity House keepers in England and Wales and the Channel Islands and Gibraltar made an invaluable contribution to the safety of shipping, at times overcoming conditions of great hardship.

Often, several generations of a family succeeded each other in the profession and many of the keepers' exploits are enshrined in folklore or have become a matter of public record, most notably, perhaps, the heroics of Grace Darling who accompanied her father, Principal Keeper of Longstone Lighthouse, in the courageous rescue of nine souls from the paddle steamer *Forfarshire* on 7 September, 1838.

On his visit of 26 November 1998 HRH The Master unveiled a plaque commemorating the history of North Foreland Lighthouse and the completion of the automation programme.

In the Station Order Book he paid credit to the keepers down the years with; '… *the ceremony marked the completion of the Corporation's lighthouse automation programme and the formal closure of the last manned Trinity House lighthouse, thereby ending some 400 years of steadfast service to the mariner by the Lighthouse Keepers of the Corporation of Trinity House. His Royal Highness conveyed the appreciation and good wishes of the Elder Brethren to the last Keepers: Mr T J Homewood, Principal Keeper, Mr T Sturley, Assistant Keeper, and Mr B V Simmons, Assistant Keeper for their, and their predecessors, many years of loyal and devoted service to the safety of mariners.*'

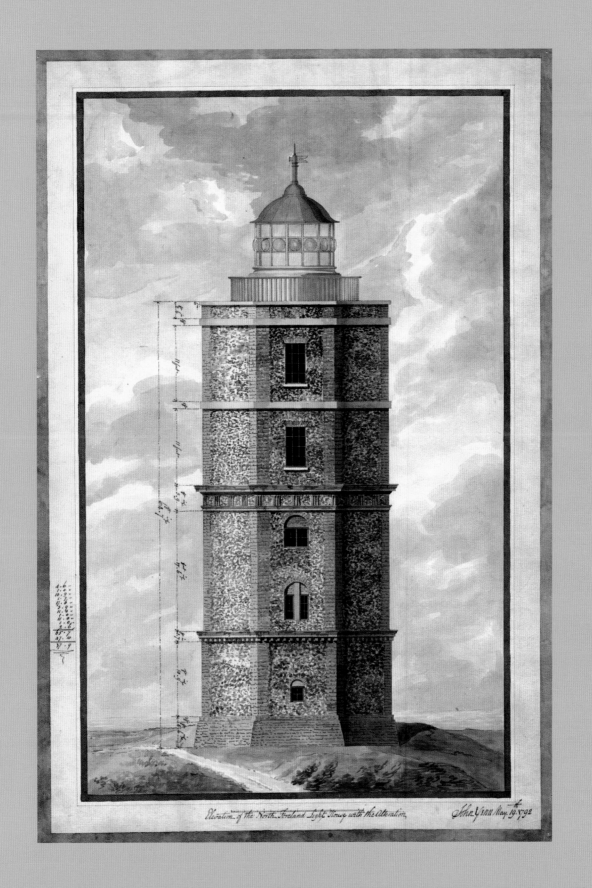

Elevation of the North Foreland Light House with the Alteration. John Yenn May 19.ᵗʰ 92

113

Blackwall Training School was where all new lighthouse keepers undertook basic training.

Above left: The lighthouse in the Training School was used to demonstrate equipment.

Above right: A new keeper is measured for his uniform.

Opposite top and right: The magic of the Paraffin Vapour Burner apparatus being demonstrated.

Opposite left: Elementary carpentry being taught to Supernumerary Assistant Keepers.

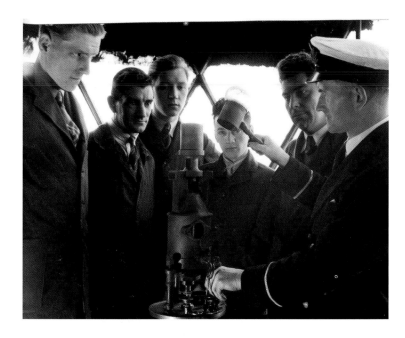

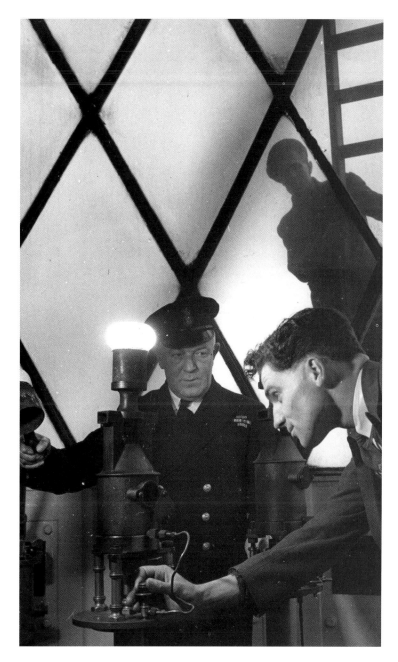

The technical aspects of life on a lighthouse were taught at the Blackwall Training School – how to exhibit, maintain and extinguish a light, how to keep good order around the station, basic carpentry, cooking, the use of the engines, communicating by radio-telephone – but everything else that comprised the daily routine relied upon the ability of a man to live in extreme confinement for weeks and months at a time with two (or sometimes three) other men. Personal habits such as biting one's nails, whistling or tapping one's feet, every day for two months on an isolated rock with no escape and limited means of entertainment, could be a recipe for disaster. Keepers with short tempers, a need for constant small talk or the inability to suffer their fellow men did not tend to last long in the lighthouse or lightvessel service.

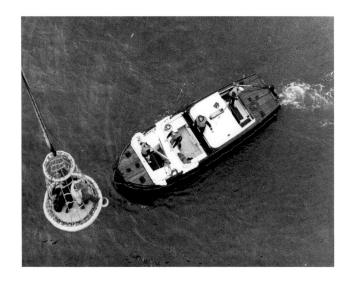

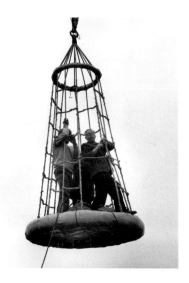

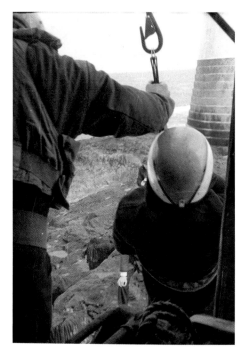

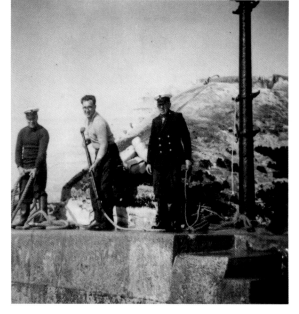

Life at an offshore lighthouse was unusual.

Top row left and centre: The 'Billy Pugh', a basket for lifting personnel out of a boat at the Inner Dowsing Lighthouse.

Top right: Personnel being landed by helicopter at Smalls Lighthouse.

Bottom row left: A keeper at Longships signalling to his wife ashore at Sennen Cottages.

Bottom row centre and right: Landing supplies at Les Hanois and Casquets Lighthouses upon the welcome arrival of the district tender or local boat.

Opposite: Heavy seas sweeping the landing at Wolf Rock Lighthouse, making the dangers of relief all too apparent.

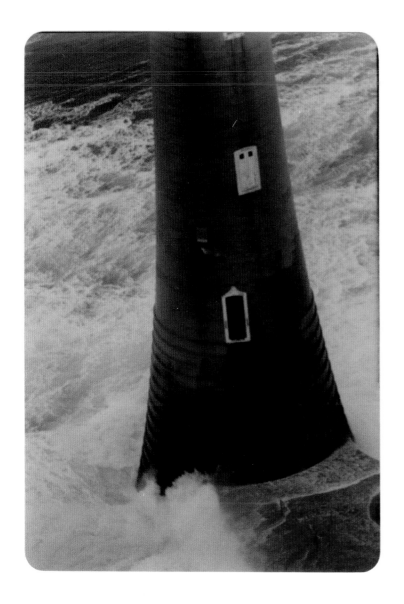 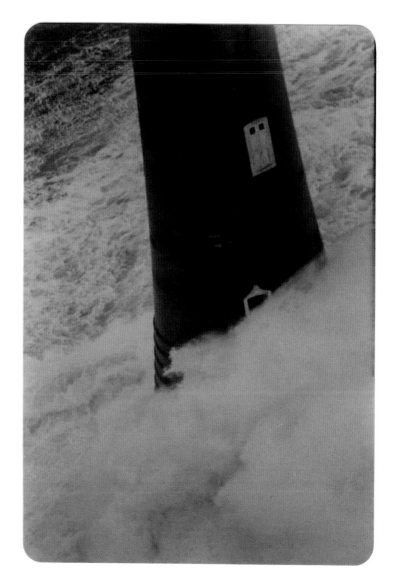

'Whatever the engineer may produce or the scientist devise, all these aids to navigation pass finally into the hands of a few men who are each responsible for the regular and uninterrupted operation of the lights and fog signals in their charge; and that, whatever else befall, the safety of shipping while at sea depends in no small measure upon their zeal in keeping a faithful watch by night and a diligent look-out by day.'

Sir John Poland Bowen, Engineer-in-Chief 1924–51.

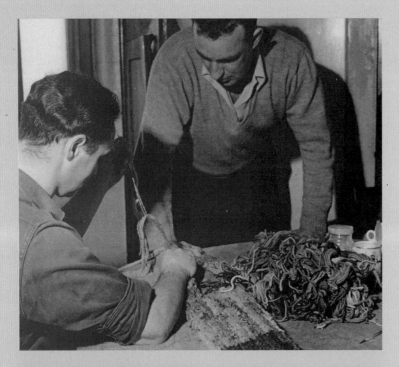

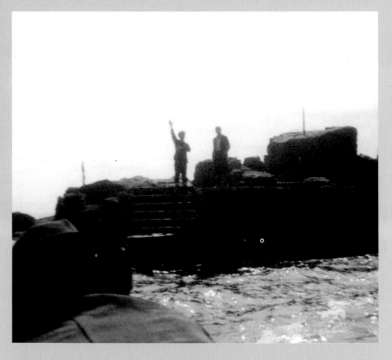

Very few people today understand the peculiar life of a lighthouse keeper. By turns communal and solitary, progressive and traditional, life on the various shore and rock tower stations coupled monotonous diligence with initiative and intelligence.

A shore station was a little colony of its own, the keepers and their families dependent on each other. With good neighbours, the time passed pleasantly enough, but discordant notes affected the social life of the resident families; the discord might be felt more keenly on offshore stations, where three men had to share the same quarters for weeks on end, made more difficult in the winter months with the gunmetal storm shutters closed fast. Hobbies and interests outside of the watch-keeping and general routine of cleaning the station and preparing the light became vital to the general well-being of the men; newspapers and letters were quickly exhausted, but Trinity House supplied travel and fiction books; the advent of wireless radio was a great boon, and boxing and football matches and music hall were especially popular. Tame gulls and seals, two-handed card games, kite fishing, mat-making, carpentry, model-making and the like kept spirits from flagging, but there were a number of disappointments too, chief among which was a delayed relief caused by bad weather, which was critical at Christmas time.

Above left: Tatting (the making of a rag rug). *Above right*: A friendly wave to the district tender's motor boat on relief day. *Bottom left*: The keeping of the ever-present records which, were eventually transferred ashore to the District Superintendent in the Depot. *Opposite*: A keeper being transferred to the district workboat.

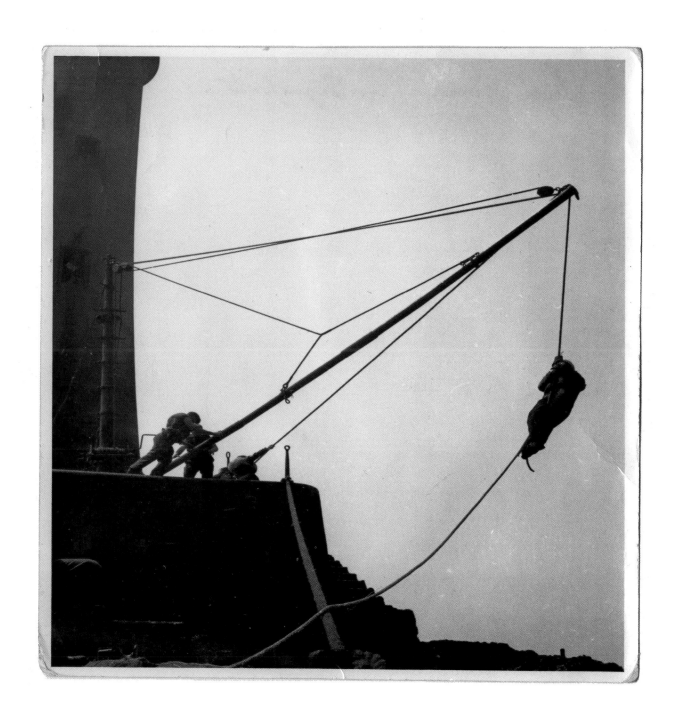

Opposite clockwise from top left: This series of photographs shows facilities at Eddystone Lighthouse: the radio with which to listen to the shipping forecast, a set of paperbacks for off duty and the station's notice board; the brasswork on the curved staircase up the tower always shone; the curtained, curved bunks in the accommodation floor of the tower; and the Principal Keeper's desk where he prepared his reports for the District Superintendent.

I have just completed my half of the painting in the living room. I have painted the ceiling and the walls and Peter is painting the woodwork. It will look quite fresh when the woodwork is completed. The colour scheme consists of white emulsion on the ceiling, magnolia vinyl silk on the walls with the woodwork in white gloss.

Such decor is the Trinity House standard, though it is acceptable for wall colours to be substituted for buttermilk or some other equally nondescript colour. Although such a colour scheme can be criticised for being bland it has stood the test of time. The idea being that its neutrality is more agreeable. It also serves to counteract personal taste and decorating disasters which could result. This was also a more practical decorating policy in the days when service personnel could be moved from station to station with little notice.

Although large areas of monotonous wall space resulted, these could be filled with pictures and ornaments which were the usual remedy in most houses. Otherwise one house was much like another.

This said, when we lived at Souter Point we were allowed to hang Laura Ashley wallpaper.

Personal journal of Principal Keeper Robert Farrah, Alderney Lighthouse, 28 February, 1997.

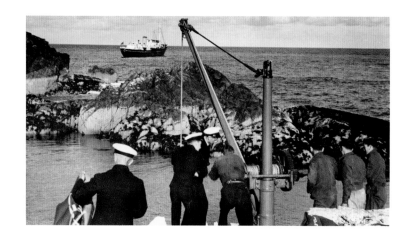

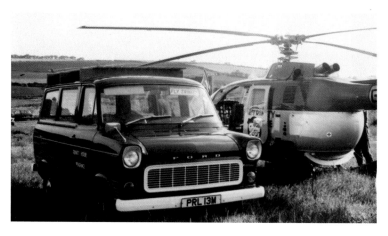

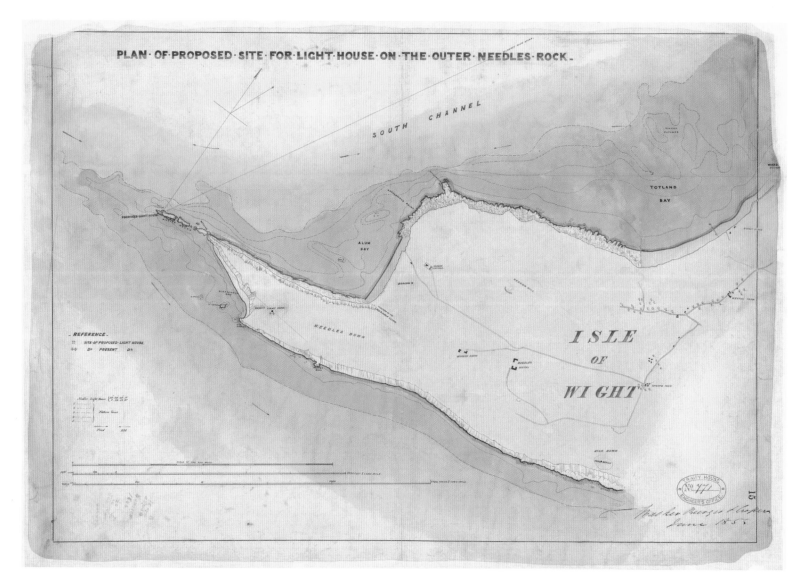

PLAN·OF·PROPOSED·SITE·FOR·LIGHT·HOUSE·ON·THE·OUTER·NEEDLES·ROCK

SOUTH CHANNEL

TOTLAND BAY

ALUM BAY

REFERENCE

NEEDLES DOWN

ISLE
OF
WIGHT

Opposite: Relief day at Skerries Lighthouse by district tender THV *Argus* and, on the right, the helicopter.

The bottom left drawing shows the proposed light on the Outer Needles Rock on the Isle of Wight dated 1859 and prepared by the consulting engineering company of Walker, Burges and Cooper of Westminster. The engineering work of the Corporation was carried out under the advice and supervision of this company whose representative was James Walker from 1832 to 1863. On the death of Walker, the post of Engineer-in-Chief was instituted.

Left: The mermaid carved into the rock face at Needles Lighthouse, while below, left, a rating in the district tender uses semaphore to signal Wolf Rock Lighthouse during the Second World War.

Below: A family of holidaymakers visiting the keeper at Bardsey Lighthouse in 1928.

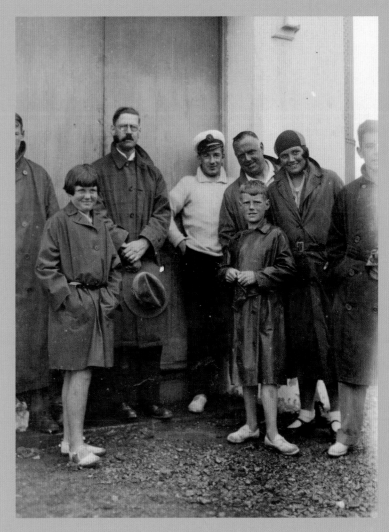

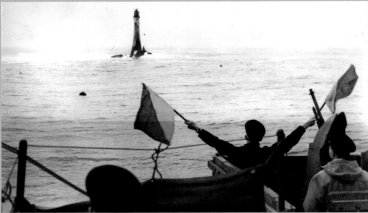

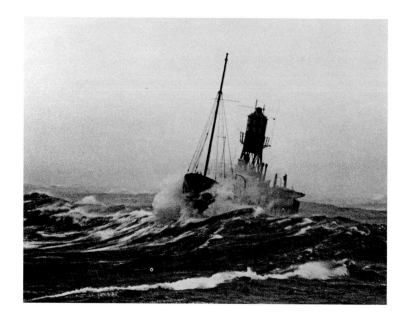

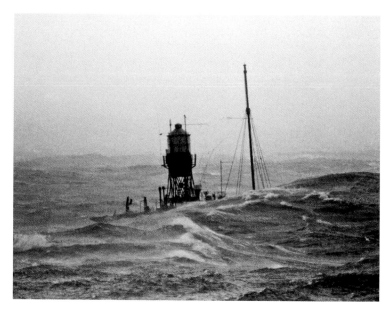

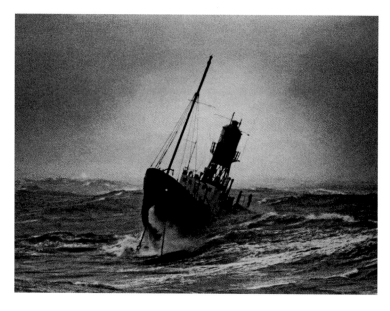

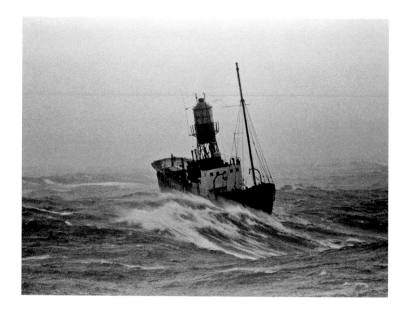

This series of photographs shows No. 15 Lightvessel under tow by THV *Winston Churchill* rounding the Lizard en route to the Channel lightvessel station in a gale at the end of 1978. Over a decade later, on 9 June, 1989, the last manned lightvessel was taken off the Channel station and an unmanned automatic lightvessel left in her place, completing the automation of the lightvessel fleet.

Although difficult at times, life for the men on the lightvessels was alleviated by rounds of fishing, cards and visitors from passing yachts with newspapers, mail and victuals. Constant exposure to the elements did present a number of problems. By way of example, when fog came in, the melancholy '*Beu... eueueueueueueu*' – as Arthur Ransome described it – of the fog signal was sounded and could roll on for days, giving the crew little opportunity for conversation or peace; just as disturbing, however, could be the sudden and eerie silence that fell when the fog passed and the noise ended. For over two and a half centuries, the steadfast lightsmen and their big red lightvessels gave a great deal of reassurance to mariners along the coast.

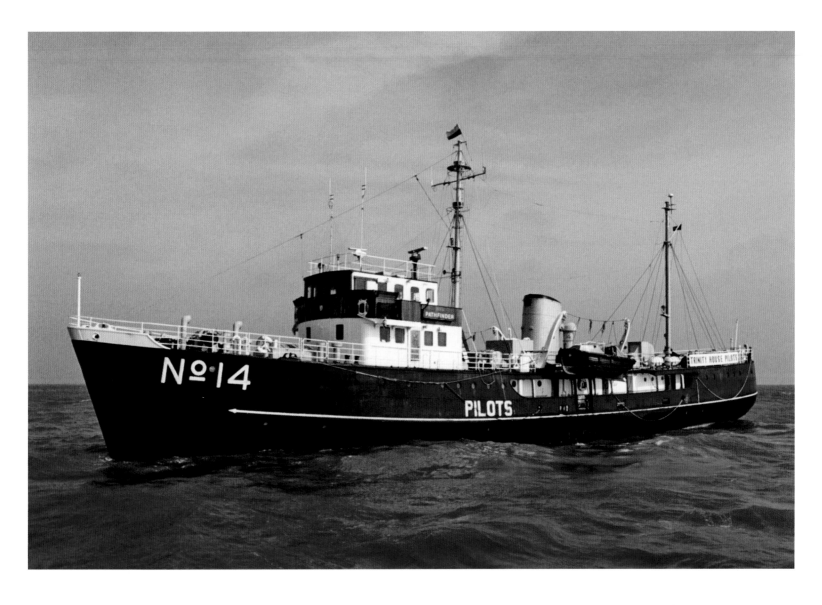

Another era came to an end when THPV *Pathfinder*, the last cruising cutter in the Trinity House Pilot Vessel Service, was removed from the Sunk Station prior to being sold out of service in 1986. As noted earlier, she was replaced by a fleet of fast launches.

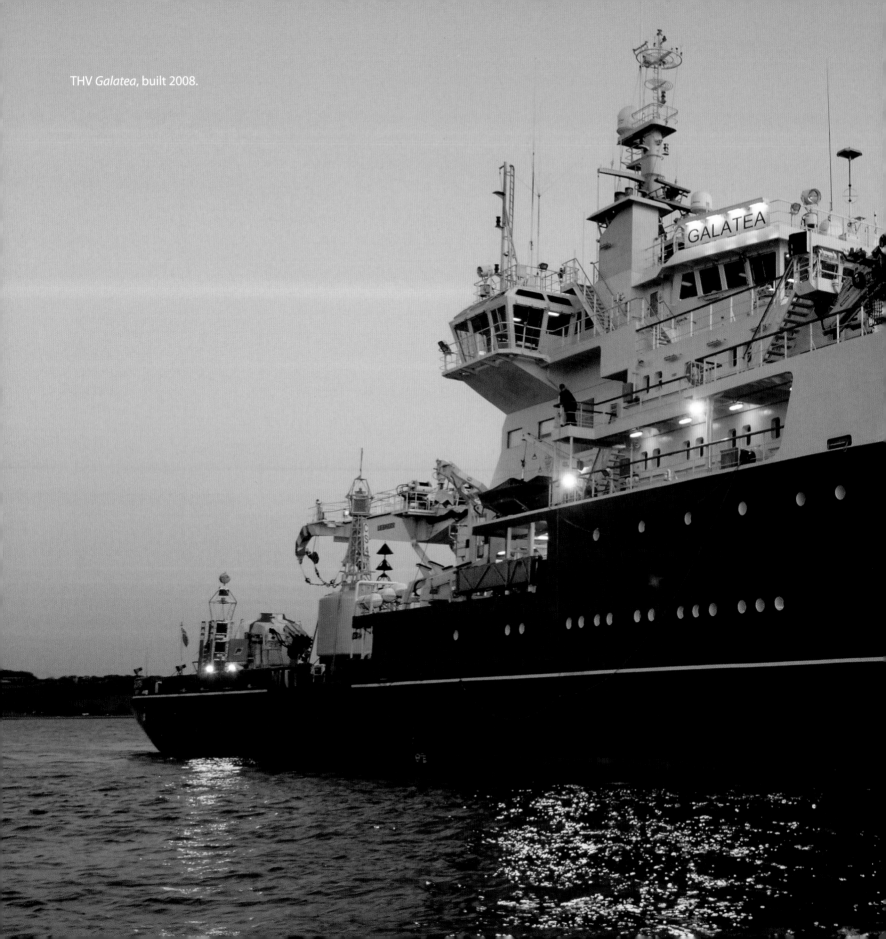

THV *Galatea*, built 2008.

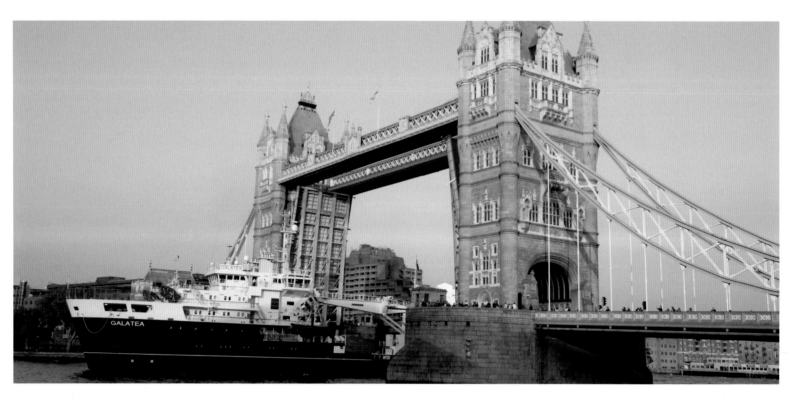

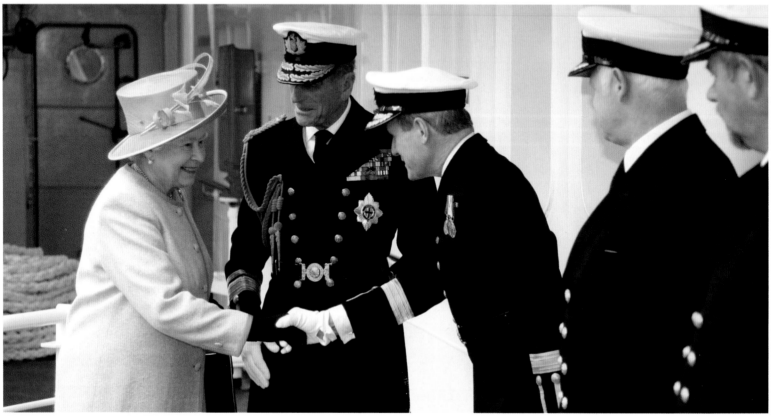

'John Sabine, son of John Sabine, Citizen and Cooper of London was bound apprentice to the Sea Service to Captain Nathaniel Werry, of Southwark for five years from this day and Inrolled. And four pounds was thereupon paid to the said Captain Werry, pursuant to Mr. Mortimer's legacy.'

Court Minute, 26 April, 1738.

In 1989, Trinity House created its Merchant Navy Cadet Scheme as a means of sending young men and women to sea for training. Many have undertaken their seatime in Trinity House vessels.

To date it is estimated that the Trinity House Maritime Charity has successfully contributed to the training of some 400 young people for advancement as officers in the Merchant Navy.

Above right: A cadet is shown being put through his navigational skills, while another, on the left, learns the intricacies of the workshop.

Opposite: In October 2007, THV *Galatea* passed through Tower Bridge to enter the Pool of London. Here, HM The Queen was welcomed on board by HRH The Duke of Edinburgh as Master of Trinity House. The Deputy Master Sir Jeremy de Halpert is being presented to Her Majesty during the *Galatea*'s naming event.

The Trinity House Vessel *Galatea* was commissioned in 2007 as a multifunction tender and her duties include buoy maintenance, surveys, the delivery of stores and equipment to automatic lightvessels and lighthouses and the tow of lightvessels to and from station when they are removed for dry docking.

Trinity House Vessels are equipped for wreck marking, carry wreck-marking buoys and with their sonar are able to find wrecks and establish their extent and whether or not they are a danger to navigation, a duty carried out more frequently than might be popularly supposed.

Below: One of *Galatea*'s motor boats lowered and powering away to carry out its task.

Opposite top left: A series of buoys prepared for station; on the right is one of *Galatea*'s motorboats, equipped for surveying as well as other tasks.

Opposite bottom: Mooring cable is gauged for wear, part of the never-ending round of work of Trinity House Vessels.

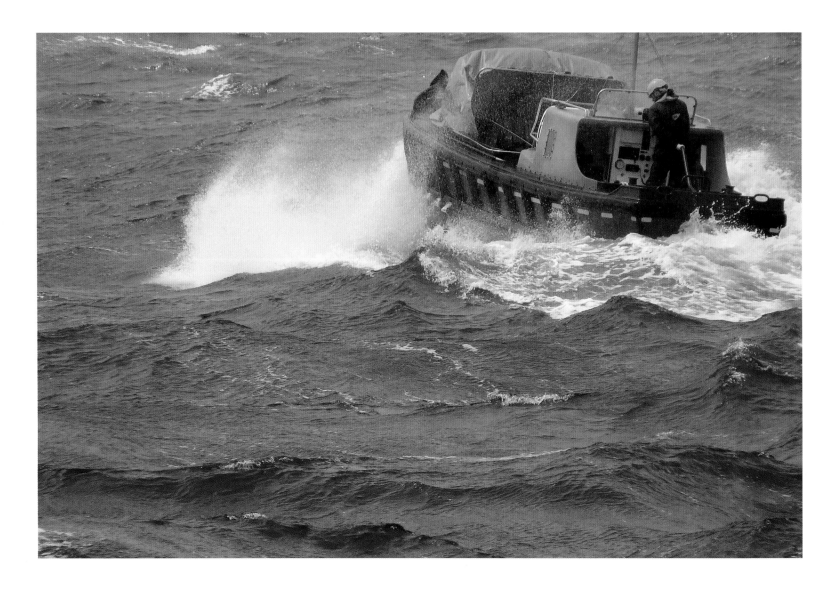

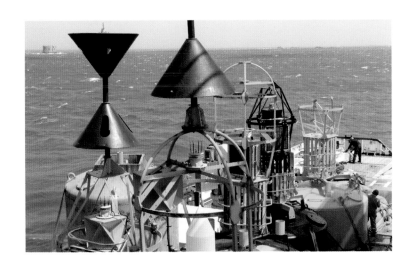

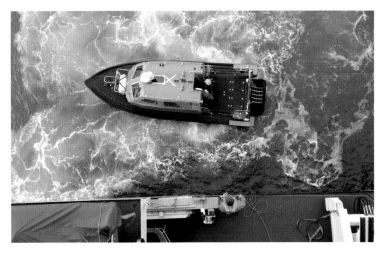

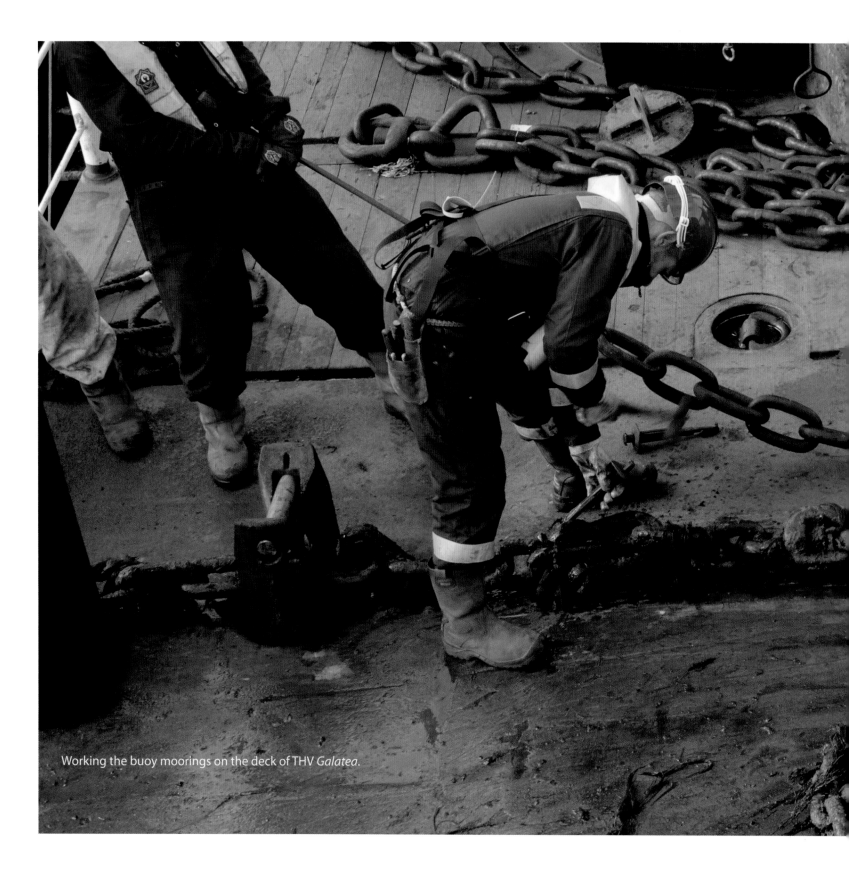

Working the buoy moorings on the deck of THV *Galatea*.

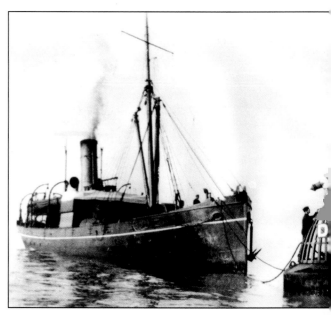

Buoys have evolved from the simple wooden floating markers of the 18th century to today's brightly coloured, often colossal steel seamarks.

Buoy maintenance is a major part of the day-to-day work of Trinity House and the photographs opposite show (left) the wharf opposite Trinity House Depot, Penzance; (centre) THV *Patricia* (1920 to 1947, renamed *Vestal* in 1938) working buoys from Harwich Depot; and (right) the second THV *Triton* replenishing an early lighted buoy with oil gas. As an illuminant, this was later replaced by acetylene.

Below: Grit blasting and painting. *Right top*: The buoy being lifted in the Buoy Yard at Harwich. *Bottom*: Welding on a buoy body. Buoy maintenance is carried out here and at Swansea.

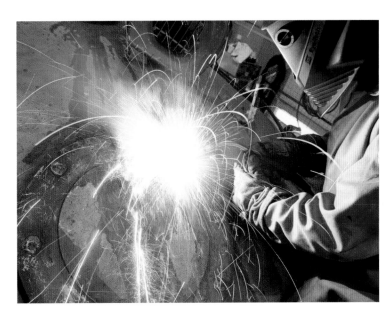

A fouled cardinal buoy on the working deck of THV *Galatea*. The buoy awaits inspection, cleaning and redeployment.

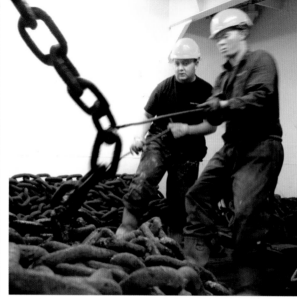
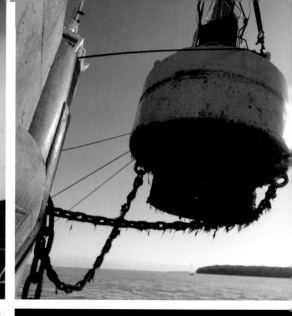
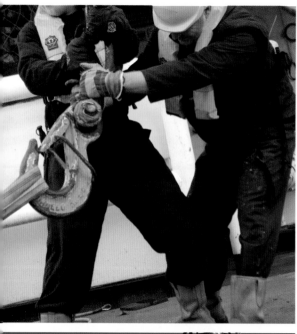
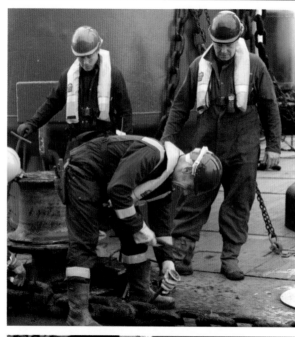
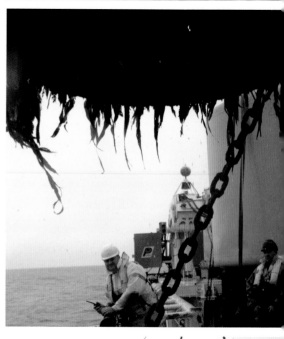
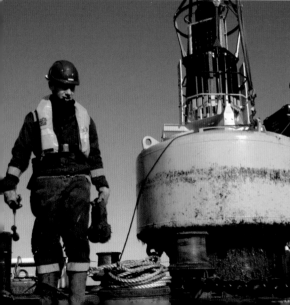

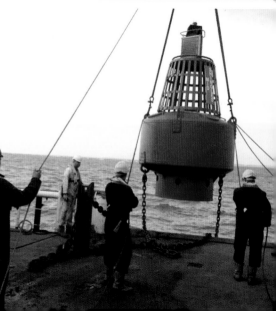

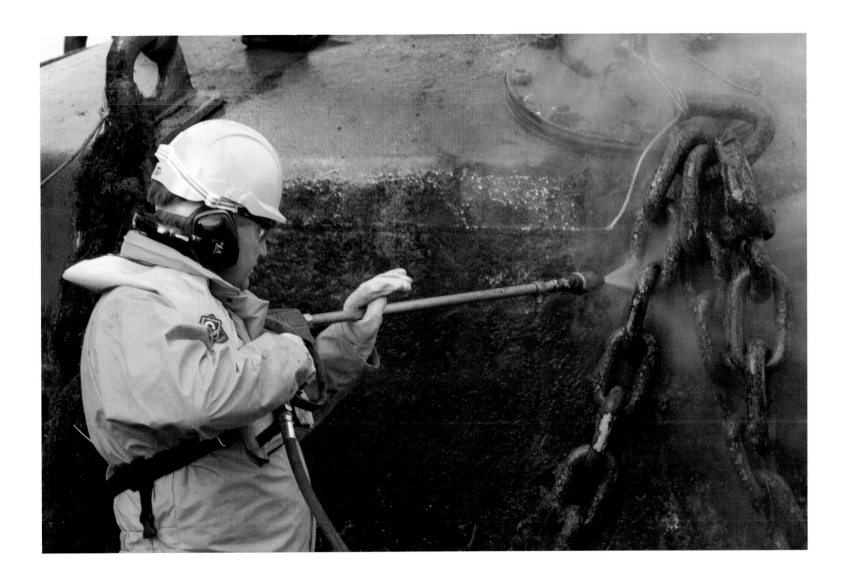

More buoy work on THV *Galatea*. This essential process involves the lifting of the buoy, removal of marine growth, inspection of the moorings and sinker and all their associated shackles. On completion, the sinker is returned to the exact 'Assigned Position' of the buoy station in question. It is usual to verify the depth of water to ensure that the danger that the buoy is marking has not moved, a not-uncommon occurrence in certain areas of the southern North Sea.

Although the work of the modern Trinity House Vessels remains essentially much the same as it did in the 18th century – supporting lighthouse engineering, buoy and lightvessel positioning and maintenance, channel surveying, wreck marking and the transfer of personnel – the size of modern ships, the encroachment of offshore renewable energy resources and other factors make the work much more technologically demanding. The capabilities of the newest multifunction Trinity House Vessels are therefore much greater. The *Galatea*'s 17-strong ship's company operate her as a hydrographic survey vessel, a scientific research platform, a guard ship and a marine hazard search and marking vessel. She is as comfortable attending offshore wind farms and hauling fouled chain from the seabed as she is accommodating the Elder Brethren on their annual inspection of Trinity House's aids to navigation.

While technology changes over time, the sea demands the same diligence as ever, and in mitigating the risk of navigation in our waters the men and women of Trinity House have earned themelves an enviable reputation for reliability and constant service.

Whether creeping over the shallows of the Thames Estuary to attend a buoy in shoal water, or replenishing a West Country lighthouse in conjunction with a helicopter in a gale of wind, or laying a wreck buoy on a recent wreck in thick fog, Trinity House seafarers have to be skilful masters of their craft.

Opposite and below: The workboats of THV *Winston Churchill* and THV *Galatea*, respectively, performing their vital work, manoeuvring people and supplies into tighter spaces and shallower waters than their mother ships are able to access.

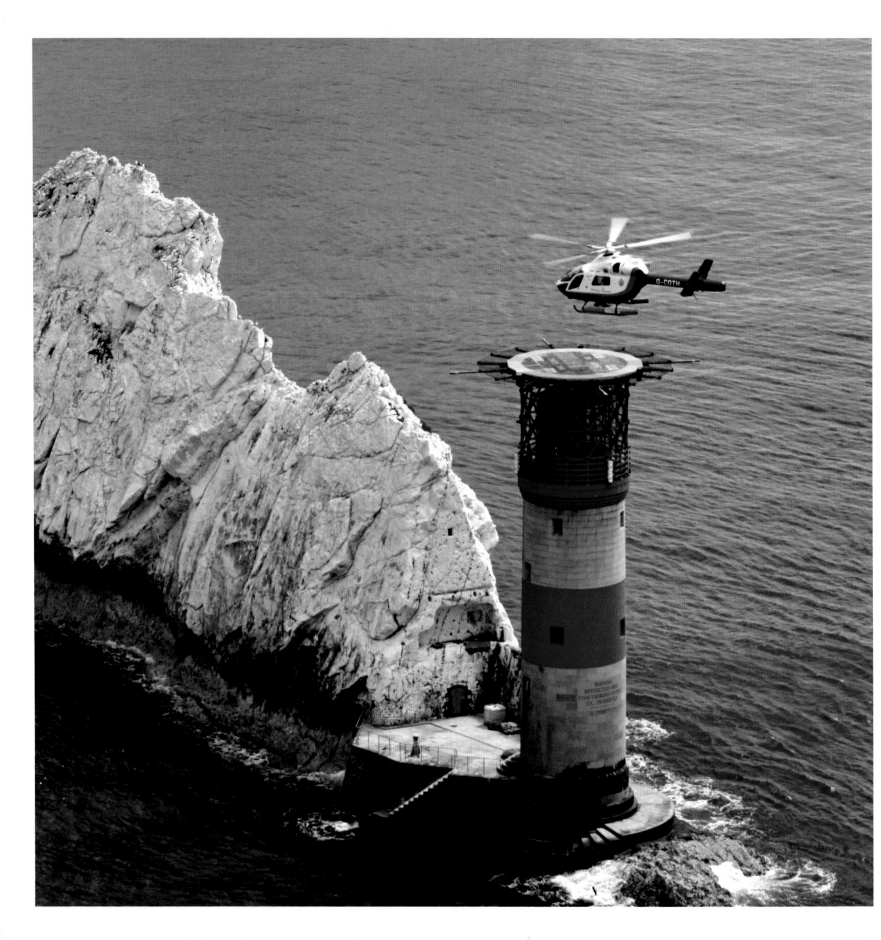

In 2011, Trinity House commissioned a new helicopter named *Satellite*, which perpetuates the name of a ship in the Trinity House service first used in 1840.

Opposite: *Satellite* is seen above the Needles Lighthouse.

In February 1948, severe weather delayed the relief of the men at the Wolf Rock Lighthouse by three weeks; with rations dwindling and no sign of the weather abating, the opportunity was seized to make the first use of a Royal Air Force helicopter at a lighthouse. Food and mail were successfully dropped by helicopter to the keepers below, all effected in a 40-knot gale. Reportedly, the keepers could be seen dancing and shouting with joy on the lantern's outer gallery upon the delivery of the much-needed food.

The year 1969 saw the debut of helicopter reliefs to and from lighthouses and lightvessels. The fast and safe transfer of keepers, crew and technicians was a great step forward for the service, and stories of keepers trapped by foul weather with limited rations and fuel became a thing of the past. In 1973, the first offshore helideck was installed permanently atop the Wolf Rock Lighthouse, the station that enjoyed a reputation of the greatest infamy for overdue reliefs. The helideck would prove vital to the latest technological innovation – automation. This began in the 1980s and was completed by the end of the 20th century.

Opposite: Smalls Lighthouse off the coast of Pembrokeshire. *Below*: The delivery of oil fuel for the standby generators at the otherwise solar-powered Eddystone.

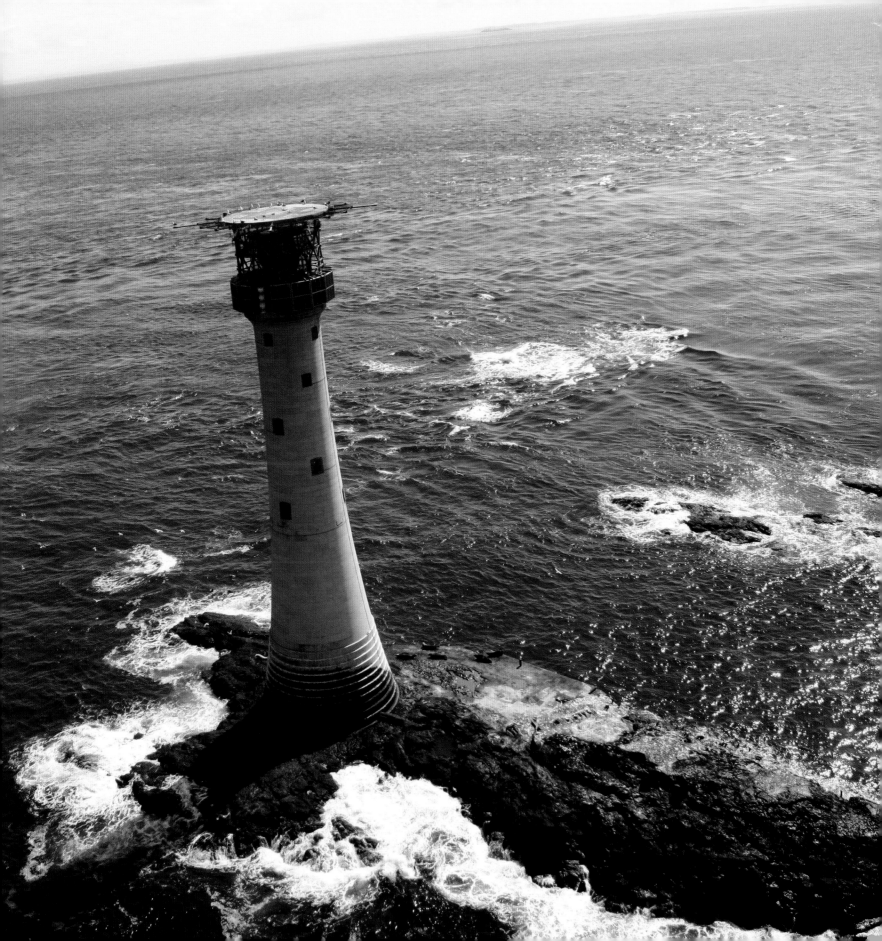

Above and opposite are two examples of modern light sources, using light-emitting diodes (LEDs), being tested by the Research & Radio-navigation Directorate. The RRNAV is jointly operated by the three sister General Lighthouse Authorities of our islands: Trinity House for England, Wales and the Channel Islands, the Commissioners of Irish Lights for Ireland and the Northern Lighthouse Board for Scotland and the Isle of Man.

This Directorate has been responsible for great advances in radionavigation in these waters, particularly with regard to Differential GPS, advances in Loran and provision of eLoran and defence against jamming and spoofing of GPS. Experts from this Directorate attend IALA where they contribute to the forum on e-Navigation and related matters with other representatives from the world's lighthouse authorities.

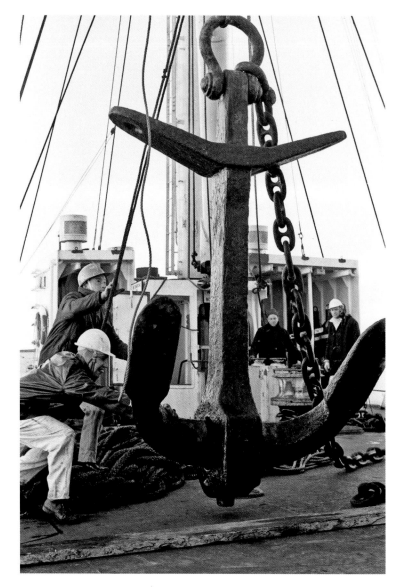

Over the last three decades, the huge increase in the availability and use of positioning, communications and information technology has fundamentally altered the nature of marine navigation; however, concerns over known vulnerabilities in, and over reliance on, the satellite-based GPS system must be taken into consideration when determining the provision of future aids to navigation.

As commercial ships are becoming larger – up to 400 metres long – and the age and abilities of the international fleet are becoming more varied in meeting the requirements of modern, state-of-the-art ships with fully integrated bridge systems as well as 30-year-old cargo ships with basic bridge and navigation equipment, it is clear that lighthouses, buoys and beacons will continue to play a vital role in a balanced mix of visual and electronic aids to navigation.

The essential ethos of the Trinity House lighthouse service is to provide a full marine aids-to-navigation service for the users in its waters. This responds to the needs of the modern shipmasters and shipowners, bringing together electronic aids to navigation so that the modern bridge fit carries receivers for DGPS, eLoran, AIS and VHF. All are used to monitor a vessel's movements where it can be plotted safely from shore to the benefit of the user and the environment.

The United Kingdom transports 95 per cent of its international trade by sea. Shipping has been a major source of growth for the UK economy over the past decade. Latest data shows that shipping, ports and the maritime business and services sectors contribute £31.7billion to UK GDP; they support 537,500 UK jobs and provide £8.5billion in tax receipts to the UK Exchequer.

Britain continues to lead the world as a maritime services centre, with banking and ship finance, marine insurance, law, classification societies, shipbroking, shipowning, education and consultancy combining to form the largest maritime services cluster, much of it based in the City of London.

All this is achieved with the mariners' and the shipowners' confidence in the maritime safety of our waters and a major contribution is that of the aids-to-navigation providers such as Trinity House.

For 500 years Trinity House has had links with the monarch: the granting of charters, approval for the grant of a coat of arms, the authority to erect seamarks, the Defence of the Realm, the election of Brethren, the occasional Royal Escort duty and Coronation and Jubilee commemorations.

Left: The Queen's Diamond Jubilee Pageant on the Thames on 3 June, 2012. TH No 1 Boat conveyed the Deputy Master, Captain Ian McNaught, Vice-Admiral Sir Tim Laurence and HRH The Princess Royal, Master of the Corporation.

Above: Manned by volunteers, the Trinity House Thames Waterman Cutter *Trinity Tide* with a flotilla of similar craft taking part in the Pageant.

Also taking part, top right, is the Sea Cadet flotilla of Trinity 500 craft built to a design sponsored by Trinity House. Each flew the flag of a member state of the Commonwealth.

Right: On 27 July, 2012, as part of the Olympic Torch Relay on the Thames from Chelsea Harbour to Tower Bridge, the *Trinity Tide* escorted the shallop *Gloriana*. Replicating a state barge of the reign of the first Elizabeth, the *Gloriana* was commissioned by Lord Sterling, Elder Brother of Trinity House.

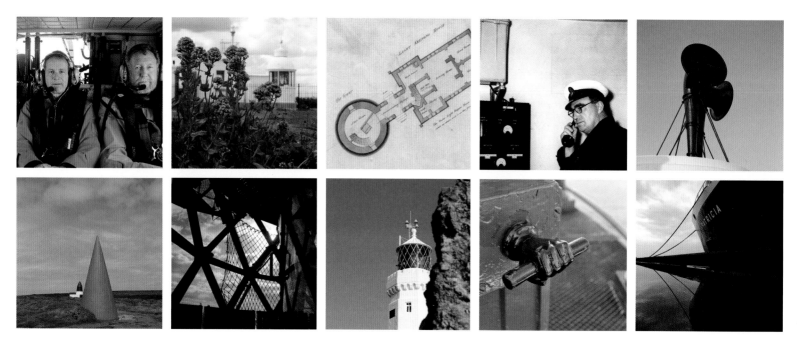

Any corporation or organisation that can track its history in centuries rather than years or decades will have more stories than can properly be contained in a single volume, and so it is with Trinity House. The same fraternity that distributed alms to the sailors and widows of Deptford, Limehouse and Stepney 500 years ago now drives and supports – through its workforce at large – developments at the highest international levels in safety at sea, radionavigation, engineering and building conservation, as well as providing funding for initiatives across the UK maritime charity scene. Since the Royal Charter granted by Henry VIII on 20 May, 1514, Trinity House has received over a dozen further charters and grants, but it is the robust but flexible 1685 charter from James II drafted by Samuel Pepys, along with the Merchant Shipping Act 1995, that allows the Corporation to change with the times and ensure its usefulness and relevance to the mariner as a General Lighthouse Authority, a major maritime charity and a Deep Sea Pilotage Authority.

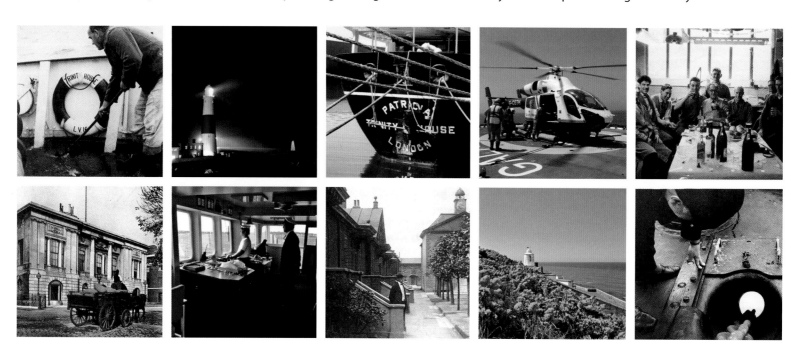

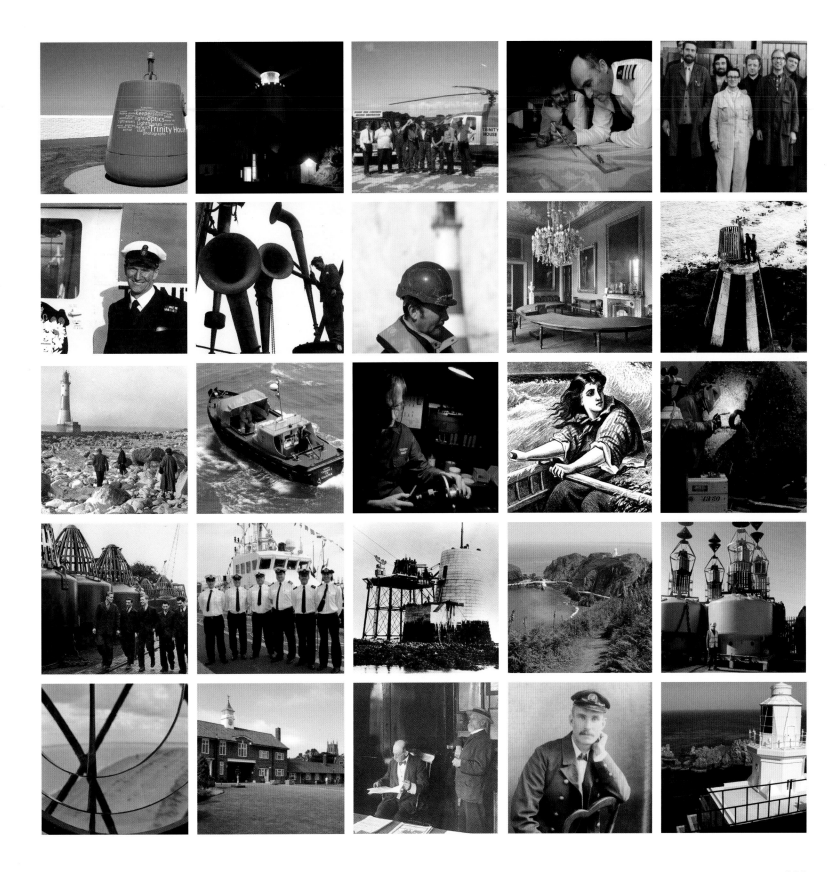

Trinity House still relies upon people, machinery, bricks and mortar, concrete, stone, iron, steel, fuel and nuts and bolts, as well as a fleet of service craft, all supported by hard-working and dedicated staff at four locations: Harwich in Essex, Swansea in South Wales, St Just near Land's End and at headquarters in the 200-year-old Trinity House, on London's Tower Hill, opposite the Tower of London. Without these elements the mariners of the world would struggle to navigate in safety in our waters.

Finally, the Corporation must acknowledge its debt to the countless numbers of staff past and present – and the many families that have provided successive generations of 'Trinity Men' to its various services – be they lighthouse keepers, lightsmen, engineers, ballast heavers, pilots, Elder Brethren, seamen, administrators, clerks, mechanics, technicians, divers, helicopter pilots, light dues collectors, draughtsmen, typists, scientists, navigation examiners, photometrists and more, as well as the thousands of Younger Brethren who over time have expanded and raised the organisation's profile across Britain's maritime sector.

As Trinity House celebrates five centuries of service to the mariner, to the nation and to the world's seafarers, all is set fair for the next half millennium and beyond.

AFTERWORD

As an Elder Brother of Trinity House, I am all too aware of the conditions faced by the staff at the business end of our operations: the crowded waters of the English Channel, the Strait of Dover and the North Sea; the rocky west coast, the hazardous sands and shoals of the east coast and the violent tidal streams of the Channel Islands.

Factor in the increase in man-made marine structures and the unpredictable weather systems around these isles and the reader hopefully begins to understand the difficulty in maintaining the aids to navigation that bring our seafarers and cargoes to safe harbour.

As an island nation we are none of us more than 72 miles from the sea; I hope this book will offer many an opportunity to appreciate the beauty and the menace so close to our doorsteps and the challenges that are overcome every day by Trinity House staff.

What the next 500 years holds no one can say for certain, except that the sea will continue to play a vital role in maintaining the way of life we all take for granted. With over 90% of goods entering the UK by sea, our lives would be very different without our mariners and to them we say thank you.

I would also like to take this opportunity to thank my colleagues throughout Trinity House who work so tirelessly to ensure we provide a world class service on a daily basis. It is also fitting that I pay tribute to those who have gone before us who have raised us to this position which we strive to maintain every day.

Captain Ian McNaught
Deputy Master
May 2014

IMAGE CREDITS

Unless credited otherwise, please assume that images are copyright the Corporation of Trinity House or are of unknown or expired copyright. Many thanks are due to J. Reid, M. Rayner and M. Dalton who supplied a number of images. All rights reserved.

Front cover Mirek Galagus; 47(t) courtesy of Ronald James; 51, 83(br) courtesy of E. Summerbell; 56–7, 69(tr), 71(br), 92(bl), 93, 101(br), 101(tr), 102, 108, 124, 125, 130, 131(tr), 131(tl), 148(b), 149(t,bl), 150, 151(tr,tl) Ambrose Greenway; 59(main) courtesy of *Motor Boat & Yachting* (IPC Media); 69(bl) Mark Tapley; 78–79 Alex Callis; 80–81 Tim Stevens; 83(tl), 85(bl) Richard Woodman; 83 (2nd from top) D. Smeeton; 83 (3rd from top), 104 John Snape; 85(br) D. Wilkinson; 95(t) Keith Morris; 98–9 Andrew Menadue; 109 Tricia Kennedy; 114(r), 115(tl) Getty Images; 128(t) Paul Bigland; 142 Beestons Media; 151(b) Tim Hodges.

Please note that wherever possible we have endeavoured to respect the copyright of third-party photographers where provenance was known; no offence is intended where agencies have proved defunct and permissions unavailable.

The Corporation would like to thank Captain Richard Woodman, Ambrose Greenway and all of the men and women of Trinity House both past and present for making this book possible.

FURTHER READING

Adams, Andrew & R. Woodman
Light Upon The Waters: 500 Years of Trinity House Trinity House, 2014

Barrett, C. R. B.
The Trinity House of Deptford Strond Lawrence & Bullen, 1893

Cotton, Joseph
Memoir on the Origin and Incorporation of the Corporation of Trinity House of Deptford Strond Private press, 1818

Hague, Douglas & R. Christie
Lighthouses: Their Architecture, History and Archaeology Gomer Press, 1975

Harris, G. G.
The Trinity House of Deptford 1514–1660 Athlone Press, 1969

Lane, Anthony
Guiding Lights: The Design & Development of the British Lightvessel from 1732 Tempus, 2001

Majdalany, Fred
The Red Rocks of Eddystone Longmans, 1959

Mayo, Walter
Trinity House London Smith, Elder & Co, 1905

Parker, Tony
Lighthouse Eland, 2003

Renton, Alan
Lost Sounds: The Story of Coast Fog Signals Whittles, 2001

Stevenson, David A.
The World's Lighthouses Before 1820 Oxford Press, 1959

Tomlinson, C.
Smeaton and Lighthouses: A Popular Biography 1844

Whormby, John
An Account of the Corporation of Trinity House of Deptford Strond and of Sea Marks in General Private press, written 1746, published 1861

Woodman, Richard
Keepers of the Sea: The Story of the Trinity House Yachts and Tenders Chaffcutter Press, 1983, 2005

Woodman, Richard & J. Wilson
The Lighthouses of Trinity House Adlard Coles Nautical, 2002

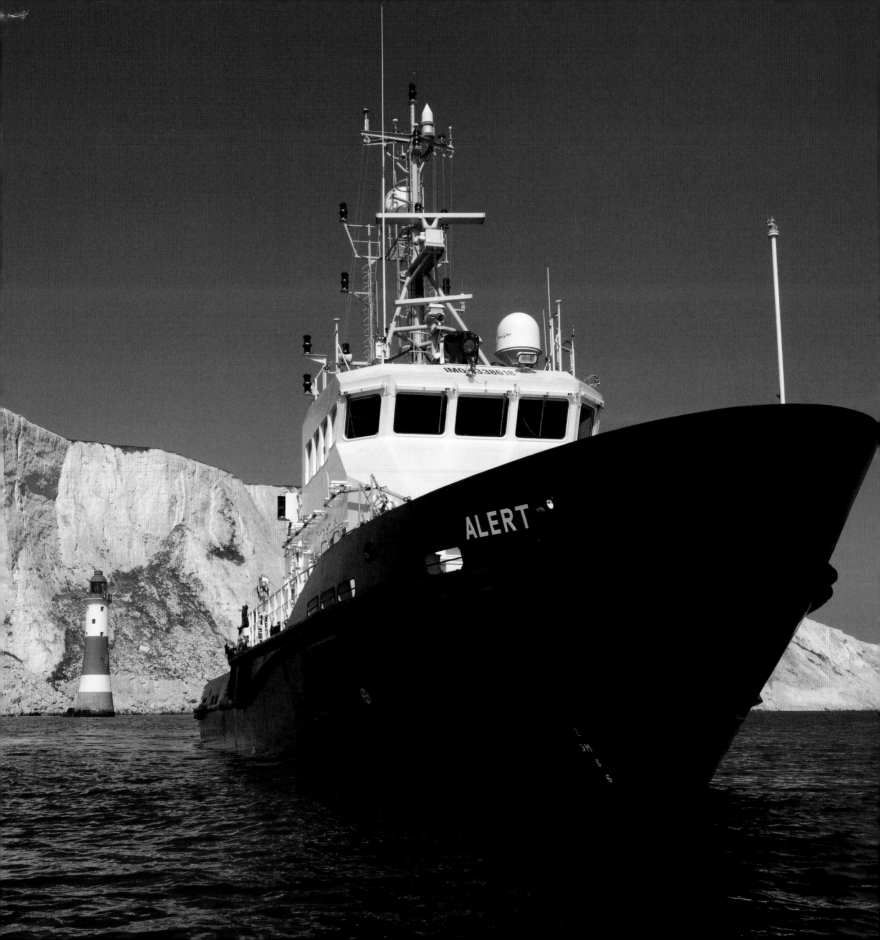